REDUCING MADE EASY

THE ELEMENTS OF MICROFILM

James H. Mann

MOORE PUBLISHING COMPANY
DURHAM, NORTH CAROLINA 27705

Published for:

International Micrographic Congress

P.O. Box 484
Del Mar, California 92014

Library of Congress Catalog Card Number: 76--25335

ISBN 0-87716-069-4

CONTENTS

PREFACE

There have been quite a few books written on or about the microfilm field (now called the "micrographic" field by the recently renamed National Micrographic Association).

To mention a few, we have Frederic Luther's *Microfilm: A History 1839-1900*, written in 1959 (published also in microfilm, microfiche, and even microprint formats.) As the title indicates, this work deals strictly with history. Then we have Carl Nelson's *Microfilm Technology*, published in 1965, which is often referred to as *the* book on microfilm technology and which is still consulted by technicians in the micrographic field as a textbook. As its title suggests, the book is devoted to the technical aspects of micrographics and concentrates on the engineering field.

Since then there havy been many books, pamphlets and articles written on the subject, but in most cases they have been sponsored by manufacturers with expected emphasis on their products or systems. There have also been surveys which deal with many aspects of the micrographic field but are primarily directed toward markets and used to guide corporate planners on future products and sales efforts plus supposedly giving the purchaser some idea what his competition is doing or may do.

James Mann's book is, I believe, completely unique in that it has something for everybody who has even the remotest interest in the micrographic field. He doesn't give you only history, techniques, markets and trends, but gives you highlights of all these important aspects of the field without over complicating or becoming too involved in details.

Whether you are someone thinking of going into the field

as a technician, a salesman, a designer, an engineer, an independent service organization, or a prospective user that has heard about the benefits of microfilm, you will find this book of real value. If I were running a company engaged in any form of micrographic work, I would have it as *must* reading for every employee.

Jim Mann is in a unique position to write such a book. He has been an owner of a service company which was small enough even in its largest growth to permit him to involve himself in every phase of a micrographic business. Few people in this position have been able to take the enormous time required to put together all the experience and lessons learned over many years. Different than most in this field, Jim has no axe to grind and doesn't pull punches where the truth as he sees it will help the reader better evaluate the lessons learned. He does not preach or dictate, but gives an overall picture as an observer of the strengths and weaknesses of an industry which too few of those going into it, those in it, and the general public know much about.

The most impressive feature of the book is the style in which it is written. There is a sensitivity, humor, and understanding that can't fail to keep everyone's attention. Even when he deals with technical problems which could be complicated he has a light touch which amuses you while it instructs.

My wife, who has lived through many N.M.A. meetings and microfilm related sessions and heard of micrographics so much that even the mention of the word "turns her off", after reading the manuscript said that every wife of a "microfilmer" should read this book, and, if she did, would be more understanding of the strange bug that appeared to have bitten her mate.

Having been in the micrographic field almost as long as anyone I know, in recently re-reading the manuscript, I found myself refreshed, re-enthused, and re-educated in the field in

which I have spent all my business life. I am certainly glad that Jim took the years of labor to put this all together for the benefit of those of us who will always find this field most fascinating.

Karl Adams, Jr.
Weston, Massachusetts
January, 1976

INTRODUCTION

My father was the last of the Victorians, austere to the end. "Son, the way to get to the top is to start at the bottom," he always told me. Of course, that was in the days when yardmen became railroad presidents, runners turned into bank presidents, and lumberjacks frequently climbed to the top of other than trees. Today, we have neither the time nor the inclination to start at the bottom; we simply have to take some short cuts to hold our own, much less to get to the top. This book might be termed a "short cut." Although it is not a textbook in any sense, it attempts to explain in non-technical language (wherever possible) the whys and wherefores of this fascinating and too often misunderstood industry.

Since our subject is rather sophisticated, there is no way to restrict our vocabulary to everyday language all the time, much as we would like to do. Although we do define technical terms wherever practical, we simply cannot interpret each and every term as we come to it. Fortunately, quite a few are common to other industries. If you do run into difficulty, you will do well to consult the National Micrographic Association's *Glossary of Terms* which is quite complete.

The actual construction of this book, the sequence of chapters, has posed somewhat an unusual problem to the author. Which is the horse and which the cart? Film, camera, processing —all these have to be discussed separately. Yet, it is difficult to understand film without first knowing what goes on inside a camera as well as how it metamorphizes in the dark room. Similarly, should a concise history of the

industry be the first or last chapter? Or the middle? The sequence as finally determined is fairly logical – we hope.

What is microfilm? An all-inclusive term that refers to the raw material, the film itself. It is also the finished product. Also the industry, the whole technology. It is an adjective, a verb and a noun. As an adjective: "What business are you in?" "Microfilm (business)." As a verb: "How can be dispose of these records?" "Microfilm" (them). Or as a noun: "How can we retrieve these records faster?" "(Through) microfilm."

Using the term in its broadest sense, we must commence by admitting microfilm is a very peculiar product. All the characteristics of the final film are the very opposite of the original. Let's say this particular page you're reading has been reduced to microfilm. The image that emerges after it has been developed consists of white letters on a black background. The image, in addition, will be upside down and reverse reading. This upside-down-wrong-reading business can be handily corrected by projection on a screen utilizing mirrors and/or optics, or by simply viewing the film from the back side after turning it over. And the images can be made positive, i.e., black on white, by copying on to another film. Parenthetically, we might add that the white on black image is often preferable; positive paper enlargements of superior quality can be made from negative film, and studies have shown that, when projected on a screen, a dark background is easier on the eyes than a white background. Remember, if you date back that far, the subtitles in the silent movies?

The equipment, produced by a host of manufacturers, is equally unorthodox. Like the accessories for a yacht or the appurtenances in a hospital operating room (not to mention a space ship), microfilm hardware seems inordinately dear. But one must remember that it is precision made, and doesn't sell like McDonald's hamburgers. Thousands of one model micro-

film reader may be sold in a year, but much specialized equipment may sell in the hundreds or even tens. Maybe only one. Repairs are difficult without recourse to the serviceman. Nuts and bolts are odd sized and often with non-standard threads; transformers are specially made, relays and thermo-sisters cannot be replaced at the local electronics shop, and as for lamps — there's a real headache. With plenty of malice aforethought, design engineers must have had plenty of chuckles specifying a different lamp for each new piece of equipment. I have not made any personal count, but there must be at least a hundred currently in use for different equipment — cameras, readers, densitometers, printers, etc. Many are of the same general wattage but with different bases (prefocus, bayonet, screw-in), different contacts (single or double), different voltages (220, 110, 32, 12, 6, etc.), and finally different shapes and filament locations. And, oh yes, don't forget tungsten, mercury vapor, quartz, ultra-violet, infra red and arc. Fortunately, obsolescence keeps this problem within manageable proportions.

Our jargon at times can be quite exasperating. One may say vertical when he really means horizontal; reference may be made to a positive that is really a negative (e.g. an X-ray); the term higher may indicate smaller, but lower doesn't necessarily mean larger. Direct negative and positive are synonymous, but omit the word direct and they become opposites. An original drawing may be inaccurately referred to as a tracing. In normal photographic parlance, aperture refers to the adjustable diameter of the lens opening; in microfilm it refers to the picture area of the film. A thin negative describes the degree of opacity, not its physical thickness.

We love acronyms. We adore abbreviations. We dote on description in numerics. Like the computer boys with whom we are closely associated we obfuscate the laymen in our midst with mysterious references to COMs, MPEs, 600-Cs, MRD2s — things any fool (microfilmer) should know.

Let's reemphasize the thoughts in our opening paragraph. A practical working knowledge of one's chosen field is invaluable. Nothing, but nothing, is more damaging to a salesman's or serviceman's credibility or effectiveness than ignorance of his product, technical as well as cosmetic. Of course, no one is expected to have all the answers, but if the prospect or customer is knowledgeable, and the microfilm representative strikes out on a simple technical question, then let not the buyer but the seller beware.

Although I am deeply indebted to many individuals and organizations in various ways, my particular thanks go to Karl Adams for his unselfish assistance in editing the manuscript and writing the foreword; to the late Dr. Dick Hale for his much needed encouragement and help; and to Vernon Tate for providing me with information and many suggestions (it was his idea, by the way, that I attempt such a book). Material was derived from assorted sources, particularly from Gipe's *Nearer to the Dust*, Fred Luther's *Microfilm: A History 1839-1900,* Neill MacKay's *Hole In the Card*, and many NMA Proceedings.

References to particular manufacturers and specific pieces of equipment have been kept to a minimum in the interest of objectivity. However, proper names have been used when necessary for proper identification or when they have contributed to history.

WHAT IS MICROFILM?

Van Phillips, one of Kodak's top executives, tells a story about his early travels that could easily happen today some thirty odd years later. The year was 1936 and he was a budding young salesman with six months experience in the business to back him up. Banks were practically the only customers Recordak had in those days and Van was covering Utah and Oklahoma. His research (motivated no doubt by Dale Carnegie's *How To Win Friends and Influence People*) uncovered the fact that the sole bank in a small Oklahoma town had for officers a clan of Phillips — the president, the vice-president and the cashier. Van figured that he could turn this into a neat advantage so lost no time in calling on them. He introduced himself to the first person he saw who turned out to be the cashier, a Mrs. Phillips, who in turn introduced him to the vice-president, Mr. Phillips, and finally he was escorted into President and Chairman Phillips' lair. The old gentleman was very cordial, leaned back in his chair to take in the pitch and smoked his stogie. Van outdid himself, explaining in great detail what microfilm could do for him, for his bank, and in particular what a Recordak Microfilm Machine could do. In his own words, Van told me, "I explained to him all the many advantages of microfilm, making these tiny little pictures of all his checks instead of having someone laboriously write into a huge ledger 'Payable to John Doe X number of dollars drawn on such and such a bank and the dates before mailing them. The scheme of course was to microfilm the checks in case they were lost instead of describing them. So I thought I had explained the system to him beautifully. I'd taken him through the transit checks which are the ones they mail out of town, I'd

explained to him the bookkeeping system, how much better his records would be, and I finally got through and was eager to push for an order, so like a typical good salesman, I said 'Well now, shall we bring in one of these machines and sign you up?' At that point the old gentleman leaned back in his chair very thoughtfully and said, 'Mr. Phillips, you certainly have made a fine presentation, I can assure you if we buy portraits this Christmas, we will not only think of you; we'll call you in!' " Not too different from the people who, in response to my saying I'm in the microfilm business smugly remark, "Oh yes. That's the thing the radio and television announcers use."

So what is microfilm? It depends largely on who has been asked the question. For my part, I conjure up an image of a roll of photographic film approximately 100 feet long, an inch or so wide, wound on a plastic spool and containing several hundred or several thousand minute images of certain documents. But one cannot stop there; microfilm is much more than that. It is an industry, it's a system, and to use an old chestnut, it's a way of life.

First of all, it's a branch of photography, which the Encyclopaedia defines rather succinctly. "Photography," it says, "is the process or art of producing visible images on sensitive surfaces directly or indirectly by the action of light or other form of radiant energy." In its 1971 edition, the prestigious Oxford Dictionary failed to list microfilm even in its supplement, although in the preface it acknowledged indebtedness to Mr. Albert Boni of the Readex Microprint Corporation. As late as 1952 Webster grudgingly included *microfilm* in its addenda of new words and defined it thus: "A strip of film, often of standard motion picture film size, used for making a photographic record on reduced scale of printed matter, manuscripts, etc., as for storage or transmission in small space, which is enlarged for reading." It will be rather necessary to enlarge on this a bit. Let's start on the

film in microfilm.

It is a thin, transparent sheet, strip, roll or ribbon of plastic, either acetate or polyester coated with a light sensitive emulsion. After exposure in a suitable camera, the film has acquired a latent image which is then made visible by development and processing in certain chemicals. This emulsion consists of silver halide particles suspended in gelatin which in effect turn black when exposed to light. The finished product consisting of an image on the film is called a "negative," because those areas that receive the most light have turned black, and the areas receiving the least light remain clear, the direct opposite of human optics' interpretation.

Thus far the description parallels that of other photographic forms for the simple reason that basically the principles are the same. However, since microfilm serves a unique purpose, its characteristics necessarily differ from other films. The prime prerequisite of microfilm is the ability to retain the image of a document photographed at a greatly reduced scale and then to allow it to be enlarged back to its original size (or thereabouts) with a minimum loss of detail. Without this capability, there would be no microfilm.

In order to accomplish this, the film base itself must be thin, optically clear and free of aberrations, pliable but strong, scratch resistant, and for safety's sake fire resistant.

On this base goes the emulsion. Whereas conventional films are often coated with several layers, each with different characteristics, microfilm must stick to one coating, and that a very thin one. The purpose of multilayers in other films is to increase exposure latitude and improve gradation (the gray shading all the way from black to white); in microfilm the single coating is used to increase resolution. Another essential feature is low granularity, or, to put it another way, only very fine grain emulsions are acceptable. So not only must there be only one layer; that layer must be, as nearly as possible "grainless." These objectives are achieved but at a certain

cost: microfilms are much "slower" than other films, requiring longer exposures or higher light intensitites, and furthermore, these exposures must be correct. Processing is also more critical.

Now that we have taken a look at the ingredients, we must get down to classifications, as microfilm comes in all sizes, types, shapes and flavors. With a couple of notable exceptions, it all starts out as a roll. Let's proceed.

Sizes

8mm. Microfilm is measured laterally in millimeters and longitudinally in feet in the United States. Don't ask why. 8mm, this smallest size film, is phenomenally unpopular. Very few truly 8mm cameras have ever been built, and 8mm film as such is not obtainable from any listed manufacturer. Usually, 8mm film is obtained from a 16mm unit that has been modified so that only one half of the width is exposed. After a series of exposures has exhausted the roll of film (usually 100 ft.), the 16mm reel is turned over and reinserted in the camera where the other side of the film is then exposed. It is then processed in the usual manner and subsequently slit into 8mm widths, or more frequently simply left "as is."

16mm. In lineal feet, more 16mm film is used than any other. Generally this size is used to film the smaller sized documents, such as checks, deposit slips, correspondence, legal documents, invoices, etc. With the increased use of sophisticated retrieval systems, 16mm is also being used for filming public records, small engineering drawings and other data heretofore reserved for our next size, 35mm.

35mm. The "quality" film. Used to film large copy such as newspapers, engineering drawings, maps and bound volumes. Also, when top quality is desired, such as in the filming of deeds, wills, rare manuscripts, etc.

70mm. At one time, the advocates of 70mm film were

pretty optimistic. An 18 x 24 drawing for instance could be reproduced by a 6 diameter enlargement whereas 35mm film required 16 diameters. The difference in the results were startling; the 70mm enlargement was nearly as sharp as the original — perhaps with better contrast — while the 35mm blowup was a bit fuzzy. The difference was even more noticeable on large drawings such as 36 x 48. But 70mm film had its drawbacks: the cost was materially higher, it lacked flexibility in retrieval, space saving was minimized, but lastly, 35mm techniques improved to the point that quite acceptable reproductions could be made from high reduction ratio film. Consequently, 70mm film is not gaining many new adherents.

105mm. It is axiomatic to say the larger the film the better the results, everything else being equal. But one ponders the question; can a negative in the neighborhood of 4 x 6 in size and containing one large image be considered a microfilm by any stretch of the imagination? A reduced negative, yes; but not a microfilm. Even 70mm film is suspect. I must add parenthetically that 4 x 6 is true microfilm as it contains a series of separate images greatly reduced from the originals — 20x or higher.

Lengths

In addition to various widths, microfilm also comes in assorted lengths. Most 16mm cameras are designed to accept either 100 or 200 ft. reels or cartridges, although a few are limited to 50 ft. reels or cartridges, and 400 ft. spools are available. The same lengths apply to 35mm camera film. Although 70mm and 105mm is generally used in 100 ft. lengths, 70mm is also available in 500 ft. lengths and 105mm may measure 250, 350, 400 or 750 feet. Both camera and print films come in what are known as "lab packs" of varying footage 400 ft. up to 1000 ft. or so on 2-inch plastic cores. These lengths are based on films of standard thickness. The newer thin base films can at least double the above figures.

Perforations

Motion picture cameras use 16mm or 35mm film which has small notches or perforations on either one or both sides. The film is driven through the camera by sprockets which mesh with these perforations. It was only natural then that the early twentieth century microfilm cameras commenced with existing film, namely, motion picture 16 and 35mm sizes. It was soon discovered that the emulsions were inadequate for the necessary resolution and these were subsequently altered, but the size remained even to this day. The only modification was the gradual elimination of perforations. Today non-perforate film is standard, but it is still possible to obtain on special order 35mm film perforated on both sides and 16mm film on either one or both. If one wonders why the perforations were eliminated, a single glance at the film should provide the answer. Microfilm cameras do not require a positive advance, that is the distance between the beginning of one frame to the beginning of the next does not have to be precisely the same. Consequently a roller drive mechanism can be substituted for the more precise sprocket with the elimination of perforations. Thus a larger image area is available without an increase in film width, allowing a lower reduction ratio.

SPOOLS

Forgetting the other odd sizes, raw negative film comes on 100' or 200' metal reels. After exposure and processing, the film is respooled on 100' plastic reels. The configuration of the center holes on the negative film can vary considerably as you can see from the illustration. Years ago each manufacturer designed spools that would fit only his cameras, the idea being that his film would be used exclusively on his own equipment. This worked fine for awhile until an enterprising manufacturer decided to make a universal reel, one that would go on any camera This sort of spoiled the party, but it

made standardization possible. Plastic reels have only one peculiarity in this respect. They can be purchased with square holes on either side or with one round and one square. The idea behind the round-square theory was to prevent us dummies from trying to load a viewer incorrectly. It didn't totally solve the problem; you could still load it wrong, but it was more difficult. Today we are supposed to be smarter, so the square-square type is more popular since some readers require the film to be loaded from the left hand spindle and others from the right.

Windings

Film is normally wound with the emulsion inside. This allows film with a tinted or opaque backing to be loaded into the camera in daylight. On special order, the film can be wound so that the emulsion is on the outside.

Type of Base

Whenever light rays are directed by the camera lens to the film emulsion, they are not content to expose the film and quietly die away. Rather they tend to bounce about and disperse, adversely affecting the integrity of the image. This dispersion is called halation, and it is minimized by what is called quite naturally an anti-halation coating. This takes several forms. The film base of either acetate or polyester may be tinted blue or gray; or the back of the base may be coated with a dye which may be soluble and disappear in the developer, or it may require mechanical removal (called scrubbing); or the coating may be applied between the base and the emulsion, called an "anti-halation undercoat". These various films have assorted trade names, but in normal parlance they are called (1) blue base or gray base films, (2) dye-back films,(3) soluble dye films, and (4) AHU films, an abbreviation of anti-halation undercoat, a Kodak trade mark.

The tinted base films are rapidly losing popularity for two

reasons: they must be loaded into a camera only under subdued light (and then at some risk) and the final product is not so pleasing to the eye. Technically it does not have the same contrast differential as the dye-back films. A roll of the latter may be safely handled under normal room light conditions. AHU film, on the other hand, must be handled (and processed) more gingerly, but it produces film of the highest resolution.

Thickness

Just a word about this. Films used in microfilm vary from about 8.2 mils for the production of microfiche down to about 2.5 mils for the newer polyester base films. As of this writing, the standard thickness of most camera and copy is around 5.5 mils.

Classifications of Film

Thus far we have been able to stay pretty well on dry land, but now I'm afraid it's time to get our feet wet. Microfilm is divided into two general categories, depending on the function; camera film and copy or print film. Of all camera films ever produced, silver is still king, still the accepted material. We'll give the others the once over lightly treatment, and return to silver.

Camera Films

Thermal or vesicular — Although this is primarily a copy film, some experimental cameras have been built for this medium, thus far with very limited success. Utilizing the principle of molecular gases and the light dispersion principle, this inert film has a polyester base and after exposure is impervious to gamma rays, ultra-violet or infra red light, etc. Exposure and processing is performed with light and heat

alone. Thermal film is a most exciting material, but its chief drawback thus far is its slow speed — fast enough for contact printing, but too slow for rapid camera photography.

Thermoplastic and Photoplastic Film — This product was invented by William E. Glenn of the General Electric Company Research Laboratory, and embodies the principle that some materials have the property of becoming soft and pliable when heated and then holding their shape when cooled. Exposure is made via an electron beam similar to a cathode ray tube. The theory is that since the material is subject to change when heated, erasures and changes can easily be made on the same film without the usual time-consuming splicing procedures. This technique, despite its promise, had no takers for a full decade. Now, finally at least one company has commenced production. The speed is the same or faster than silver negative film and the character positive although a negative can also be produced.

Electrostatic — Recently electrostatic recording has made its debut and is quite promising. This film, like thermoplastic, has add-on capabilities, and although a direct positive type film, can also produce a negative by changing the polarity or toner. Amazingly enough, resolution is excellent and the speed quite comparable to the traditional silver films.

Between the thermoplastic, electrostatic and dry silver (mentioned subsequently), the total concept of microfilm may well be altered.

Video Recording. Despite the fact that this is not micro-filming in the accepted sense, as the storage medium is

magnetic tape rather than acetate film, a camera is employed and the material compressed, so it is a microform. We'll give you an over-simplified explanation of its principle; you've seen stop motion on the television screen. Substitute a document for the scene and you have it. Images can only be created by motion in magnetic tape. In the case of stop motion, the image is reconstructed by the movement of the pick-up head, the tape remaining stationary. The video tape is 2" wide and comes in reels of varying length up to 7200'. At a resolution of 100 TV lines (mind you not lines per millimeter), a third of an inch is required per image. This means that up to 135,000 pages can be stored on one roll at a material cost of around 1/4 cents each.

The advantages of instantaneous recording and processing, selective erasing and updating, transmission capabilities, rapid electronic searching and retrieval, etc., are largely offset by the somewhat obvious disadvantages, such as relatively low resolution, the high cost of materials, (tape), the questionable permanence of tape, but above all the monumental cost of the equipment. And add this to the space requirements of equipment and tape; both require considerably more than their conventional microfilm counterparts.

Before the editor adds a footnote here with an apologetic explanation that this comparison is merely one man's opinion, let me hasten to add that it is possible to obtain high resolution in video recording, and the "zoom" capabilities make clearly legible even the smallest characters. However, and it's a large however, at present hard copies made from tape are not as sharp as those reproduced from film. As to permanence, the tape base and coatings do indeed compare favorably with acetate and gelatin, but the possibility of accidental erasure, changes made through manipulation (e.g. to conceal fraud) or even erasure through sabotage present enough hazards to prevent the product from being stamped permanent.

Silver Films. The classic silver negative camera films are divided into two categories depending on their color sensitivity; orthochromatic and panchromatic. Both films of course "see" only in shades of gray, but they interpret the various colors in the spectrum differently. Orthochromatic, or ortho for short, is insensitive to red for instance which makes it quite handy in the dark room as it can be safely handled under a red light. Panchromatic, or pan, on the other hand is sensitive to all colors, and must be handled in total darkness. Nonetheless, it is the more popular of the two by far.

Negative camera film is further subdivided according to speed, or light sensitivity. Most producers market films of two basic speeds, called here for convenience sake *slow* and *rapid*. The slow films require longer exposures or a higher light intensity than the fast. Although the speed index varies somewhat from manufacturer to manufacturer, the slower speed films have finer grain and consequently higher resolution. The rapid films are quite satisfactory, however, and were developed to keep pace with the constantly increasing speed of automatic feed cameras.

Then we have the special purpose films, which may be ortho or pan, slow or rapid. Special tonal film has been designed specifically for the filming of X-rays. It is a very low contrast, very slow, fine grain film. *Tonal reproducing film*, manufactured under several labels is used in the microfilming of photographs or wherever a long tonal range (called a gray scale) is required. The film is usually quite rapid and has a medium fine grain. Then, of course, we have the color films, negative and direct positive, the COM films (computer output microfilm) and the ultrafiche films.

Electron beam and lasar ray recording is being satisfactorily performed on *dry silver film*, but thus far only on COM units. As you will see later, a COM unit converts information from computer tape or disc directly to microfilm. Dry Silver, as its names indicates, requires no chemicals for processing; only heat.

COPY OR DUPLICATING FILMS

Silver Print Film. Remember the Introduction: We are still thinking *negatively.* All images created by a microfilm camera are negative in character like a Photostat. When we copy this film by running it through what is called a positive printer, together with a duplicating film, the reproduction faithfully copies the original in reverse, so we now have a *positive.* If we take this positive, and make a duplicate, we end up with a film that is again negative in character. Rather disconcertingly, this print film is usually labelled "Positive Print Film" since it normally winds up as a positive print, but the film is still negative in character.

If you have threaded your way through this, we can proceed. This film is the most commonly used for duplication, although some other materials have made noticeable inroads. It is sensitive to blue, has a very fine grain and is "color-blind." The printing speed is high and it requires no special processing equipment (using the same as the camera negative).

Thermal Film. Although we have briefly discussed this as a possible camera film, let's go into a bit more detail of it as a duplicating film. It is primarily a negative type film, just as silver, but the manufacturers have succeeded in also producing a direct positive type product, one that makes a positive from a positive or negative from a negative. In either case, the exposure is made with near UV light, and the development is with heat. As a copy film, the material is somewhat more expensive than its silver counterpart, but it has the happy facility of requiring only one piece of equipment for exposing and developing, and in broad daylight as well. The resolution compares favorably with silver and the contrast characteristics are excellent.

Direct Negative Silver. This positive type film is officially called *direct negative*, which indeed it is, but *direct positive* would have been an equally apt description. At any rate,

except for the fact that it is much slower than ordinary print film and hence requires modification of normal printing equipment, handling is much the same. Refrigeration is required if decent shelf life is expected, but the quality of the finished product is superb. It has approximately twice the resolving power of positive print film.

Diazo Films. Dizao covers a multitude of sins. Thermal, for instance, is one form of diazo, but here we are confining our interest to the ammonia type, similar in properties to what is known in the engineering print room as a "blue line print." Of course a "blue line" is a paper contact print made from an engineering master, but it has the same type of emulsion. Diazo's character is positive, like the direct negative film, and produces a positive print from a positive original. To create an image, Diazo is first exposed to UV light and then developed in ammonia fumes. The diazo copy film is similar to the thermal product as it requires only one piece of equipment for the entire process and under ordinary light. Virtually grainless (the advertisements say the grains are 1/300 as large as the smallest silver grains), the copies made from it are very high in resolution.

Of all the negative and copy films discussed, only silver and vesicular may be classed as permanent (the word permanent as used here is of course relative). The Bureau of Standards labels diazo as a semi-permanent medium, even though it is not uncommon to find film twenty or more years old in excellent condition with no noticeable signs of fading or discoloration.

THE VARIOUS MICROFORMS

Thus far we have been concerned with roll film only. But although we usually commence with the roll, very often we end up with something else. Let's review these possible forms or formats.

Roll Film and Cartridges. Ordinarily we start with what

we call an open reel and end with an open reel. But just like tape recorders and amateur cameras, threading the film into a recorder or camera or in this case a viewer has long been a nuisance to the user. In the case of microfilm, it is more than just troublesome. The increased use of microfilm in current record keeping is due largely to its ready accessibility and rapid retrieval. Hence, the *cartridge* and not open reel becomes a necessity. Containing the same length of film as the open reel, the cartridge is its own housing and does not need to be stored in a cardboard or plastic box. Neither does it have to be threaded into the viewing device, simply snapped into position. If a nominal reduction ratio is used, 3000 images can be stored in one cartridge, or, if the new thin base film is used, twice that amount. Thus roll film, which not too long ago was threatened with obsolescence by the newer forms has managed to regain its former status.

When we leave the reel, open or cartridge, we come upon what is known generically as *unitized* microfilm. In 1958, when the NMA gave its members a good excuse to go to New Orleans, Hank TenEyck, the head cookie of Hall McChesney, cleared up the meaning of this term once and for all before the assembled conventioneers. Said he, between trips to Bourbon Street:

"Unitize — can't find it in the dictionary. I have examined carefully a 1955 NMA publication, 'A Glossary of Terms Used In Microreproduction,' edited by a chap named TenEyck, but I find no reference to the word. It looks like a verb. Is it derived from the verb 'to unite'? Webster says, 'to unite is to put together to make one; to combine, to connect.' Yet, when I hear our colleagues use the word 'unitize' it carries frequently the connotation of 'to separate,' to 'break apart.' This is the antithesis of 'to unite.'

"So then we look at the noun 'unit.' Webster says, 'one thing,' 'one group in a number of groups.'

"Now we see what has happened — some ingenious soul,

and he's probably here today, created a new word which means opposite things simultaneously. We cut a roll of film — to make units — because we wish to unite all of one type thing together."

Aperture cards. Back in the early fifties, when the detractors of microfilm chanted "Film, file and forget!", a company in Pearl River, New York, started plugging something called an aperture card. What sort of nonsense is that, I thought, taking a perfectly good roll of microfilm and ruining it by slicing it into little pieces, and then glueing these bits into holes in IBM cards? The whole idea was revolutionary, if not revolting. But when Filmsort asked me to become a dealer (which is an indication of how hard up they were) and tempted me with a free $300 reader if I would come up to Pearl River along with other prospective dealers, my Scotch blood got the best of my good sense and up I went to find out what it was all about. Well, you're wrong. After I came back, I still couldn't see any future in it. In those days we charged about a nickel to photograph an engineering drawing on 35mm film. The aperture card cost about six or seven cents more, and you still had to mount it in a card and supply some sort of indexing. In other words, you succeeded in quadrupling the cost by the time you iced the cake. And who would pay that? As it turned out, nearly everybody. Not at first, of course, but the idea did catch on. Filmsort has come and gone, but 3M owns the basic patents and turns out cards like crazy while other manufacturers all over the place are doing exactly the same thing. Well, we can't be right all the time.

What then is an aperture card? The Filmsort card, patented originally by Mr. John F. Langan, consisted of a tab size card with an aperture slightly larger than a single 35mm frame and having a strip of pressure sensitive tape surrounding and overlapping the aperture and a protective piece of glassine adhering to the adhesive. This protective piece is removed

when the film is substituted. There are other methods of singly mounting frames of film, one of the more popular being the suspension type card. The same size aperture is cut in the card but no adhesive is used to make the film section remain in the card. Instead a pocket is formed by mounting thin sheets of polyester film on either side of the aperture and leaving one end of one sheet unsealed so the film may be slipped in.

Acetate Jackets were also largely pioneered by Filmsort and were the first successful vehicle of mass unitizing as opposed to the single frame aperture card. The basic jacket consists of two sheets of acetate bonded together by paper or acetate ribs positioned so that sleeves are formed to accommodate 35 or 16mm film as the case might be. Thirty, forty, fifty, even a hundred images can be contained on a single jacket. Acetate jackets come in many forms and shapes and colors.

One of the more recent additions to the jacket line is the so-called micro-thin jacket. It was designed specifically to compete in the microfiche field. The form and shape is nearly identical to the ordinary jacket, but the materials differ. Polyester has been substituted for acetate and the paper ribs have been reduced in thickness so the overall product is immeasurably leaner as it were. One of the sheets is finer than the other, having a thickness of only .00025. As explained later one of microfiche's great selling points is the ability to make duplicates or contact prints directly from the original. Micro-thin jackets have this same capability. Ordinary jackets do not.

Microfiche. At the time of printing, microfiche and cartridges were sharing the glamour spotlight, with the former perhaps having a slight edge. Later on we'll tell you why. But for the time being, let's stick to the essentials. Microfiche is a crazy sounding name, certainly not conned by Madison Avenue as a trade name. Just a French word meaning

"small sheet."

Strangely enough, Microfiche is one of the oldest micro-forms. As you will read later on, microfilm was developed before the motion-picture roll film concept was dreamed of, and as early as 1906, microfiche (although it was not known by this term) was mentioned as a possible replacement for books.

Microfiche is really quite simple, it consists of a series of images in rows grouped on a sheet of film, the sheet being usually 4 x 6 inches (or 105 x 148mm), although other sizes such as 3 x 5, 5 x 8 inches or tab size can be used. Depending on the size of the card and the individual size of the images, anywhere from forty to a hundred images may appear on one sheet. Originally specially designed camera equipment was required for its manufacture, but more recently certain adaptations have been made so that conventional cameras can produce a form of microfiche: strips of film made on a 16mm camera are mounted on the sheets by means of adhesive. This technique is called strip-up microfiche.

The Micro-opaques. The earliest known microphotographs were opaques. When transparent film replaced the metal plate, the opaques fell into disuse and as far as microfilm was concerned remained so until the Thirties when Fremont Rider revived the concept in the form of 3 x 5 cards which he named Microcards. The Microcard and its child, Microtape (or Microtak, Microbond or Microstrip) belong to the family of micro-opaques, and more precisely the product is a series of positive micro-images printed on fine grain photographic card stock, rather than film. Since it is an opaque, images can appear on either or both sides of the card. The microcard is a contact print made from a single master negative; the microtape is similar except instead of a single master negative, the contact print is made from a continuous roll film strip which is subsequently cut into strips and mounted by means

of an adhesive to plain card stock. One might say that microcards and Microtape are the paper and opaque equivalents of microfiche and strip-up fiche. Microprint differs from Microcard only in that it is actually printed on an offset press rather than being a photographic contact print.

The opaques enjoyed tremendous popularity before large scale duplicating came into vogue. Unfortunately the opaques are not adaptable for making contact duplicates or paper enlargements while the transparencies are. As a result, the opaques are doomed it seems.

Of the remaining forms, one that currently seems most promising is ultrafiche. Actually it is simply microfiche that employs extremely high reduction ratios. Instead of forty or ninety images per sheet, up to a thousand or so may be compressed on one card. These extremely high reduction ratios require special film as well as reading and printing equipment. The proponents of this microfilm are constantly seeking to improve the quality of the image. With present day technology being what it is, it may well be that they will succeed.

Then we have the *film chip*, which has quite a few proponents. The chip is a single piece of film, usually about a square inch in size containing one or some images. A number of these chips are then contained in some form of magazine. The chips are the nucleus of some highly sophisticated retrieval system.

Micro-stick is rather like the chip, consisting of a group of 16mm strips, each containing two dozen or so images housed in a magazine shaped like a stick. This system is less sophisticated than the chip and considerably less expensive; actually, very little is currently in use and it threatens to become obsolete.

THE HISTORY OF MICROFILM

One of the things you'll learn in the pages that follow is that you are not in on the ground floor, just in case you have any illusions. Microfilm is now more than a century and a quarter old; that should set you back a peg or two. While it is true that very little occurred for the first hundred years or so, the metamorphosis was complete in the thirties and by the early sixties the industry came of age.

It is with a great deal of embarrassment that I confess I knew very little about all this until I took pen in hand together with an armful of books to start writing. However, when I started out in 1950, there was very little in the way of history available; in fact, there wasn't a great deal in print that even dealt with the subject. Today it seems inconceivable that anyone dedicated *in perpetuum* to this glorious field not know at least something of its glorious and sometimes inglorious past. Now, although my knowledge may be superficial, I at least see microfilm in a new and better perspective. In fact, I can bandy the names of Dancer and Dagron and McCarthy about as well as anyone; and so can you.

In the beginning, microfilm was nothing but a toy, at best a novelty. Gradually its character changed. A method to transmit messages. A way to copy irreplaceable documents. A space saver. Today an active "information transfer" medium. One thing you will note as you read along: microfilm did not meet with universal acceptance, with joy and thanksgiving. On the contrary, it had to fight for survival in a skeptical and reluctant world, particularly in the thirties and forties and fifties, as the boys who were in on the ground floor will tell you. There aren't too many of them around to tell you

because the corporate mortality in this business has always been pretty deadly. In those days it was an actuary's nightmare.

The history of microfilm closely parallels that of photography for somewhat obvious reasons. With a few notable exceptions, photography is basically interested in copying some subject at a size materially smaller than the original. So is microfilm; it's just a matter of degree. In the very early days, the neophyte photographers employed a variety of subjects, in fact anything that didn't move was fair game. Some of these were three dimensioned and some two. The photographs resulting from three dimensioned subjects might be classed as conventional photography as we know it today, while the images made from two dimensioned subjects could well be called early microfilm.

The actual day or even year that photography was "invented" is necessarily obscure as there were a series of seemingly unrelated steps made periodically from the time of Leonardo da Vinci until the first relatively permanent print made its appearance some time in the 1820's. The parties responsible for this phenomenon were William Henry Fox-Talbot of England and Louis Jacques Mandé Daguerre of France who unwittingly turned up with the same product at about the same time, but by entirely different processes. Somewhat later, in fact in 1839, one John Benjamin Dancer, photographed a document at a reduction ratio of 160x which was perfectly legible when viewed with a 100 power microscope. Mr. Dancer was a young, brilliant and highly educated Englishman who was primarily a physicist and astronomer. As a lecturer, his interest in optics was heightened by his use of the so-called "magic lantern" for illustrations to accompany his dissertations. The flickering oil lamp then used as a light source cast extremely weak images on the screen, and he succeeded in replacing this with a small lump of lime rendered incandescent in a flame of oxygen and hydrogen. Incidental

intelligence: this method of lighting was subsequently used on the stage, with the performers "basking in the lime-light."

Meanwhile Daguerre and Talbot were actually producing permanent photographs, and Mr. Dancer's curiosity was piqued to the extent that in 1838 he started his own experimentation and one year later microfilm was born. Dancer's minute photographs were sensational to say the least, and it was not long before he was supplying slides to Manchester novelty dealers at a handsome profit. At first Dancer utilized the then only existing material, namely the daguerrotype which was an opaque direct positive, but as soon as collodion wet plates, which used glass as a base, were produced, he switched to these. The copy varied: written documents, portraits of individuals, famous scenes, whatever was wanted, Mr. Dancer provided.

Unfortunately, Dancer was too enterprising for his own good; so varied were his interests that although he possessed amazing energy and endurance, he was unable to exploit to the full (or should we say develop?) any or all of his astonishing ideas. For in addition to micro-photography, he experimented in macrophotography, stereo-photography, all the while manufacturing telescopes, sextants, transits, microscopes and a complete line of cameras. In addition to this, as time went on, he provided a developing and finishing service for his camera customers. And, to round out a full day, he was a frequent lecturer at night.

So much for the acknowledged inventor of microfilm.

Twenty years before Dancer produced his first microphotograph, one René Dagron was delivered by his mother in Beauvoir, France. His destiny was to follow in Dancer's footsteps. While Dancer was the inventor, it was to be Dagron who would convert it into an industry. After a somewhat uneventful youth, Dagron became a portrait photographer in Paris at which he was not phenomenally successful. In 1857 he viewed some photographs by Dancer and immediately

became obsessed with the possibilities. Although it was not his idea, he envisioned tremendous sales resulting from the manufacture of novelty jewelry utilizing minute photographs which in turn could be viewed through small lenses. He would manufacture miniature opera glasses, or rings or pendants, or what have you containing an image of a loved one, or a famous scene or a sentimental document, and fame and fortune would be his. But how was he to get started?

Whereas Dancer had been something of a magician and livened up his lectures with a bit of legerdemain, Dagron was a showman of another sort — what we today would call a super salesman. Dancer was the scientist; Dagron the merchandiser. In 1859 he obtained a patent on one of his miniature micro-film viewers which was the basis for his novelty jewelry, and set about introducing this product. Since he was in no financial position to advertise extensively in the Paris newspapers, he sought a free method of obtaining publicity. The story goes that he hired a gentleman to stroll into the police prefecture on the Champs Elysee one day, a spot quite popular with Parisian newspaper reporters, and announce that he had just found a very unusual ring lying on the sidewalk and would very much like to find the rightful owner. He also obligingly told the reporters and police that if they would look into the tiny hole in the ring, they would soon find out what he meant by "unusual." Just what they saw we don't know, but we do know the papers immediately snapped up the story, and an industry was born almost overnight. Up to this point he had enjoyed very limited success with his novelty jewelry business, but in a remarkably short period of time his business increased to the extent that he was employing one hundred and fifty men and women working like crazy.

Everything was not beer and skittles, however. Dagron had some financial reverses, sued and was in turn sued by many of his competitors, but nevertheless he became famous and

financially successful. All of us, government willing, would like to have our own private little monopoly, and Dagron was certainly no exception. However, he soon found out that this was impossible and as a result he not only relinquished his monopolistic hold on the industry (we aren't too sure that he did this gracefully), he also commenced selling his cameras and supplies to amateurs and his competitors as well. Indeed, he even published detailed booklets explaining his various processes. *"Si vous ne pouvez pas triompher de votres ennemis. . ."* ("If you can't beat 'em. . .") he said to himself.

Meanwhile photography was flourishing in the United States, but microphotography wasn't doing too well on an international level. In the year 1869, Sutton's "Dictionary of Photography" for the first time described in detail the microphotographic process whereas in the previous edition some nine years before it had been dismissed as a harmless novelty. However, the truth is it was still nothing but a novelty. Things change though, as they say. . .

The Franco-Prussian war was the cause. Napoleon III of France, one of those egomaniacs who crop up from time to time foolishly attacked Bismark, who was an egomaniac in his own right, and within six weeks was disastrously defeated. This, however, did not end the war, and the Prussians soon advanced to the outskirts of Paris and surrounded it. The siege had begun. Just how Paris was supplied with food during this siege is really not our concern, although I can't resist mentioning that there were an estimated twenty-five million rats domiciled in the city at the beginning and dramatically less when Paris finally capitulated. But just how messages were relayed to the beseiged from the Free French located outside the German ring is our business.

All of the classic methods of transmitting messages were tried. So effective was the internal German spy system and so tight the noose around the city that couriers simply couldn't sneak out. Of eighty-five who attempted, a bare eight were

able to scramble through. No one wanted to volunteer when the chances were ten to one he'd be captured — and probably shot as a spy. So next dogs were substituted, with messages enclosed in their collars. At best the pay load per courier was small. But it really didn't matter; between the efficient Prussian sentries and the hungry Parisians, the dogs' percentage of completed missions was even lower than their human counterparts'. The Third Republic's brass was willing to try anything, for instance floating semi-submerged cannisters filled with messages down the Seine. To make an awful pun, the Germans were ready with their little nets, and simply seined the Seine. Not a cannister got through. It was almost discouraging until someone came up with another bright idea; why not balloons? Here was something that really carried a payload, say a thousand pounds of mail plus a few assorted humans who either had urgent business or a lot of pull. Furthermore these huge lighter-than-air machines were immune from ground fire — at least at first. The idea was put into effect and it worked up to a point. Balloons leaving Paris were a great success, since the only object was to cross the enemy lines. But the reverse procedure, getting balloons to land in Paris was a different matter. Balloons are subject to the caprices of the wind, and very few managed to land within the relatively small confines of Paris. So failure again.

What else? Pigeons? A pigeon couldn't even carry one one-ounce letter. Finally someone remembered M. Dagron's tiny photographs and called him in. Well, to make a long story short he accepted the challenge, and after a great many futile and heartbreaking attempts succeeded in evolving a system of microphotographs that eventually allowed several hundred thousand messages to be flown into Paris via pigeon.

At last microfilm had been put to some useful purpose! Despite the tremendous publicity resulting from the "pigeon post" and M. Dagron's proven capabilities, the world still was far from ready to accept microfilm as a useful tool.

Immediately after the capitulation of Paris and the withdrawal of the Prussians, France was subjected to yet another revolution, and Dagron attempted to persuade the existing government to microfilm its valuable records in the event they were destroyed or captured. But although the government was impressed, the project was not approved. Dagron did, however, succeed in persuading a large insurance company to have him film their policies and supporting data. So far as we know, this was the first commercial application of microfilm.

At this point, let us bring to your attention the *quality* of the microphotographs produced by both Dancer and Dagron. Reduction ratios were much higher than those in general use today, which seems at first glance rather incongruous considering the present state of the art. Actually those early processes are still in use today. To quote Frederick Luther, "The wet collodion process was a giant step forward. Even today it is still in use for the production of reticles or extremely fine 'cross hairs' for optical micrometers, and in the printing industry for the production of high contrast negatives. Showing almost a complete absence of graininess, and giving excellent blacks in the lines with a sharply defined edge to the lines, the wet-collodion process is still capable today of producing some of the best microfilm images."

After explaining how the glass plate is coated with emulsion, Mr. Luther continues and tells us why the process is not in general use today. "At this point," he says, "the collodion layer becomes sensitive to light, but such sensitivity lasts only as long as the collodion remains wet, and exposure must be completed and development started before drying begins, which may be within six to eight minutes. It may be good nail polish, but you can't produce very many thousand microfilm images per day."

Well, from 1887 until 1928, microfilm, with a very few exceptions, remained in a state of limbo. There were many, many advances in photography. Mr. Eastman started a

company in Rochester, New York and started putting out
Kodaks; nitro-cellulose film was introduced to the world;
moving pictures started flickering; and diazo film was
discovered. Photography became big business. As for
microfilm, in 1900 an American patent was granted for a
check microfilming camera, but history shows it wasn't
successful. In 1913 Oscar Barnack designed a 35mm still
camera capable of producing high quality negatives. This
camera, later designated the Leica, was employed by the
Germans in World War I for filming valuable documents.

There was one really bright light in an otherwise near
microfilm void: Amandus Johnson (1877-), the researcher.
After a few years of laboriously copying (or having copied by
others) manuscripts in Scandanavia and having to cope with
proofreading, errors and illegibility, he determined that
copying by photograph was the only possible means that
would insure accuracy, and hopefully speed as well. Con-
sequently, in 1906 he carried to Europe a bulky 5 x 7 plated
camera together with glass plates and holders with which he
extensively copied manuscripts. The following year he
stumbled on a much more compact camera in Germany which
used 1 1/2" x 2" plates. This was a great improvement, but
still too bulky. Still another year later, he visited a movie
theatre in Philadelphia. In 1959 at the NMA convention in
Washington, he expressed his reaction.

"As I entered (the theatre)" he said, "the text of a letter
was projected on the screen. It was perfectly readable. This
gave me an idea. When the showing was over, I asked the
manager for permission to visit the projection room to see
how the operator managed the machinery and how the film
looked. After some discussion this was granted. I was now
convinced that the most efficient and practical manner to
photograph manuscripts was by a strip of continuous film on
a roller and placed in a camera that would be operated by a
crank to move the film in taking the pictures. To my mind

the problem of taking cheap reproductions of manuscripts was solved. I returned home and began making sketches for a camera that would take a roll of film.

"As mechanics and carpentry are two of my hobbies, I had no difficulty in making a model of such a camera. I cut two small wooden centers from a broom handle, to each of which I attached two circular cardboard discs four inches in diameter (I had been told that 100 feet of film wound on a one inch core would measure about 3 1/2" in diameter), thus making two spools that would take 100 feet of film each. The side of the camera could be opened for loading; below I attached my miniature camera."

Mr. Johnson concluded his talk which, by the way, was his acceptance speech for the third Pioneer Medal, ". . . .By proving to many . . . that microfilming could be done to great advantage at small cost, I may have made a contribution to microfilming by giving it a start earlier than otherwise would have been the case."

From pure expediency this remarkable gentleman built the prototype of the 35mm planetary camera as we know it today.

Then in 1928, one George L. McCarthy came on stage, a man who was destined to revolutionize the industry, or to be more precise, to change it from an art to a business.

Mr. McCarthy started his career as a bank messenger and worked his way up to a vice-presidency of the Empire Trust Company of New York at the age of 39. He became fascinated with the mechanics of the then silent motion pictures, and reasoned that since moving objects could be "frozen" in individual frames, there should be a way to photograph moving documents and similarly "freeze" them. What he was driving at of course was how to speed up the photographic process; documents traveling on a series of endless belts could be filmed at high speed. He soon discovered this was not going to be an easy task. Very high

speed shutters would be required; fast shutter speeds meant fast lenses and fast emulsions and high light intensities. High speed lenses were notorious for poor resolution and fast films were grainy. This seemed to be a dilemma with no solution, and then, he had an idea.

George McCarthy was neither an engineer or a scientist, which was quite a handicap when it came to executing his ideas. However, as he was totally lacking in photographic knowledge, it meant he had no preconceived ideas. Consequently, he looked at the problem from a fresh viewpoint. Having dismissed the conventional between-the-lens and focal plane shutters of the still cameras, and the butterfly shutters of the movie camera, he decided to sack the shutter completely. Instead, the film and the copy would pass on either side of the open lens in perfect synchronization. The image on the film would consequently be "frozen" as both the document and the film were traveling at the same relative speed. If this idea worked, the only limitation on the speed at which documents could be photographed would be mechanical. It worked. This was really revolutionary; and the flow camera was born. McCarthy had another trick: although all professional movies were made on 35mm film, it certainly wasn't necessary for filming small documents like checks. So, as he worked for a bank and not a film manufacturer, he selected 16mm film for its economy.

By 1926, McCarthy had actually constructed ten of his machines called "Checkographs." They were crude but they worked. He showed them at various bankers conventions, but for the most part the bankers viewed the new contraption with jaundiced eyes. The thing was interesting but not practical. Finally, however, it caught Kodak's attention. Mr. T.O. Babb, Kodak's West Coast manager, quickly saw that such a device, if successful, would devour great quantities of film. He arranged for a most willing McCarthy to visit Rochester where a mutually satisfactory agreement was soon

arranged. In return for assigning his patent rights, McCarthy became genreral manager of a new subsidiary for marketing the Checkograph machine together with film and film processing. The name of this subsidiary was Recordak.

It wasn't long before Eastman engineers materially improved the now named Recordak, and on May 1, 1928, the first camera, Model No. 1, was installed in the Empire Trust Company. Page one of modern microfilm history had been written. The large metropolitan banks soon adapted his newfangled system, so many and obvious were the advantages. The transit department no longer had to make laborious handwritten transcripts of their foreign checks. The book-keeping departments were protected from unscrupulous depositors who might claim unfounded charges had been made on their accounts, and conversely the honest depositor could prove when he had made payment, even if he had lost the cancelled check.

In his acceptance speech for the Pioneer Award at the NMA convention in 1954 shortly before his death, Mr. McCarthy mused about his beginnings in the field: ". . . .It was, as most of you know, during the 19th century that a French patriot and a pigeon collaborated in the first known use of microfilm. Fortunately, I did not learn of this until long after the first Recordak had been installed. I do not know what it would have done to an Irishman's pride had I realized at the time I was building the first modern micro-filming machine that I was taking up where a French pigeon left off."

McCarthy was a shrewd businessman and a master salesman, but he had more than the salesman's enthusiasm; he had vision. In this same speech he predicted, "Probably the most spectacular advances which loom upon the horizon involve the combination of microfilming with electronic machines of superhuman efficiency and speed. In this connection there is every reason to suppose that just as the

mechanical tabulating systems of today will be superceded by electronic tabulating in the future, the paper medium of the present day tabulating system will also be superceded by coded microfilm reels for implementing the speed of these almost incredible creations of the electronics age which are even now on the threshold of general use. . ."

By 1969 there were already at least seven manufacturers of equipment designed to convert computer tape directly into microfilm.

From 1928 on, the history of microfilm if followed in detail is voluminous, and could very nearly compete with the *Congressional Record*. Perforce we must stick to the highlights and milestones, events on personal accomplishments that dramatically influenced our country or the world as well as the future of microfilm.

Everyone — at least if you are thirty five years old or more — is familiar with the V-mail system instituted in World War II for delivering mail to the GI's overseas. A billion and a half letters were delivered without loss while valuable air cargo space was made more readily available. Everyone knows microfilm did the trick, but few realize that outside of the banks, this was the first large scale use of microfilm. V-mail served another function. In addition to providing unprecedented mail service to the boys at the front, it made the general public aware for the first time that there was even such a thing as microfilm.

Several years before the War, there were quite a few pioneers who preached the microfilm gospel. They might be divided into two groups; the professionals and the men to whom microfilm was more of an avocation than a vocation. In the latter group, four stand out.

Albert Boni (1892-) is a publisher, one of the co-founders of the publishing firm of Boni-Liveright, who in 1934 began experimental work on microprinting. This micro-opaque is similar in all respects to the microcard except

for size (being considerably larger) and more importantly the final product instead of being a photographic contact print is a card which has been actually printed on a printing press. The obligation owed to him by the industry is not so much the invention of the process as the field he was instrumental in opening up — micro-publishing and micro-reprinting.

Robert Cedric Binkley (1897-1940) was an educator, whose prime interest was documentation technology. He was a prolific author, producing books on such diverse subjects as *Responsible Drinking, What's Right With Marriage* and *Manual On Methods of Reproducing Research Materials*. He had infinite confidence in the future of microfilm, and possibly his greatest contribution was his insistence in 1934 that the code hearings of the NRA (National Recovery Administration) and the AAA (Agricultural Adjustment Administration) be microfilmed on a Recordak rotary camera for permanence rather than being made available through imperfect and impermanent hectographs. This appears to be the earliest effort to document material larger than checks on such equipment. Its success paved the way for the acceptance of flow cameras in the filming of industrial and academic materials.

Fremont Rider (1885-1970), was a librarian, previously mentioned, whose conception of the Microcard closely paralleled Albert Boni's Microprint. He was gravely concerned with the guinea-pig multiplying characteristics of research libraries. Unless the physical growth was held in check somehow someway, libraries would be necessarily either incomplete or mammoth monstrosities. Hence the Microcard.

Atherton Seidell (1878-1969) was a chemist who became an enthusiastic microfilm aficionado in the early '30s. So convinced was he that 35mm microfilm had limitless possibilities as a reproduction medium, that he designed and sold inexpensive viewers to libraries and indeed even *gave* several dozen cameras of his own design to scientific libraries to further the dissemination of scientific data. Fred Luther

told me this: "In the thirties he designed and had built at his own expense a score of cameras which he gave at no charge to a number of reference libraries, asking only in return that they microfilm material for inter-library loan and not make any charge to the reader for the filming, but consider it like any other free library service, such as reader's guide pamphlet production, telephone request lookups and the like. A number of libraries refused to accept his camera under such a condition and Dr. Seidell plaintively asked me in 1959 if I thought he or I could get such a service accepted if we also donated free film to them to use in the program. . ."

When we come to the "professionals," the ones who are in the business either as manufacturers, users or contractors, this is not the place to extend to them proper tribute. Tales about a few of them will be found in the chapter "Anecdotes," but here, because of space, we cannot even list them all (not to mention the possibility of omitting a score or more important names).

After World War II, the dust and fall-out gradually settled and the world returned to normal, and microfilm quite a bit below. True, Recordak, Remington-Rand and Burroughs kept plugging away at the banks, and a few manufacturers filmed their now obsolete military drawings to save space and maybe even a few current drawings for insurance purposes, but in general and the service companies in particular, the clouds were gray and there was no silver lining anywhere. Prices plummeted, for example, from above 25 cents per drawing to less than a nickel. Most things went up; microfilm went down.

The ex-GI was partly the cause. He remembered the glamour of V-Mail and the little rolls of engineering drawings and he wanted to get in on the ground floor of this new promising industry. He was told that the film cost a penny per frame and he could sell the finished product for 25 cents, a neat profit. Why not 24 cents and get *all* the business? So he bought a camera on time and got his feet wet. Soaking, in

fact.

Now my story is not at all unusual; in fact, since it is quite typical, maybe it's even worth relating. It was early spring in 1950 when I visited Rochester to inquire at the font if it were practical for me to go into the microfilm service business. Sandy Sandell got me in his very able clutches and entranced me with the tremendous possibilities in such a venture, citing the prosperity that several in the field were enjoying like Micro-Photo out in Cleveland and Graphic Microfilm down in New York. Millions of feet of film spewed out, millions of dollars flowing through the till, millions of customers just standing around waiting to be sold. I simply couldn't wait to get home and start this new enterprise, but forced myself to stop by New York on my way home and talk to the great Dick Batchelder who, Sandy told me, could be of inestimatable help in starting me off right.

Well, two days later I appeared on Liberty Street in down-town New York and found myself climbing some narrow stairs up to what might mercifully be called a first class loft. No chrome, no florescent lighting, no overstuffed chairs, no carpet, no sexy receptionist. Only a small anteroom with two straight back chairs and a small glass window behind which finally appeared a bedraggled looking female. She looked at me questioningly and I announced my desire to see *the* Mr. Batchelder.

"Have a seat," she said laconically. "He's with someone right now."

She disappeared, presumably to some other job. Shortly thereafter, a pleasant looking young fellow with a glint in his eye came out of the only door and marched down the stairs. I can't describe the expression on his face. Some preachers have it; maybe you could say it was a dedicated look. Anyway, he had it. A few minutes later a dapper mustached young man opened the door and introduced himself as Dick Batchelder. I told him Sandy had sent me.

"Any friend of Sandy's a friend of mine," he said. "What can I do for you?" Whereupon I told him *plenty*, and proceeded to unburden myself with my plans. I was going to start up a service company. I waited for his approbation. It didn't come. Instead, as I talked his face became progressively more downcast. Finally he interrupted me.

"Mr. Mann," he commenced, "if you are going into this business because you think it's glamorous, forget it. It's damn hard work, and not very rewarding. Sometimes it is mere drudgery. I've been in it long enough to know. During the War, sure, we made good money and felt we were doing a real service to Uncle Sam, but that's all over now. And brother I mean the glamour *and* the money.

"You know what'll happen to you? Everybody in business these days is interested in microfilm, but nobody knows anything about it. You'll go home and start making some calls. The general manager, or the plant engineer or the purchasing agent will invite you in. Tell us all about it, they'll say. And you will. Maybe you'll know enough to talk maybe an hour. The man you've been talking to has been visibly impressed. When you've finished and think you've done a pretty good job, you'll lean forward to pick up an order. He'll lean back.

" 'That microfilm is quite a thing. Never knew how much it could do before. Everyone's going to be doing it one of these days. Right now there must be lots of places where it'll fit in. But I'm afraid we can't use it.' "

Mr. Batchelder looked at me. I remained unimpressed. I was a dis-believer. The world was waiting for me.

"You know the mortality in the service business?" he continued. "About 90%. Did you see that young fellow that just left?" The young Crusader with the dedicated look, I surmised. "Well, he just bought a bunch of hardware from us that we had previously repossessed from a concern that went broke. Now, if you'll be patient and wait six months you can

buy that same equipment."

Dick was telling the truth, the cold facts. Things were tough in the fifites, really tough. I went home, rented a third class loft and one month grossed $5.48. But that's another story.

Since Mr. McCarthy's flow camera, there have been innumerable advances but possibly one has had the most profound effect on the industry's destiny. This product is, of course, the aperture card, the original unitized microfilm and its relatives, the jacket and microfiche.

Who then invented the aperture card? Don't ask too many people because you'll only get confused. One thing seems certain: no one man can claim responsibility for its ultimate success. Rather it has been a series of men, each of whom contributed his individual share. Dr. Atherton Seidell suggested the idea of an aperture card as early as 1934, and a bit later John Q. Kerrins actually developed and utilized a card with a hole in it. These first aperture cards were fabricated by cutting apertures into thin card stock, the holes being slightly smaller than a single 35mm frame, and the card stock being about 2 x 4 inches. Two pieces of this card stock were sandwiched with a frame of film in between and then laminated. The exposed section of film was visible through the resulting window. Mr. Kerrins used this concept for land title records and although his system was admired and even accepted, the cost of this method precluded wholesale adoption by the title companies.

Meanwhile, John F. Langan, a classification expert and chief of the Pictorial Records Division of the OSS during World War II cast about for a method of filing and retrieving the millions of photographs in his files. This came about as a result of a government request that citizens send in their snapshots previously taken in Germany, France, and the other occupied countries in the hopes they might be of some military value. Literally millions poured in. These had to be

inspected, sorted, graded and, if of possible value, coded and filed. This was *input. Output* was equally frustrating. A requested photograph had to be found, duplicated by re-photographing and printing — and then re-filed. Physically the combined task of handling various sized originals from 35mm contact prints to 8 x 10's and larger was virtually impossible. If these could be reduced to a uniform size, and the folders and envelopes eliminated, the battle would be half won. If retrieval could be mechanized and reproduction reduced from two steps to one, the whole problem could be solved. By photographing on 35mm film the assorted size prints, uniformity could be achieved. But 35mm roll film wouldn't solve the other problems. But a series of cards each holding an individual negative would.

Whether Mr. Langan was impressed with Mr. Kerrin's approach or merely enlarged on Dr. Seidell's ideas is unclear, but it is certain that he struck out in a new direction, being faithful only to the basic idea of a card with a hole in it. Rather than a small laminated card, he selected a standard tabulating card. Something that could be key punched, interpreted and machine-sorted. Next he isolated an area for the aperture that would allow the card to pass through a sorter without damaging the film. Certain rollers, apparently not essential to its operation, had to be removed from the sorter but the location selected did not unduly restrict the information carrying abilities of the card. So far so good. Next he needed a new method of making the film stick in the hole. He searched for a pressure sensitive tape that was optically clear and would not bleed to bond the edges of the film strip to the edges of the aperture. At first he used strips cut from sheets of laminating plastic, sheets used by archivists to laminate valuable and disintegrating documents. In other words, his approach was to suspend literally a section of film in the aperture, and since card stock was .0067 inches thick and the film only .0055 inches, no thickness was added to the

card.

The entire operation was by hand, slow and tortuous, except that the hole itself was die-cut, but the system worked to the satisfaction of the powers-that-be. And thus the first aperture card system using a tab card was installed in the offices of the OSS in 1943. That Mr. Langan's thinking was sound is evidenced by the fact that although his product was primitive in its manufacture, his basic formula, a tab card and a pressure sensitive adhesive for mounting, remains unchanged today, and is part and parcel of the DOD specifications. Refinements, yes, have been added, but the basics are the same.

Well, as long as the War lasted, so did the interest in the aperture card. The Navy Photo Service Laboratory at Anacostia, the Naval Academy's Department of Foreign Languages, the Federal Bureau of Investigation, the War Crimes Commission and countless other federal agencies could very well have installed similar systems, but fortunately for everyone except the inanimate aperture card, the War ended. And, as *The Hole In the Card* so aptly put it, "Like so many other developments of the early forties, 'the hole in the card' was a war baby spawned by the urgent needs of national survival. It was one more bit of proof that necessity is the mother of invention. The situation changed, however, when the War ended. Like many other veterans, the microfilm aperture card had to look for a job. This reversed the adage. The microfilm aperture card became an invention in search of a need."

The search was long. Langan patented his process and shortly thereafter sold his rights to a couple of entrepreneurs, a Mr. Roberts and a Mr. Casey, and after a luckless stint of trying to find a market for this glamorous but unwanted product, they sold out to Dexter Folder, and the company's name was changed from "Film 'N File" to Filmsort, an improvement if not a great one. As everyone knows, 3M

finally acquired Filmsort for their stables and it has been a winner ever since.

What changed the Filmsort card from a loser to a winner? Frankly, I don't know, and maybe even Scotty McArthur and Earl Bassett of 3M who were in "on the ground floor" might fumble around for an answer. It was so gradual that it would be difficult to even pinpoint a turning point. The late Joe Curtin's story, for example, in the last chapter will illustrate at least one of the links in the chain that pulled the card out of the mire of obscurity.

No history of microfilm would be complete without paying tribute to the role played by the National Micrographic Association, formerly the National Microfilm Association. In 1952, Eugene Powers, then president of University Microfilms, Richard Batchelder, President of Graphic Microfilm of New York, Vernon Tate, Archivist for the U.S. Naval Academy and several others invited interested parties to gather in Washington to discuss the possible formation of a trade association. Ninety odd mildly interested parties showed up — a few manufacturers, a few consumers, but largely service personnel. A charter was drawn up and subsequently adopted, and under the aegis of kindly Vernon Tate who was appointed executive secretary (and Mrs. Tate the unappointed assistant secretary), the association flourished. It now consists of more than 8,000 members and recent conventions have recorded attendance figures in excess of 20,000. In fact, few cities have the facilities to accommodate such a large group.

Through the years, the character of the association has changed. Originally it was dominated by service organizations. Slowly, the control shifted over to the manufacturers. And now, although both service and manufacturing personnel are represented on the board of directors and various committees, the consumer, the user, is possibly the most influential force. The power may have changed hands, but the purpose of the organization has not. Under the directorship of Gordon

Banks, it continues to be the guiding star of the industry, a cohesive force, promoting the increased use of microfilm, setting much needed standards and keeping its membership ever aware of advances in hardware and techniques.

Working towards the same purpose as the NMA but in a worldwide field is the International Micrographic Congress, founded by three former presidents of the NMA, with the sole purpose of spreading the use of microfilm around the globe. It has had conventions in Japan, Germany, England, Brazil and Australia and future meetings are scheduled for Sweden, Canada, and South Africa. There are now over twenty national microfilm associations throughout the world who are members of the IMC.

In recent years there have been literally dozens of steps forward that have diversified microfilm's scope. Whether one could say these technological advances are synonomous with history is questionable, but the effect of these advances has indeed been profound. Some have been new approaches while others simply fostered by inter-company competition. There is, for instance, the suspension type aperture card, the "thin" jacket, paste-up microfiche, the ultrafiche, the cartridge, the new thin base film; there is also the low cost mass produced reader, the super sophisticated retrieval system, the not-so-eternal triangle of microfilm-computer-video tape, the table top processing unit, the truly portable flow camera — and many more. For the most part, these have been products of evolution, and the individuals responsible legion.

Thus we arrive at the present, where history is taking place every day, certainly a cliche, even if true. More sophisticated products are yet to be produced, more applications yet to be applied. But the agonizing days are over; the world has finally accepted microfilm.

EQUIPMENT

There is a plethora of hardware available these days, so much so in fact that the mere evaluation of equipment could well become an industry all its own. I hark back to 1950 when, so far as I know, Recordak had only three readers available for their customers — two 35mm and one 16mm. Remington-Rand boasted of two, both constructed of plywood, and rather thin plywood at that. Burroughs had only one, but it was very sophisticated; there was an electric motor instead of a hand-operated knob to advance the film. Griscombe had more sizes and shapes than anyone, but I believe Murry Gristle will be the first to admit he didn't sell many units of whatever type. Truth was you had very little choice, and little very choice. But even as long ago as 1966, the available selections, according to the "Guide to Micro-reproduction Equipment," was divided among some thirty manufacturers, many of whom offered half a dozen different readers. A single year later, in its Supplement, the "Guide" added fourteen new readers introduced by previously listed manufacturers plus four new makers! One might give some accurate figures today on the total number of readers on the market, but not tomorrow.

I recall a conversation with an assistant chief engineer of the Virginia Power & Electric in Richmond, Virginia, a few years ago. My spy system had not functioned very well and I got in on the scene too late, after the final decisions had been made. "Mr. Mann, the engineer said, "I have been assigned to this project for more than a year now. I have been instructed to make positive recommendations for a system together with

the equipment required. I have investigated and reinvestigated, evaluated and re-evaluated until I am tired and thoroughly confused. Even if I am wrong, I have made up my mind and my selections. I simply can't evaluate any more." Sixteen years had made the difference from too little to too much choice.

In this chapter we will deal with the equipment peculiar to and necessary in the microfilm industry. No specific recommendations are made and few evaluations; merely descriptions. Even approximate prices are avoided for obvious reasons.

Cameras

We start with the most important component of any microfilm system. A microfilm camera can be considered as being divided, like all Gaul, into three parts: the film unit, or camera, the transport and control mechanism, and the cabinet or structure that houses these parts. Mechanically they are divided into two types — planetary and flow (also called rotary). One can hardly categorize them by the size of the film they use, but usually a 16mm camera is a flow type, while 35mm, 70mm and 105mm are very nearly always planetary. There are, however, some flow units that can accommodate either 16mm or 35mm film as well as some planetary cameras.

Planetary Cameras: The reason for the adoption of this description is unclear, but it would seem logical to me to assume that planetary was selected because the film and the copy are both in the same plane, or parallel to each other. Actually, it's nothing more than a glorified copy camera that happens to use very small film. There is a shutter, and each time it "snaps," the film advances a predetermined amount, the shutter resets itself, and it's ready for the next "snap." The total cycle may require a second or two.

Let's look at a typical unit. It consists of a *base* on which

the copy to be filmed is placed. Attached to this base is a *column* from which the *camera* is suspended with its lens downward towards the base. The *controls* may be contained in the base, which greatly contributes to its compactness. Or the mechanism may be housed in a separate cabinet. Four lamps are attached in pairs to arms on either side of the base and provide *illumination* for exposure.

Planetary cameras are also called "flat-bed" cameras. The copy board or base is certainly flat, and I suppose that accounts for this choice. All this terminology sometimes leads to misunderstandings. Dick Loud, the former genial proprietor of General Microfilm up in Cambridge, Massachusetts, recalls such an instance. A young lady was being interviewed for a job by his personnel manager, and when she explained she had had previous camera experience, the manager's ears perked up.

"And what kind of a camera did you use?" he asked.

"I filmed on one of those cameras," she answered. "You know, office records and things."

This indicated experience with a flow camera, and at the time they were looking for a 35mm planetary camera operator. "That's nice," he said, "but how are you on a flat-bed?"

She eyed him coldly. "I'll thank you," she answered, looking him up and down, "to leave my personal life out of this."

Of all the descriptives that might be applied to a planetary camera, versatile is perhaps the most appropriate. First of all, a light meter diagnoses the correct lamp intensity, which can then be set by a built-in rheostat or variable transformer. Or, on some of the more exotic models, the adjustment is automatic.

Next, the reduction ratio can be selected at will, merely by raising or lowering the camera, either manually by a hand crank or electronically.

Focusing may or may not be automatic, but if not, it can be set correctly by manipulating one simple control.

Format can be varied simply by rotating the camera a quarter or half turn.

The size of the aperture or frame can be changed to any desired width (approximately from 1/4 inch to 1 5/8 inches) by the turn of a knob.

The distance between frames can be altered also, and the film unit can be modified so that a double exposure is possible, allowing the front and back of the same document to appear on one frame.

Many cameras are designed to accept an accessory that permits 16mm film to be used as well as 35mm. One camera contains two film units so that two rolls of film are exposed simultaneously, presumably so that one can be mounted in aperture cards while the other becomes a roll film master.

Planetary cameras are required for filming certain copy, bound volumes being the classic example. Also, they are generally used for filming large copy, such as engineering drawings, and where sharp detail is desired. In other cases, the type of camera used is optional, depending in part on what is available.

Some flat beds are not as versatile as the ones described, but this does not mean necessarily that they are inferior or less expensive. Let's say instead that they are more specialized. There are several behometfor around designed specifically for engineering drawings, capable of producing film of breathtaking sharpness. Frame size and pull-down are fixed; reduction ratios are limited. Other special purpose planetaries are designed for county-recording with one reduction ratio, one frame size and perhaps with double exposure capability. And portability is the prime objective of at least one manufacturer who has succeeded in building a 35mm unit that can be stored in a single small suitcase.

Since the principle of the planetary is simple, a cheap

camera is not hard to build. One can even take a secondhand Leica, mount it on a homemade stand, and truthful claim ownership of a microfilm camera. In the forties, there appeared on the market a planetary designed to compete with the flow camera, pitting cost against speed. Ever since, similar machines have periodically been presented to the public, like the British unit displayed at the 1967 NMA convention in Miami. Quite recently one of our large manufacturers has marketed another brand new one. In essence, it is a box containing a film unit and a set of lamps. The top of the box is glass, and the film unit is zeroed in on this glass. The copy is placed face down on it and the picture snapped. The unit is inexpensive, can be used in a well lighted room (as opposed to most planetaries), takes a creditable picture and can be used to photograph books. But it doesn't have glamour and is slow.

However, don't get the idea that a sophisticated camera is a simple mechanism, or cheap for that matter. Prices for the above may be very modest, but on the other hand, you can drop as much as you'd like for a custom job. Let's take a glance at some of the planetary's guts. The whole unit must be rugged, capable of taking literally millions of pictures with a minimum of service. The shutter must remain accurate and the spacing constant through all these cycles. The lens is something quite special. The ordinary photographic lens is primarily concerned with speed and its ability to diffract colors of different wave-lengths and project them in register with each other on the film. A lens that will do this is called achromatic. A microfilm lens is concerned with the latter, but speed is not a do-or-die requirement. Resolution is, however. In portraiture, very often poor resolution is desirable in order to achieve a soft focus effect (particularly when the subject is a young gentleman with acne, or a middle-aged lady with wrinkles, and very seldom in a landscape is the photographer anxious to show the flies on a cow's back). In microfilm, on

the other hand, we want to reproduce as much as possible, and then some. Even more difficult to attain in a lens is the flat field capability. Nobody who takes ordinary photographs cares a hoot if the edges of each negative are razor sharp, or if the field is curved. In microfilm, the corners are just as important as the center. All lenses have this tendency to "fall off" not only in resolution but brilliance at the edges. From a technical point of view, the reason is that the distance from the edge of the copy to the lens is greater than from the center to the lens. This means that the focal distance from lens to center of the film should be greater than from the lens to the edges of the film if the entire frame is to be in sharp focus *unless* the lens is "corrected" sufficiently. Furthermore, there must be no distortion. All of this has been accounted for in the lens design as far as state of the art permits, but it seems that correction simply cannot be 100%. One of the larger manufacturers came up with a novel solution a few years ago. Why not, they reasoned, make the film behind the lens bend very slightly to compensate for this distance differential? This was accomplished by substituting what is known as a curved platen for the original flat platen.

Sorry I brought this up.

Flow Cameras: This is a different kettle of fish. Mr. McCarthy as you remember started the paper flowing, which it has done ever since. the basic difference between the two types of camera you already know. In a planetary camera, the copy remains stationary. You position the document, press the button, the shutter clicks, the film advances and you replace the document with another one. In a flow camera, the copy is filmed as it passes the camera lens. The film moves also, and in synchronization with the copy.

Flow cameras also have another name, rotary. The earlier cameras, many of which are still rotating, employed a drum for the transport mechanism, around which the document wrapped as it rotated. The drum has given way to belts in the

newer cameras, primarily because the design requires the documents be carried further away from the filming area. If we follow the document's path, we find that first it is dropped into a hopper where it is picked up by the revolving belts (or drum), transported between a pair of glass guides at which point the document is photographed, and then carried to a tray which stacks it along with the other documents in the same sequence that it has been filmed.

Flow cameras may be quite neat but are no more eye-catching than any other piece of office equipment. The film unit is concealed inside the machine, and is usually removable, and for two reasons. Accessibility, for changing film as well as camera maintenance is one. The other is that another film unit can be substituted, for any of several reasons.

The strongest point in favor of the flow camera is its awesome speed. An average operator can film in a given day ten times as many documents on a flow camera as on a planetary. If an automatic feed is added, the speed is increased theoretically 500%. This makes the planetary seem a rather pitful piece of equipment. Tremendous speed, though, is not always the primary requisite, and sometimes the nature of the copy is such that it simply cannot be achieved. Take automatic feed. The documents must be of approximately the same size and thickness, such as checks, before the feeder can be used. Even so there is always the possibility of a double feed, the picking up by the belts of two documents at the same time, thus failing to film the bottom sheet. Although this accessory usually has a built-in safety device that absolutely prevents a double feed (if you believe everything you read) or shuts off the machine if it does happen, sometimes it does neither.

To continue on the red side of the ledger, flow cameras are confined to filming records of legal size or smaller (with a few exceptions), and the quality of the image is not, at least theoretically, as good as the planetary's. Synchronization may

be 99.9999% perfect, but never 100%.

Some time ago, photographing various colors presented quite a problem to the operators of flow cameras. It was essential to vary the light intensity, or compensate for the varying shades to obtain first class results. This was accomplished by pressing one of several buttons or turning the knob of a rheostat. As you can well imagine, this was a time-consuming process. More recently, someone dreamed up the idea that foot-pedals would allow an operator to change voltage without sacrificing speed. This was correct, the only limitation being the number of pedals the operator could conveniently manipulate. And of course mixed colors could not be fed automatically unless one was willing to sacrifice uniformity of the image densities.

The electric eye may solve this particular problem. The meter reads the degree of light reflection as the document approaches the filming area and determines the correct voltage. This voltage is then applied to the lamps with a "hold" until the paper has left the picture area. The speed is such that it is successful even with automatic feed.

Before we leave roll film cameras, we might mention the "duplex" feature common to many. Originally designed for filming checks, the duplex camera films front and back of a check simultaneously, and these two sides appear side by side on the film. The whole thing is accomplished by a series of mirrors. Somewhat high reduction ratios are necessary for this as one half of the film width, or 8mm, pictures the front of the document and the other half the back. Of course, if one desires to film only one side of a document with this equipment, he need only press a button, eliminating the filming of the reverse side. At the end of the roll, he simply re-inserted it, turning it over at the same time, and exposes the other half of the film. This money and space saving method is called, for no logical reason, triplex filming. And oh yes, one more item. Most flow cameras have a double film

unit: that is, two rolls of film may be used simultaneously. As on the planetary camera mentioned earlier, the possible uses are obvious.

The step-and-repeat camera, an expensive and slow apparatus, is one of two that does not accept conventional roll film. Instead here the material is a sheet approximately 4 by 6 inches in size (or perhaps 3 x 5 inches or tab). The camera looks like a top heavy planetary camera, which in fact it is. In operation, the first image is made with the film positioned to expose a section near the top left part of the sheet. After the shutter has clicked, the film is moved over one frame and the cycle repeated. At the end of the first line, some twelve exposures, the film is returned to its original position except one line lower. After five lines or some sixty images have been made, depending on the reduction ratio used, the film sheet is mechanically removed and a fresh sheet substituted. Of course the series on any one sheet can be terminated at any point. Top resolution can be expected with this kind of equipment, and one can expect to pay a high price. Such a camera may use 105mm roll film instead of cut sheets.

Another camera is the aperture card processor-camera. This unique contraption stores a deck of unexposed silver aperture cards somewhere in its interior. Not only does it make individual exposures on the film part of the card, it manages to completely process that film without getting the card even faintly damp. The whole process takes less than a minute, and despite this speed, it produces a virtually permanent image. The cost of the whole package is about the same as − or less than − the price of a medium-priced roll film camera.

Readers

We have exposed our film and developed it (processing is in another chapter) and now we want to see what we've got. The necessary instrument is called a "reader" or if you prefer,

a "viewer." It is a self-contained unit with a projector and a built-in screen. Without the screen, it would be simply a projector.

Now the ideal objective of the design engineers has always been to build a unit that (1) is inexpensive, (2) compact, (3) projects a brilliant image, (4) which is critically sharp, and (5) has controls that are professionally acceptable. Very often the engineers have failed on one or two counts, and sometimes on all five. The designers usually concentrate on one particular feature at the expense of the others, maybe at the insistance of the sales manager, or the comptroller, or a particularly good customer, or anyone who talked loudly and long enough. Cost, appearance, versatility, size, weight — it's hard enough to achieve one. Consequently, from a user's point of view, it is safe to say the most criticized piece of microfilm hardware is the reader, perhaps unfairly.

Readers can be divided and sub-divided many different ways. Optically there are two types; the one utilizes a translucent beaded screen positioned vertically with the image projected from the rear. The other uses an opaque screen which lies either flat or slightly tilted, with the image being projected upon it from above. With one the image is transmitted, the other reflected. Which is superior is strictly a matter of personal preference. The only comment I might venture is that the translucent type tends to be more compact. The screen, however, is often installed in a near vertical position, and wearers of bifocals complain reading from such a screen gives them a stiff neck, whereas they can read at a more normal angle from a reflected screen.

Viewers can also be classified by *input*. There are roll film readers, there are aperture card readers, and there are jacket microfiche readers. There are also readers which handle all three, but their versatility is more apt to be a result of afterthought than good design. If the unit is conceived as a fiche reader, the roll film attachment will be makeshift, and it

may accept aperture cards but not with pleasure. Roll film readers are generally designed to handle a specific size of film — 16mm, 35mm, 70mm or 105mm though 16mm-35mm machines are not uncommon. All have a device to advance (and rewind) the film, and almost all have what is called a rotating head, so that images appearing on the film sideways or upside down can be seen in a normal vertical position. Nearly all incorporate a scanning lever; the film advance allows scanning of the film throughout its length, while the lever performs the same function for the width.

Greatly increasing in popularity is the film cartridge reader. Motorized advance, which may or may not be on the ordinary roll film reader, is standard equipment for the cartridge reader. Cartridges, as the name suggests, require no threading, a process that is admittedly slow but not as difficult as some people would like to think. The cartridge is also a self-sufficient unit, and doesn't require boxing to protect it. Retrieval is implemented by any one of three indexing systems which are incorporated in most cartridge readers. The first is simply a footage counter, similar to the ones used on tape recorders, and if properly indexed, any document on a given roll can be found with reasonable accuracy in a matter of seconds. Another system employs vertical lines which walk laterally (between images) across the screen as the film advances. The location of any document can be determined by the position of these lines. The most sophisticated of the systems requires the filming of digital information adjacent to or parallel with the documents concurrently. With this system, retrieval is truly automatic; just punch the correct code keys and your record is there.

Unitized microfilm is responsible for the other breed of readers. The early aperture card and jacket readers were quite simple affairs, with the jacket being manually placed between the condenser system and the projection lens and then shoved back and forth, up and down, until the desired frame was

properly positioned. The trouble was when you moved the card to the right the image went to the left; when you pushed the card away from you, the image went down. And it usually required three tries before you could get the card in right side up.

That reminds me of my first contact with Robbie Robbins of Filmsort. I was nursing a bad cold at home, as I remember, in January of 1952 when the phone rang. I crawled out of bed to be told Mr. Robbins was in my office and wanted to see me. He couldn't help it if I were sick; he was in town, and Filmsort couldn't afford to squander money on incompleted calls. So he drove out to the house to give me his pitch, and showed me among other things his Inspector 100. This was the first acetate jacket reader I had seen. It looked nice and simple and inexpensive and projected (for the time) a creditable image, but I wasn't exactly bowled over.

"What does it list for?" I asked, fully expecting he would say fifty or seventy-five dollars.

"Two hundred and ninety seven dollars," answered Robbie very slowly and distinctly.

I was visibly shaken, as they say in the murder mysteries. "Why that's ridiculous," I countered. "There's nothing to it — just one moving part for focusing. Why this awful price?"

Robbie hesitated. "Profit motive," he said.

Proved he was frank, anyway.

Some months later I was making a presentation to the staff of a hospital up in West Virginia. Everything was going smoothly. They liked the idea of jackets rather than rolls. Finally the chief of staff asked the price of the reader, the Inspector 100.

"Two ninety seven," I said, just as slowly and distinctly as Robbie had.

"Great!" exclaimed the doctor. "Good merchandising! Like selling the razor for practically nothing to get the blade business."

There's nothing like a little misunderstanding. We got the job — on roll film.

Getting back to readers, they vary considerably in size, this being determined in large part by the size of the viewing screen. 8 1/2 by 11 inches is about as small as the latter gets, and 18 x 24 inches is about as large, although there are a few mini-readers around as well as a few giants with 24 x 36 inch screens. These extra large as well as extra small might be classified as non-standard. There are also hand-readers which are quite handy for quick reference, but not recommended for extended use. These readers consist of a magnifying glass, a small housing and perhaps a built-in light source. They can be used satisfactorily with fiche, jackets and aperture cards, but not roll film.

Reader Printers

As it indicates, a reader-printer is a reader that also contains a built-in enlarger, misnamed a printer. We can't take this type of equipment too seriously as its impact on the industry has been tremendous. It is quite questionable that the industry would have attained anything approaching its present degree of consumer acceptance had it not been for the reader-printer. The desire for copying approaches being a mania in the American business office, and with microfilm it becomes easier to make a paper reproduction than with an original. Simply push a button. No feeding in or retrieving an original. You can't beat it.

Of course, paper enlargements have been made for many years from microfilm. But until the first pushbutton reader-printer was introduced in 1957, all enlargements were produced by hand, complete with messy chemicals, subdued light conditions if not total darkness, wet prints unless one was willing to wait patiently during a drying out period, and so forth. As bad as conventional photo-copying processes were, microfilm reproducing was worse.

Although the original price of this first automatic reader-printer was an unrealistic $700 or so to stimulate sales, there were many in the industry who shook their heads. The price was too high and whoever bought it was going to hatch more breakdowns than prints. When the printer met with immediate success, a newcomer up in Massachusetts got busy and soon there were two. Then along came the 18 x 24 printer and there were three. And then the proliferation started.

In simple terms, the RP operates somthing like this: the searcher finds the particular image he wishes to reproduce and centers it on the screen. After he has pressed the appropriate button, the image on the screen fades, an inside mirror positions itself so the image will be projected on sensitized material. After a set exposure period, the material is carried off by rollers or belts to be processed, and upon completion emerges from the machine. The total cycle takes from five to thirty seconds.

The reproducing material together with the processing method varies. It may be electrostatic, dry silver, electrolytic, or conventional silver. These various processes, except the last, are too complicated to attempt an explanation here, and you are already familiar with silver.

Speaking of silver reminds me of an incident down in Florida a few years back. I was calling on a large concern for the first time, and was absolutely dumbfounded at the extent of their in-plant operation. The department chief, after brainwashing me with his technical competence, showed me his high speed diazo roll-to-roll printer which he assured me ran a minimum of eighteen hours a day, his two large processors, both of which were rolling, his two planetary and four flow cameras, busy like all of his other equipment, his Copy-Flo printer and ended up pointing out two dozen spare readers he kept in reserve for replacing any of the three hundred odd ones located throughout the plant.

"Sorry I can't show you our new reader-printers," he said.

"Placed an order for fifty with an option for seventy more if we need them. Beauties they are." He puffed on his cigar. "First one's due next week."

Not wishing to appear presumptuous by asking the make, I asked, "Are they silver printers?"

"No," he said slowly. "Let me see. As a matter of fact they're green and gold."

As a parting shot, I might add that reader-printers produce what is called a permanent print. This does not mean "of archival quality," but it does mean that they will last from a few months upwards. Electrostatic printing is permanent, so the base or paper is the deciding factor in its longevity.

Enlargers

As you have probably gathered, enlargers and contact printers are often confused. A contact printer necessarily reproduces the original faithfully as to size. No lens is employed, and the reproduction is created by pressing together in direct contact the master and the sensitized material, with light passing through the former and exposing the latter. In an enlarger, the master and the sensitized material are separated by a lens system. The image is transferred, but its brilliance greatly diminished in the process, so the copying material must be much more sensitive or "faster" to require a similarly short exposure. The difference in the final product of the two processes is that, as previously mentioned, a contact printer makes a 1:1 reproduction while an enlarger may make a print larger than the original master or negative, the same size, or even smaller by manipulating the locations of the lens, the negative and the paper.

Enlargers can be classified as continuous or step. The continuous enlarger is to the flow microfilm camera what the step enlarger is to the planetary. Actually, the former operates rather like a flow camera in reverse. Both paper and film are synchronized in exactly the same relationship as in the

camera, but instead of going from paper to film the enlarger goes from film to paper.

Far and away the most popular continuous enlarger is Xerox's Copyflo, introduced in 1956, which works on the electrostatic principle. This unit spews out reproductions from a continuous roll of paper at the rate of 20 feet or more per minute, and at any one of fifteen magnifications. Its only competitor (that is, today), is a continuous silver printer which is threatened with obsolescence since the process is considerably more expensive.

Several semi-automatic step enlargers are on the market. I say semi-automatic as the operator must hand-feed the paper into the unit to secure a print. Ejection as well as the printing and processing are automatic. Most of these units are electrostatic. There is one step-and-repeat enlarger which is truly automatic. This is the counterpart of the step-and-repeat camera. This benevolent Frankenstein will reproduce all the images on a sheet of microfiche with the operator having to set only two dials, one for the number of rows on the fiche and the other for the number of images on the last row. Introduced at the NMA convention in 1962, this unit was the first one to utilize the dry silver process. With a five second interval between enlargements, a fiche containing sixty images can be blown back on sixty 8 1/2 by 11 inches paper pages and stacked in correct sequence — all in a mere five minutes. Much more recently an even more sophisticated step-enlarger has been marketed complete with a built-in computer and using the electrostatic principle. It does everything the dry silver unit mentioned above does and more because of its computer brain. Faster, "more programmable," its present drawback is the cost.

The printers described thus far are designed for medium to heavy production as opposed to the reader printer. This latter is basically a reader rather than a printer; some may take exception, but I'll stand by the statement that the RP is not

normally designed for heavy production work. Maybe *capable* of heavy production, but that's not the same thing.

All enlargers make opaque prints. Some, however, have the happy capability of turning out translucent intermediates which in turn can then be used to make diazo prints on a so-called blueprint machine. Some even make paper plates for offset press runs. Another unique type which has not been too successful thus far is the diazo enlarger that makes possible the utilization of inexpensive diazo paper for enlargements. Previous experiments in this direction had led to a dead end; photographic lenses simply would not transmit enough UV light to permit short exposures. And to have to wait several minutes for one print was rather ridiculous to a reproduction room technician. This machine successfully transmits a large percentage of UV light, and the time cycle is surprisingly short for small prints – only a few seconds – and even 18 x 24 inches enlargements are practical.

Hand operated enlargers, utilizing silver paper, are still in use and promise to be for many years to come. We will go into some detail in the chapter *Processing*. They are slow and the resulting prints are expensive, but the quality of these prints cannot be equalled by any automatic process, at least thus far. We had, and still have for that matter, an enlarger which is so sharp that I call it a "projecting microscope." In making a 32x enlargement or so, it will make visible the surface defects on the emulsion, and these in turn will show up on the print. As a consequence, it is necessary to throw the lens slightly out of focus so that these blemishes will disappear; otherwise the prints will have a lunar surface background.

There was a time, which I remember with mixed emotions, when I necessarily performed all the technical tasks in the darkroom. One day I was making enlargements on this same enlarger, some 18 by 24 inches transparencies to be precise. My assistant (that particular day) was a nice little mountain

girl with a formidable command of Carolina Mountainese. When tray developing a print, there may be areas of different density on the master negative, and these characteristics have been faithfully transferred to the enlargement. An area that promises to be too light in density can be helped somewhat by rubbing with one's fingers the reluctant spots. The finger, being much warmer than the 68° temperature of the solution will hasten development. My assistant was fascinated as she watched me under the faint red light force these areas. "Why, Mr. Mann," she asked. 'What are you fangering?'"

Printers

There are certainly enough different types of contact printers around without trying to include enlargers in the same family. First we have roll-to-roll printers. As in the case of all printers, these are duplicating devices, and they vary somewhat in construction depending on the copying material to be employed; silver, diazo or thermal film. The basic design for all three machines is the same. We start with two rolls of film — the film to be copied which is usually negative in character, and the copy film. The master film is superimposed over the print film and together they pass over a series of rollers designed to keep them in perfect register and under tension until they reach a drum, perhaps some three or four inches in diameter. As the films pass over this drum in a semi-circle, they also pass a light gate. This light penetrates the negative and exposes the copy film. From this drum the films pass over another series of rollers and are finally separated and wound back up on two receiving reels.

In the case of silver printing, the exposed reel is then removed from the shaft and developed in a processor, the same type processor that develops the master negative. If direct negative film has been used instead of ordinary negative type print film, the machine must either be slowed down or the light intensity increased as the direct negative film is

much slower in its reaction to light.

If diazo film has been used, the machine is designed a bit differently. Instead of a tungsten light, a UV light source is used, and the copy film passes through an ammonia vapor developer before it is wound up on the receiving reel. This means the unit not only exposes the film, but develops it.

Units utilizing thermal film resemble diazo printers. Near UV light is the illumination requirement, although the same lamp usually can expose either film. Development is accomplished through heat rather than ammonia, and the image is "fixed" by a short re-exposure to light.

Both of these last two types can be operated under normal room light, and there are a few units available that can handle either film with no modification.

All printers are fast to my way of thinking, but some are faster than others. The slowest can reel off 3000 feet per hour, and some achieve 10,000 feet with ease. Prices for silver printers are relatively reasonable with diazo or thermal units a bit dearer, quite understandable since the latter two provide their own development.

One bit of non-essential information: motion picture printers differ from microfilm in two respects. Movie film is perforated, and the printers are sprocket driven. The most expensive ones can step-and-repeat, i.e., each frame is individually exposed. On the other hand, in the microfilm printer the film is driven by pinch rollers and runs continuously.

Considerably less popular because of restricted use are the roll-to-card and the card-to-roll printers. These are generally ot the diazo or vesicular variety. Since the name pretty well describes the function of each unit, perhaps an illustration of the application might be more fitting.

Company X has a large file of aperture cards. They want a security roll, but for one reason or other do not have one. In this case, they require a card-to-roll printer.

Company Y has a different problem, the distribution of

large quantities of microfiche — 50 copies of one card, perhaps 75 of another, and 100 of still another. They need a semi-automated machine to achieve high production rate. A different type of card-to-roll printer is called into use, one that uses 105mm film. The correct number of copies for each fiche is dialed into the machine. The roll, upon completion, is placed in an automatic cutter and cut up into fiche cards. This is not what one might call the direct route, but it's fast.

Company Z has still another desire. It happens to have a backlog of roll film, and wishes to convert this to aperture cards. Now there are two ways this can be done; with a roll-to-roll printer in which case the duplicate film will be mounted in aperture cards or with a roll-to-card printer. Company Z elects to use the latter.

This brings up an interesting point: which method is better? I'd like to settle it by saying it all depends on what type of equipment you have. But let's say you have no equipment and are loaded down with money to spend. Probably you wouldn't be reading this book, but since you are, let's just say, neither method is clearly superior, but under certain circumstances, one might be more preferable than the other. For in-plant operation where duplicate cards might be requisitioned constantly throughout the day, a roll-to-card unit is the obvious choice. Also if the number of copies from each frame varies on a particular roll, like one card from frame 1, three of frame 2, one of frame 3 through 6, three of frame 7, etc., the roll-to-card printer is a must. Also, if a single aperture card has been lost, damaged or destroyed, it is simple to find the frame on a security roll, make the single card, and return the roll to its file.

That doesn't seem to leave much argument for the roll-to-roll printer when the final requirement is an aperture card. One advantage it has is on materials; negative silver, direct negative, silver, diazo or thermal — any of these can be mounted in an aperture card from a roll. The image can also

be mounted so that it reads right from either the front or the back of the card. Again, the blank aperture card can be key-punched in advance, and can be verified as it is mounted, i.e., the card and micro-image can be matched up.

Neither has a clear-cut advantage in speed and cost, so if one has an enormous backlog of film or a tremendous volume of current work, which method is preferable? Either one. Let your prejudice be your guide.

Continuing down the line, we come to the card-to-card or fiche-to-fiche printers. Both of these are quite similar, indeed most fiche printers will accept aperture cards but printers designed for aperture cards generally don't believe in integration. Fiche printers may be of the continuous type, in reality a miniature diazo or blue-print machine. You feed in your sandwich of fiche master and copy film instead of a drawing and blue-print paper, and process is identical. Or you may have a contraption that looks (and acts) like a professional photographic contact printer. Neither the continuous type or the step printer in its simpler form can produce fiche of the highest resolution. It requires a step printer with a point source of light and a vacuum frame to hold the sandwich in perfect contact.

Possibly the most exotic duplicating equipment of this sort today is the gizmo that will not only take a pack of aperture cards and duplicate individual cards in any predetermined quantity, but will also duplicate the key-punching and printing. This unit, as you can imagine, is quite expensive, and the other less sophisticated printers taper down quite rapidly in cost.

Coming down a bit from this rather elevated financial plateau, we come to another breed of machinery. But first let us diverge a bit. Acetate jackets, popular in the fifties, have gradually given way to genuine microfiche, paste-up fiche and the super-thin jacket. Conventional fiche is made on a step-and-repeat camera as previously mentioned, and excepting a

developing machine, requires no other equipment in its manu-
facture.

Synthetic microfiche, more popularly called paste-up fiche,
is nothing new. As far back as thirty years ago various
experiments were attempted in this form of utilization. Some
few reached the market with varying degrees of success, or
perhaps we should say failure. In at least one case film was
literally glued to acetate sheets. Later strips of 16mm film
was literally glued to acetate sheets. Later strips of 16mm
film were bonded together at the edges and became a card.
Like a topless waitress, there was no visible means of support.
And like a tired one, the card wasn't very rigid and sagged.
More recently a method has been developed for a flow camera
to produce normally spaced images on a roll for a predeter-
mined length, say 6 inches, then skip for perhaps a half inch,
and then resume the normal filming for another 6 inches and
then a space, and so forth. The film is then cut into strips 6
1/2 inches long and fastened to a sheet of acetate with a 6
1/2 inch width. Adhesive on the lateral edges of this sheet
hold the strips in position. Six inch duplicates can then be
made from the master, and the position or composition of the
adhesive is not critical as it is not in the picture area.

The most successful of the synthetics to date has been the
Microfolio system. Physically, it bears a similarity to the older
Microtape concept with two notable exceptions. Whereas
Microtape starts with a card stock base on which 16mm paper
contact strips adhere, making it an opaque in every respect,
Microfolio starts with a clear sheet of acetate to which is
attached 16mm negative film strips, resulting in a trans-
parency. Thus we have on one hand an opaque positive, on
the other a transparent negative. There is one other basic
difference: Microtape uses a pressure sensitive adhesive over
its entire rear surface, Microtape has optically clear adhssive
only on its edges, well outside the image area.

As microfiche, both real and otherwise, came into

ascendancy, the jacket boys started worrying. The market for their acetate jackets seemed quite likely to evaporate. Their concept was good, they thought, this protection of film from external abrasions, and furthermore they had a lot of jacket making equipment sitting around that they didn't want to sack. So what could they do? Something that seems obvious now, but didn't at the time. Microthin jackets. Something that would protect the film as always, but allow card-to-card duplication. At first, it didn't look like too good an idea. The jackets were flimsy, they had a tendency to become unglued and let the film fall out, and the resolution of duplicates was nothing to crow about. But they managed to solve all these problems, and now have a very competitive product.

So we can now return to our primary subject and discuss those products we might call for lack of a bigger name.

Ancillary Equipment

Micro-folio Adhesive Applicator and Film Mounter: In the manufacture of Micro-folio's paste-up system, it is necessary to have the applicator which places a narrow strip of 1/16 inch wide double sided adhesive on the outside edges of 16 or 35mm films together with a plastic backing. This backing is necessary to prevent the roll from sticking together after the adhesive has been applied, and the mounter removes this backing as the film strips are positioned on the acetate sheet.

NB Reader Filler: Since it is difficult to hand load a Microthin jacket, this is a handy gadget to have around with the jackets. Aside from this the NB people have been pretty considerate and no other equipment is required to produce a completed jacket. The unit also incorporates a viewing screen, so verification is possible as the film passes under the lens on its way into the jacket. The jackets, by the way, are sometimes called rather paradoxically microfiche jackets.

Rewinds: If you have a roll-to-roll printer or a large processor, or even if you simply have an inspection bench,

you must have some means of tranferring film from one reel to another. If you want to cut out a small section of film from the middle of a hundred foot roll, you can unreel it by hand and let it spill all over the floor, but that's messy. A pair of rewinds does the trick neater.

Film Editors: An editor or inspection bench is nothing more than a pair of rewinds mounted two or three feet apart with a recessed light source between — usually an opal section of plastic with a florescent light beneath it. Film can be transferred from one reel to the next and checked with a magnifying glass at the same time. Cost is nominal.

Splicers: A splicer joins two ends of film by any one of three methods. The first type trims each end to the correct length while holding them in place with a 1/10 inch overlap. The emulsion is scraped off one section with a razor-like device. A special adhesive is applied, the two sections snapped together under tension, and in less than a minute you have a bond. The equipment is cheap, and has been in use many, many years. Another splicer substitutes a wrap-around plastic tape, which is optically clear and coated with a pressure sensitive adhesive. This method is more rapid since the scraping is eliminated, but certainly no cure-all.

The most sophisticated type is the butt-weld splicer. As the name indicates, the unit electrically welds the two ends of film together. When they solidify, they are bonded.

Aperture Card Mounters come in three degrees of auto-mation; hand-operated, semi-automatic and automatic. Prices vary accordingly. Despite our pushbutton society, the manual models are usually quite adequate if the requirements do not exceed a few thousand a day. The operator removes the glassine insert from the card, places it in the unit, centers the image and finally pulls a lever which cuts the frame and mounts it in the window at the same time. When positioning is critical, as in DOD work, the semi-automatic type unit is preferable, as it contains a projection screen with arrows that

allow more exact positioning of the film. However, the only thing automatic about it is that instead of pulling a lever to manually activate the cutter and mount the film, it is done electronically by pressing a button. A somewhat higher production rate is possible, however.

The automatic mounters go further. The glassine is removed by the machine which accepts a deck of cards at a time, but the actual centering of the image is in most cases still performed by an operator.

Densitometer: These are wonderful gadgets, and an absolute necessity for critical work. However, for the average inplant installation, even a large one, they often end up by being displayed as a status symbol and seldom used. Any plant which has a really operational quality control section though needs a densitometer, and you can rest assured, if DOD work is being performed, the densitometer comes into constant play.

After these rather contradictory statements, it might be well to explain what the densitometer does. It determines the degree of opacity of some selected section of the film, usually either the background of an engineering drawing or the background of an unexposed section of the film. This degree is translated into a numerical band of .00 to about 4.00 in increments of .01. In microfilm we are principally concerned with the range from .06 to 1.8. Anything lower we won't find, and anything higher will (in all probability) be reject material. Physically a densitometer is a light meter coupled with a light source and lots of electronics in between. It reads this degree of opacity or simply density to enable the quality control department to maintain certain standards. It has been determined, and by smarter people than you and I, that a background density of 1.1 of the film will insure maximum readability and reproducability.

Film Cleaner is a term used loosely to include all equipment which treats film; cleans it, preserves it, rejuvenates it or

what have you. Microfilm people are for the most part a reticent breed. There is no way to determine the total amount of money on new micro-film equipment for any one year as the manufacturers are particularly jealous of the dollar volume and do not want to disclose anything to their competitors. Similarly, the specific chemicals used in any of the above mentioned processes are not included on the labels. Thus we suspect, perhaps unjustly, that not only is the formula secret, the cost of the ingredients might be modest in proportion to the resale price. Nonetheless, the results in certain instances are no less than remarkable. One manufacturer markets equipment and solutions that really minimize scratches. I say minimize advisedly as there is patently no product that can remove scratches. If the scratches are on the emulsion side and the emulsion itself has been scraped away, this process is useless. But where they are on the base side or if the scratches are superficial on the emulsion side, then this product can produce excellent results. This is accomplished by physically filling in the rills with a colorless substance which hardens and presents a flaw-free surface. When reprinted, the abrasions become even less noticeable.

Other treatments include removing all surface dirt from film, treating it for the prevention of "measles," rendering brittle film pliable again, and toughening or making it scratch resistant.

Automatic Cutters are handy devices for cutting rolls of paper or film into sheets, and are particularly at home in Copyflo production or Atlantic's card-to-roll printers. A small blip on the edge of the paper or film signals the cutter to activate. This blip appears on every frame as part of the photographic process.

Static Dust Eliminators: Dust is a prime enemy of microfilm as it is of all photography, but for some reason or other the consumer end of the industry has taken a rather lax attitude towards it. True, there are some installations with

dust free areas, and employees as well as visitors have to don lint-free coats before entering, but by and large the presence of dust is simply deplored and nothing much done about it. There are quite a few respectable electrostatic dust removers on the market designed, for the most part, for other photographic films but which are still adapted to microfilm use. These consist of three working parts; an element that induces an electrical charge on the dust particles that makes them lose their affinity for clinging to the film surface; a camel's hair brush that physically sweeps the dust off the film; and a vacuum air source that carries the dust particles away, hopefully not to return.

Hypo Test Kits are a necessary adjunct for the performance of DOD work. The kit consists of a multiplicity of test tubes, beakers, graduates, funnels, bottles, burettes, and a "viewing box" for comparing the turbidity of the fluids in test tubes, as well as an initial supply of chemicals, Not included in a kit but equally essential is a set of scales for weighing the chemicals plus an encyclopedia for converting troy measure into avoirdupois, liquid into dry, grams into ounces — and last but not least a pharmacist's coat for that professional look. If you fancy yourself in a Dr. Jekyl-Mr. Hyde role, you'll love the *melange*; otherwise, you'll be somewhat revolted to learn that all the chemicals when mixed into appropriate solutions have a very limited life, and most probably you will have to mix up a new batch for each test.

Without going into any further detail, this set enables you to find out if your processor has washed away most of the hypo. After performing this rite a few dozen times without a failure, you start wondering is this test really necessary. It is.

Of course there are many other machines and instruments used in the industry, but they are not peculiar to it, such as microscopes, filming equipment, random retrieval units, silver recovery machines, etc. There are still others that are strictly

accessories. Space simply doesn't allow us to discuss these here.

FILMING

Microfilming is not an aesthetic trade. It is all business. Once I foolishly hired a young fellow who had spent several months at a New York photographic school learning how to take artistic pictures of still lifes, nudes, pastorals and what not. He showed me evidence of his talents by displaying a series of huge enlargements, and felt sure microfilm was just as challenging. He lasted less than a week. The mundane job of snapping pictures of newspapers as rapidly as possible did not appeal to him. And my idea of "beauty" simply baffled him; there was nothing pretty about an enlargement of an engineering drawing. To me if it was razor sharp, had a pure white background, and all the fine lines had been retained, it was a work of art.

Most people haven't the foggiest notion about what goes on in, let us say, a microfilm shop. When I casually say we film about two hundred thousand plus documents a day, they are absolutely dumbfounded. They have visions of people running around like mad, each with a Leica, snapping everything in sight. They don't know that a single camera with an automatic feed is capable of filming 600 or more checks a minute, or theoretically 30,000 an hour. They look crestfallen if we tell them this, unless we hasten to explain that most of our documents are hand-fed, that the camera's capacity of 600 per minute is only for small documents such as checks, and that no one can keep a camera operating at this speed. The checks have to be loosened up (if stored for any length of time), the staples removed, inserted into the automatic feeder and removed from the tray after filming, the camera reloaded, all of which slows the output down to a fraction of

the capacity. After telling our friends this together with a few more details they can understand why we employ about eighty persons, and still are unable to produce close to a million images a day. You'll understand too.

Very often I am asked how long it takes to train a microfilm camera operator. If she's to run a 16mm flow camera, I say she can receive enough instruction in fifteen minutes or less to start shoving documents down the camera's throat — but she cannot be considered a really trained operator in less than a year.

It's not that it's so difficult to learn this one small facet of the art, if you can call it that. The trouble is an operator should be taught the rudiments thoroughly — and to hell with the details. A filmer who can hand feed 15,000 or more 8½" x 11" documents through a machine in one day's time has little time to make decisions or for that matter to even think. But new little problems have a habit of cropping up from time to time, and she has to be sufficiently alert to spot them, leaving it up to the supervisor to suggest the solution. Unfortunately lots of semi-skilled operators make the most costly blunders because they start thinking when they are not yet qualified. And the training of personnel for 35mm planetary work is an even longer chore as the odds of making errors in judgements vastly increase.

As a sort of side issue, you may have noticed that I constantly refer to operators in the feminine gender. Despite the Ecu Opportunity Champions, we employ female operators exclusively for 16mm flow camera work and for the most part on 35mm planetary camera for simply one reason: they are more adapted to this type work. No tangible reason, but you might ask your friendly psychiatrist.

Of course not everyone is suited for camera work. I recall the time a grease monkey down at the local filling station asked me for an interview. He was a nice kid but definitely not operator material; still I didn't have the heart not to hear

him out. So the next day he appeared at my office, all cleaned up. As kindly as I could I told him that he simply was not suited for, lets say, filming newspapers. If we needed a service man, yes, but we didn't.

I ended up my reasoning rather stupidly. "You know, George, I think you'd be very handy with a wrench or a screw driver, but turning pages on a newspaper for filming has to be done gently, so they will settle down and not move while the shutter snaps."

"Oh, Mr. Mann, I can do that," he quickly countered. "I read right many of them comic books. And," he licked his thumb, "I can turn the pages on them books just as easy," And he delicately turned an imaginary page.

While we have no intention of turning this chapter into an operator's manual for the various types of equipment, we would be derelict if we didn't point out some of the obvious pitfalls as well as explain the normal operations.

But before we start on filming, we must perforce mention that which goes before, the dark before the dawn: preparation. Many pamphlets on the subject have been published and quite rightly for this can often be the most costly part of any project, and if performed correctly can successfully eliminate many errors from showing up in the final product. Too many service organizations have gone bankrupt from underestimating this particular segment of the total cost. On the other hand quite a few projects have been scrapped because the estimator was too cautious. It's rather disconcerting, to say the least, for any office manager or department chief to be told that he can have his office records filmed for X dollars per thousand images, and while he is mentally approving such a reasonable figure, be told in the next breath that the cost of preparation will be 2X.

If documents are old, fragile and dog-eared, if they are only partially in correct sequence, if frequent index points are necessary, if the pages are folded and loaded down with paper

clips, the preparation cost could conceivably be even three times the cost of filming. Preparation then deserves careful attention from management with the view of keeping the cost within reason.

Let's get on to the filming process, commencing with 16mm flow cameras.

First of all, the position of the document; how is it fed into the camera? This may seem elementary and obvious; yet you'd be surprised how often the positioning is incorrect. The most natural and so consequently the correct way for you (unless someone told you differently) is to hold the document just as though you were reading it, and then drop it into the hopper. This results in what we call somewhat arbitrarily vertical or cine format; that is the copy runs at right angles to the edge of the film. Another way of explaining it is this: if you hold a strip of the processed film in a vertical position, the pages would be in the correct position for reading. Sometimes this vertical format is correct, but the more usual method is to turn the copy sideways for filming, referred to as horizontal or *comic* format. Some of the occasions when you should film vertically follow:

Take the legal size documents. These must be filmed vertically as most cameras won't accept them any other way (unless the camera has a 14 inch throat — a rarity today). Also, if you wish to use as little film as possible, you film vertically 3 x 5 inches, 5 x 8 inches, cards and checks — any document whose breadth exceeds its height. If the filming is done primarily for reproducing via Xerox Copyflo, the same applies, as the less film you use, the less paper is required. A rather unusual reason for vertical filming is when the reading equipment is so constructed that this is necessary. Generally speaking these readers are old and obsolete and have been replaced, but since the initial filming was done vertically, the department may wish to continue the same way. In one more instance the dimensions of the documents themselves may

determine the format. If one has a conventional camera, an 11 x 14 inch document may be filmed only one way, regardless of the direction the copy runs. Even if one is fortunate enough to possess a camera with a 14 inch throat, a 14 x 20 inch sheet can only run one way.

When filming is being performed with ordinary 8 1/2 x 11 inch copy, the normal procedure is to place the document sideways, with the top of the sheet to one's right. This results in what we call normal *pagination*, the documents appearing on both the film and the reader in this order:

Beginning 1 2 3 4 5 6 7 8 9 10

Sometimes there is a reason for filming with the top of the page on the operator's left. This results in pagination which is not the norm, but still quite acceptable. Thus:

10 9 8 7 6 5 4 3 2 1 Beginning

This method becomes quite confusing though when two pages of a small pamphlet are filmed together. The results are horrid, as the limerick goes, no chin and no forehead, thus:

9 10 7 8 5 6 3 4 1 2 Beginning

Upside down? Hardly ever, but in this business anything's possible. Suppose (and this is something not too unusual) you have been presented with a hundred thousand invoices, all of which are in numerical order, but unfortunately in reverse. Invoice No. 1 is at the bottom of the pile, and No. 100,000 is on top. Since you are conscientious (and don't say, well that's the way they gave it to me, and that's the way it's going to be filmed) and want to film in proper sequence which makes searching much easier, you put on your old-fashioned thinking cap as you realize the computer can't be of much help here. Since the cost must be kept down, you can't afford the time to re-sort. We assume you have it all figured out, so you take a pile from the bottom of the stack and place it face down and upside down on the camera apron. You tell the operator to pick up the first sheet (which is No. 1 of course) by the edge furthest away from her, turn it over and drop it in the

hopper.

Any other format? Perhaps. Several years ago while being toured through the now defunct American Microfilming Service plant in New Haven, I noticed several stacks of what looked like round documents with charcoal burned edges. You see some mighty peculiar sights in the service business but this was a new one. I inquired.

"Well," said Henry Maguire. "Funny thing about those. Fresh out of a fireproof vault. This bank customer of ours was having some welding done in his vault, and the welding company put up a sure-fire asbestos curtain to keep down any possibility of sparks while the welding was going on. Turned out the curtain was sure-fire but not asbestos. It burned and so did everything else. These, and he pointed to the round piles, were valuable. This is what's left. They can't be handled but one more time. So we're filming them and they can look at them as often as they want. At least at what's left of them."

I forgot to ask him the format. Circular? Which reminds me of another story. The engineering section of a city water department wanted to talk about filming some of their multitudinous records, so I thought it would be nice to take along a young embryonic salesman for a good foot-wetting (no pun intended again). Anyway this young man, we'll call him Bill Jones, got right into the act. The chief engineer put him at ease at the start by asking how did we charge; by the ton? He then among other things, produced some circular graph forms that showed water flow per hour at certain pumping stations. Again I never got to the format question because pretty soon Bill, impressed by the huge quantities of form, blurted out: "Chief, what you need is a good fire!" Poor Bill Jones never got very far.

Which brings us to reduction ratios and the choice thereof. This presents no complicated problem, because the lower the ratio, the better the image quality. So one automatically

selects the lowest ratio consistent with practical economics, unless factors other than quality and cost are more important. This happens all the time. Then one compromises. Typical examples would be when the filming must be done at a ratio compatible with the viewing of printing equipment that's to be used; or when the salvaging of space is the dominant factor; or when the filming must be compatible with a Copyflo machine. One doesn't film at 16x when the only available reader will have a 40x blowup, or vice-versa. And although the Copyflo provides for a wide choice of enlarging ratios, the choice is not infinite.

Unfortunataly, high reduction ratios in the past few years have been used more and more frequently as a sales gimmick; ratio is to microfilm what horsepower is to the automobile and tape speed is to the recorder. Every time a manufacturer introduces a new model, he proudly announces there has been a change in the reduction ratio, and the buyer will be able to more than pay for the new machine with the film savings. How else can one sell a replacement camera? From George McCarthy's 20x camera we have progressed to and through 23x, 24x, 25x, 28x, 32x, 35x, 37x, 40x, 42x, 44x, 45x, 48x and by the time this book appears in print maybe lots more.* To make a somewhat contradictory statement, quality has not suffered, but net improvement has. And by way of explanation we add that resolution has improved to the point that the 45x of today may equal the 32x of yesterday that it has supplanted, and today's 32x may equal yesterday's 25x, but today's 24x is much better than yesterday's. The lower ratios, in consequence, are still preferred by the perfectionists and the near perfectionists, and this includes, might I add, most of the technical people in the industry.

While there is no definite absolute standard in ratios, medical records are almost universally filmed at 24x, and checks at 40x or higher, with the front and back being filmed simultaneously. Microfiche generally comes in at approxi-

*Ultrafiche of course uses much higher ratios than these.

mately 20x, although certain fiche uses 24x for the sake of compactness. Rapid retrieval systems favor 24x also. There are a few other standard ratios for 16mm film, but by and large everyone uses what strikes his fancy. This is bad, this lack of standardization, but it is not my problem or yours – at least not here.

As an aside, the number of images on a given roll of film is dependent not only on the reduction ratio, but the sapce between the images. This becomes increasingly important because as the ratio goes up, the number of spaces increases correspondingly.

And spacing brings us to the subject of camera malfunctions, all of which should be readily identifiable upon inspection of the film. Spacing can be too far apart between images or erratic – a wide space and then a few narrow ones, but no consistent pattern – or it can be so narrow that there is *no* spacing, in fact the images overlap. This is all simply a matter of a competent service man making adjustments. I am not saying this advisedly; sometimes it's not such a simple matter, and sometimes the service man isn't so competent.

Among the other malfunctions of the flow camera is one known as "a light leading edge", which is caused by the shutter opening too soon, or if it not that type of camera, by the lamps coming on too late. The opposite, when it occurs, is known as a "light trailing edge" – and the shutter closes too soon or the lights cut off early. A light leading edge, by the way, if not sufficiently self-explanatory, means the edge of the document as it enters the filming area received insufficient exposure and hence appears on the film with less density than the remainder of the image.

Then we have "stretches" and "contractions." In a "stretch" the image appears elongated and usually is quite illegible. If a document slips as it goes through the camera, synchronization of film and copy is thrown off and the copy advances slower in relation to the film with the result that the

photographic images are longer than they should be. The opposite, a "contraction," is a chopped off image – the film has momentarily failed to advance as the document is passing through the filming area.

A "hang-up" – now there's a nice little problem for you, and one that doesn't require a service man. In this case the sheet simply gets lost somewhere in the bowels of the camera and won't come out. To retrieve it is the camera operator's job. She has been instructed early in the game how this is done, and quite likely it's her fault anyway. Maybe she has overlooked the staple that is still there or the badly turned corner, or perhaps she simply hasn't fed the document in squarely, which, by the way, could also result in a "pull." This is when the page twists as it goes through with resulting image distortion. The "pull" is first cousin to the "stretch."

By and large, most problems are due to operator error. The cameras are really pretty remarkable machines and have all sorts of safety controls built in to prevent "pilot error." For instance, there is a red warning light to indicate that a lamp has gone out. If the lamps are wired in series, this means that *all* the lights go out, and if the operator continues, the film will be simply blank. Nevertheless, unobservant operators (and I am being kind) have been known to film all day without lamps. Even more difficult to understand (or forgive) is how an operator can blithely continue filming long after a buzzer has sounded indicating the film has run out.

Film often is rejected because of dirty glass guides. These guides, as previously explained, keep the documents in plane in the film area, and little scraps of scotch tape, bits of crayon or other trash, sticking to the guide, can cause a continuous light streak on the film or a white bit of paper can cause a dark streak, both of which resemble scratches in general appearance. Or, if the documents are very dirty, over-all accumulation of dust can build up on the guides. This lessens background density, affects contrast and lowers

resolution. All of which means the operator must inspect the glass guides frequently – at least once a roll.

Probably the most prevalent error (and for my money the most inexcusable) is fogging either the beginning or the end of a roll. Only pure carelessness can cause it – or ignorance. There are many more possibilities for error – endless as a matter of fact – so we can't cover them all. Some have not even been invented yet. So just a couple more.

The saddest story I can recall, and believe me there are still tears in my eyes, was the time a hospital administrator called up to advise we had failed to film the reverse sides of a certain type of document relating to obstetrical charts. We had already completed some five hundred rolls and mounted them on Micro-folio, and this news could be disastrous if true. I told him he had to be mistaken; we always filmed both sides if there was copy on both sides. After a few mutual denunciations, he agreed to send us a box representing two or three rolls. Sad to relate, when it arrived, we found not only were the reverses missing on the obstetrical charts, they had not been filmed on any of the charts. Panic seized us at the thought of refilming five hundred rolls. There is a popular song which claims it is better "the second time around". It was not referring to microfilming; it costs more the second time around. A careful investigation cheered us up a bit by pinpointing one operator as the culprit, and she fortunately had only been responsible for about fifty rolls. This girl was experienced and had been considered quite competent. But something went wrong; maybe somebody did her wrong. Anyway, she started going to pot, and we had let her go some weeks before this catastrophe. So we refilmed her fifty odd rolls. Since that time, I can assure you, inspection procedures have been revised. Up to that time it seems we had relied too much on the integrity of the individual operators. The Bible says "Put not your trust in princes", (or presumably female operators); we don't anymore.

Just one more error. The improper loading of the film unit can cause lots of trouble, one of which will result in images either walking on or off the film, or even result in half an image being filmed on each document throughout a roll.

Many years ago the service supervisor of a large equipment manufacturer borrowed the use of one of our planetary cameras to film a few dozen documents for a personal friend. This man, most competent in his field, loaded the camera himself, disdaining our help, made his shots and removed the film. We processed it - and you guessed. Beginning and end were fogged, and the images were just half on the film.

And quite recently, one of the larger banks with its own processing department received a complaint from one of its branches claiming the processing on some of the rolls they had sent in was positively terrible because the processing department had allowed half of each image to slip off the rolls. About as ridiculous as the story Pete Brulatour tells of the neophyte competitor who appeared in his office one day, unsolicited I can assure you, and said he hoped Pete would help him out of a jam. Pete, wiping away a crocodile tear or two, asked how he could help. "Well," said the competitor. "We filmed a lot of stuff for a customer at a reduction ratio of 38x and then burned the records. Our customer claims he can't read the film. Too little. Can you make the images just a little bigger?"

Now for planetary filming and its woes. Basically the same as flow, it is more versatile with a corresponding increase in error potential. One does not simply turn on a switch and go to work. Even when an operator is trained to film only one type of copy, say newspapers, a daily check list helps. For instance, on items like this: Have the lamps and light meter been warmed up? Are the lights in balance? The film unit properly positioned? The reduction ratio right? The field correct? The counter either read or zeroed? The overhead lights out? The correct voltage ascertained? The indexing and

title sheet in order? And there are a few more. This sounds simple and it is, but if just one item is overlooked, the film may be rejected.

A few manufacturers produce planetary cameras for a specific use. With these the focus, reduction ratio, aperture and pull down are all fixed; consequently they have the same limited versatility that the ordinary flow camera has but without the speed. The planetaries we have in mind are not these; nearly everything is variable. The reduction ratio can be instantly changed, the aperture enlarged or reduced by the turn of a knob, the lighting intensity varied, the space between frames altered - only the focusing is automatic. One can have automatic controls for the lighting too, but generally the operator is dependent on a light meter, a volt meter and/or experience.

But the versatility does not end here. The size of the copy may indicate that 16mm film is preferable, or it may be requested by the client. In either case, a 16mm adapter is available and the film unit can be converted in a matter of minutes. Another accessory can be installed in the film unit to allow two exposures to be made before the film advances. This allows the front and the back of the same page to appear side by side on the same frame which is useful in county recording. Still another accessory is the subsurface illuminator which allows backlighting over a 38" x 52" area. A smaller unit, using a "cold light" lamp source makes the camera suitable for filming X-rays.

Speaking of X-rays, way back in 1953 or so I received a letter from the administrator of a hospital in the Norfolk, Virginia, area, some 250 or so miles away. This gentleman was interested in filming his radiographs and we were anxious to film them for him, having made only samples up to that time. Not wishing to appear eager, I played it cool for a decent twenty-four hours before cranking up my Chevvie and heading east.

The interview went great. The price pleased the administrator (who wants to make money anyway? It's the experience that counts.); and the quantity awed me. He told his secretary to type up an order, and as he handed it to me, he remarked,

"Of course we'll be able to use our reader, won't we?"

In my excitement I had overlooded this rather essential item. "What reader?" I asked.

"Oh, the one we use in Medical Records," he said. "The one the bank gave us when they bought a new one."

"I'm sorry," I said. I had seen it earlier and it was a real dog. "That is a 16mm reader, and besides it doesn't have enough brilliance for X-rays."

"That sounds like it's going to cost me money. All right, what do we need and how much is it?" He was still quite happy.

"Mr. Bethel, you want a Filmsort X-ray Reader, the only one on the market specifically designed for the reading of radiographs, and which we have the good fortune to handle." I was pretty pleased about this. "The price? Ten Hundred and Ninety Five Dollars!"

Mr. Bethel held out his hand, a gesture I felt that sealed the deal, so I reached to grasp it.

"No," he said. "The order."

He snatched it out of my hand and to my horror quickly reduced it to shreds. That, I am afraid, ends the story.

Most people have difficulty in realizing that radio graphs require special equipment for filming, a good light source behind the film, and similarly, when viewed, the reader must have more than normal brilliance or the fine shadings in the film will not show up. In addition, the reader's screen and lens must be such that the 14" x 17" film will project on the screen in its entirety.

Life is never dull in the 35mm section, unless one specializes in certain areas only. That is the way to succeed

and make money, but it's the monotony that gets you (it's not the heat, it's the humidity). Anyway, here we're not specializing. Consequently, we learn that ordinary documents like newspapers or books get filmed satisfactorily using ordinary microfilm; engineering drawings and faded documents respond better to film having an antihalation undercoat; radiographs require a special, very slow X-Ray type film; black and white photographs or transparencies need a tonal reproducing film; and color film. Newspapers are normally filmed at approximatley 18x; X-Rays at 11x or 14x; deeds at 14x; drawings at 16x, 24xx or 30x if done to military specifications and otherwise, almost any ratio the user wishes.

Indexing seems to be the last thing an operator learns, or a salesman thinks of. And the only way to really appreciate its importance is to try to find something on film that has been inadequately indexed. We must admit that microfilm is not much use if one cannot find what one wants. Even if in proper sequence, items can be very difficult to find without index points, and random searching in a microfilm file is pretty unrewarding, if you appreciate understatements.

Once we filmed some emergency room records for a hospital in West Virginia. Their filing method was a little out of the ordinary, but no one worried about it. The charts were filed numerically by year, with the last patient and highest number on top of each year's group. Our rule of thumb is to film in the same order as filed, for there's no point in changing a familiar system. There was no reason to deviate from it in this case. So thought the supervisor, so agreed the operator, and by the time it got to the indexing department, it was too late. The labels on the boxes looked something like this:

Reel 24. 1958 Chart No. 1365 thru 1957 Chart 2450
Reel 25. 1957 Chart No. 2449 thru 1956 Chart 1642

Now, it was possible to find any given chart providing you were a genius; but are you? So we re-prepared the entire lot,

put them in correct sequence and refilmed.

Nomination for the world's worst indexing job goes hands down to a South Carolina hospital. It happened in the fifties and we were called in by the new administrator. He had discovered the hospital had been on, as he called it, a do-it-yourself program, and since they couldn't read any of the pictures, he was a little worried. When I got there, I discovered things weren't quite as bad as he thought; if one was very patient and didn't object to eye fatigue, the charts could be made out, or at least partially. But much more serious was the indexing. I picked up a cardboard box. Inside were two rolls of 8mm film (the split 16mm we mentioned earlier). The indexing information on the outside of the box was concise. "Rolls 1 & 2."

Then there is the other extreme when indexing becomes an art of its own. For instance, the Kodak Miracode system which contains digital information on the film and allows both random filming and random retrieval. This very sophisticated method, utilizing 16mm cartridges, is much too complicated to explain here. It's even impossible to explain its primary functions in a few sentences, but let's have a try and give you a vague idea what it can accomplish. The digital information that has been filmed along with the remainder of the data allows a searcher to dial (actually punch buttons) any one of a million combinations, and the unit will locate the desired page or pages in a matter of seconds, projecting the images on a screen for viewing or printing hard copies. This particular system employs the standard 100 ft. cartridge whose capacity is reduced by the space requirements of the digital information, so the net frames are normally something under two thousand. Of course, the capacity of the system is limited only by the number of cartridges that can be conveniently stored near the unit.

My favorite story about ultra-sophisticated retrieval systems, concerns Lockheed's crystal ball developed for the

Air Force, and first used in the mammoth C5 behemoth. This strange and exotic device is housed in an ordinary cabinet and installed in the engineer's compartment. The front panel contains, among other things, a small screen, a cathode ray tube, lots of flashing lights, knobs and a set of push buttons. Either in preflight checking or in actual flight, this gizmo purportedly signals on its own initiative any malfunction of the planes vital parts — landing gear, turbines, generators, brakes, elevator controls — you name it. Let's say a hydraulic pump has gone awry. On the panel a red light flashes its warning and immediately the screen provides the details. The engineering officer presses a button and the oscilloscope shows the wave pattern of the ailing pump. He presses another button. On the screen the normal pattern is displayed. He presses yet another button, and the screen displays the remedial action to be taken.

The story goes the plane is flying along and suddenly the box projects on the screen via many flashing lights that a wing has fallen off. Quickly the engineer presses the remedial action button. "Pray," says the screen.

The way this automaton gets its story across to the engineer is through microfilm. The system utilizes one 200 ft. roll of film containing some fifteen thousand frames with appropriate digital information opposite each image. Incidentally, American Telephone & Telegraph is currently using an adaptation of this system for their Long Distance Information set-up (called by them, I believe, Directory Assistance) in certain areas.

Except for the most elementary filming, the indexing is an integral part of the finished product, and the more complicated the indexing, the more it is tied in with the filming. Something becomes increasingly evident also: although the filming process itself has made tremendous strides in recent years — higher reduction ratios have lowered film costs, faster flow cameras have increased per person production, automatic

feeders have become more and more foolproof and even semi-automatic devices for planetary cameras have been successfully introduced, the preparation of documents remains slow, and the cost of indexing has rapidly mounted as retrieval systems have become more and more capable.

PROCESSING

In our parlance, a processor is a machine capable of developing or making visible the photographic images on film. In silver films it is achieved thorugh liquid chemical action; in diazo films through ammonia vapor, and thermal films through heat and light. Of course all of this is subsequent to exposure.

If the unit will handle only a few feet of film at a time, we call it simply a developing tank; if it has a capacity of 100 ft. or more, we dignify it with the name processor. The simple ones usually have a capacity of a single roll, or 100 ft., and may require more than an hour to complete the process. Others may handle in excess of 1000 ft. at a time with a speed of 100 ft. or more per minute. As you might imagine, prices for these machines vary accordingly.

Before we go into the equipment itself, it might be wise to give the actual process a quick once-over. Film after exposure is an extremely helpless and indeed useless product – of only latent value. You can dream up all sorts of similes and metaphors – it is like a foetus and needs development, or gestation, before it is ready for this world. Exposure, of course, is conception: processing gestation. Anyway, film is of no earthly use until the images are born or brought out so you can see them. Film doesn't change its appearance after exposure; indeed, Mr. Eastman himself couldn't tell a piece of raw film from an exposed section. The best we can do is to *assume* it has latent images if we find it on a receiving spool (as opposed to a supply spool). Our hopes may be dashed and it may be blank, but we can't find out unless we process it.

In total darkness (or periodically under a minuscule amount of green light), the film is bathed in a *developer*. Without going into a chemical analysis, let's say this liquid turns the silver grains in the emulsion black where it has been exposed to light and leaves unaffected the unexposed grains. After a given period of time at a certain temperature, it is necessary to stop further development to prevent "fogging." In simple words this means that if the film remains in the solution too long, all of the silver grains will slowly turn black, regardless if they have been exposed to light or not. This action can be effectively stopped by thoroughly rinsing the film in water which *discontinues* development; or dunking it in a mixture of acetic acid and water which *neutralizes* development.

At this point the image has been brought out, but if exposed to light for any length of time will quickly fade out. Furthermore, the film is milky looking or, as we say, not "cleared." So, it is immersed in an acid solution, called hypo or fixer, that effectively clears the film and "sets" it for permanence. But we still aren't through. If this acid solution which has embedded itself in the emulsion is allowed to remain, the image will slowly deteriorate, so we must wash the film until these chemicals are removed. This can be accomplished simply by prolonged washing, or the span can be shortened materially if the film is first immersed in a "hypo eliminator," which neutralizes the acid fixing solution and seems to make it lose its affinity for the emulsion. Now the process is complete except for drying. Film can be air-dried, but if heated and filtered air is passed over the film in a dry-box, only a fraction of the time is required, not to mention the elimination of the dust hazard.

Mind you this entire process is very, very carefully controlled. The temperature is critical, particularly in development, and a first class processor will maintain the temperature within a plus or minus $1/2^\circ$ range. There is a very definite

temperature-development time relationship; the higher the temperature the shorter the development time and vice-versa. Consequently, the development time must be carefully monitored, and kept within a tolerance of a second or two. The other baths are not so critical. There is a minimum time requirement rather than a maximum, and the temperatures may vary as long as they remain within a few degrees of developer's. Dry box temperatures are subject to a little more scrutiny; the air should be hot enough to thoroughly dry the film in the allotted time but not so hot as to cause warping, curling or brittleness.

Processors are divided into three general types: rewind, spiral reel and continuous. Although excellent results can be obtained with all four, the last mentioned or the continuous is by far the most popular. One might safely say that 90% of all microfilm is processed in a continuous processor; maybe even 99.9%. Nonetheless, we'll give you a brief run-down on the first three.

The rewind unit consists of a light-tight tank in which two 100 ft. or larger acid-resistant reels are suspended. These shafts are driven either by hand, by a hydraulic motor or by an electric motor. The film, previously loaded on to one reel is wound on to the empty one until full when the movement is reversed. The reels are submerged in liquid; first the developer is poured in and the film wound back and forth from reel to reel for a predetermined time. The developer is then rapidly poured out through a light-tight spout and replaced with a stop-bath. The cycle is then repeated for a fixer, the hypo eliminator (if desired) and the final wash. The film is then wound on large wooden racks for drying.

The spiral reel is the old cumbersome reel-and-tank made compact. Only ten inches or so in diameter and less than two inches wide, it nevertheless accommodates a 100 ft. length of film, and keeps the film separated by means of a narrow track. Procedure is the same as reel-and-tank but very little

space is necessary and only nominal amounts of chemicals.

Quite creditable work can be performed by either of these methods. Scratching and abrasions to the sensitive film is all but eliminated, but rigid control over time and temperature is difficult to achieve, since all chemical changes are manually performed. So we pass on from the high labor cost processor to the automatic or continuous type.

As the name implies, the continuous processor feeds a ribbon of exposed film through a system of rollers from one end of the machine to the other. At the beginning we start with a large reel consisting of several rolls of exposed 100 ft. film that have been fastened together with stainless steel staples, and at the end we have a similar reel with the film completely processed and dry. It has passed through successively a series of tanks, each containing a specific chemical or water and finally a drying box before being rewound on the take up reel. All of this of course has been automatic.

There are two sets of rollers in each tank, one set at the top above the solutions and the other at the bottom of the tank. These rollers are flanged so the film cannot slip or climb off. If a tank has two rollers at the top of a single shaft and one on the bottom shaft, the film makes one complete pass — down, back up and out. If there are four rollers above and three below, three passes are made. The more rollers then, the longer the film remains in the solution. The depth of the tanks also affects the length of development; as the distance between the top and bottom sets of rollers increases, so does the travel time. In many processors, the bottom set of rollers can be raised if desired, thus shortening the length of pass. The third method of controlling the time of processing is the speed the film is being transported. This, on most machines, can be varied considerably by means of a rheostat on the motor or a variable gear box on the drive.

How many tanks are required? Or, should one say,

desirable? A dry tank or "elevator" should be No. 1. Of course this is really not a tank, although some processors make it water tight so it may be used optionally as a pre-rinse tank. The elevator, by the way, works on the "block and tackle" principle and it serves as a reserve supply of film which allows the film to flow uninterruptedly through the tanks while a new reel of film is being spliced to the end of the old one. Next comes the developing tank followed by the rinse or stop. Tank No. 4 is the hypo tank followed by a water rinse with No. 6 holding the hypo eliminator. Finally, there is an oversize tank with spray nozzles for the final wash. Now it is humanly possible to eliminate all the tanks except the developer, hypo and final wash, but it certainly is not desirable. After this final wash, the film passes through a heated dry box (forced hot air, infra-red or dry heat), winds up on the receiving reel, and presto, we are through.

Every 100 ft. roll of film has about 3 ft. of leader or blank film on either end to facilitate handling. In a processor, leader is employed in an even more important function. Physically, the leader is usually clear polyester or acetate which is gray on one side and black on the other. Either type can be readily distinguished from the film to be processed. While some machines are either self-threading or require no leader at all, the usual unit has to be threaded, and with perhaps a hundred feet or more of leader. In operation, the exposed film is attached to the end of this leader and dutifully follows it through the machine. At the end of the film to be processed there has been previously attached another section of leader, so that when the run has been completed, the machine will be still threaded. If this procedure were not followed, the processor would have to be threaded each time it were used. Similarly, if a faulty splice results in the film separating from the leader at either end, the film runs out and rethreading is necessary. This can consume an hour quite easily and is considered the most odious job in all the

processing department. The reason is plain; it shouldn't have happened in the first place. Somebody goofed.

On examining a good machine, the novice will be greatly impressed by all the gleaming stainless steel and watch in fascination as the nylon rollers smoothly drive the film on its tortuous way from one tank to the next. He may observe the vast amount of electronic gear — toggle swtiches, rotating knobs, wiring circuitry, motors and relays. Unless he is deaf he will notice the constant popping of relays. He may also wonder if it is necessary, and for a gizmo to be so complicated and cost so much.

Well, a processor is not an easy thing to design, or for that matter, to make relatively foolproof. Just two illustrations: Remember the temperature variance of only $1/2°$ in the developer tank? This is maintained by a built-in refrigeration-heating system. Ultra-sensitive probes read the temperature. When the heating element raises the solution to the desired temperature the refrigeration unit takes over; a few seconds later the fluid has lost enough heat for the heating unit to take over again. Some moments later, the refrigeration compressor starts up as off goes the heating element, and so on. That accounts for the relay popping one hears.

Another little item: film, as you might imagine, expands when its gets wet and lengthens. Consequently, if all the drive rollers in the unit ran at a uniform speed, some tanks would soon fill up with film, causing a jam. So a system of overdrive and clutches was developed to take care of this expansion, and then contraction as the film dries. Some rollers travel faster than others; actually the top shafts of each tank rotate slightly faster than the preceding tank's. This not only takes up the slack between tanks but keeps the film under a slight tension. To calibrate exactly the correct speed for each set of rollers is impossible; consequently they are all designed to rotate slightly faster than necessary, and slip clutches on each shaft maintain the proper tension.

Only a few years ago, all processing was performed by the various film manufacturers for their customers, and to a more limited degree by service companies, mostly for their own in-plant film. However, with the increased use of microfilm as an active tool came a demand for self-performance which included not only filming but also processing. The demand really was for instant microfilm; and this was one step in that direction. Compact units requiring only a half dozen square feet of floor space appeared on the manufacturers shelves (or floors) and several desk top models quickly followed. Like other office equipment such as the typewriter, the adding machine and the calculator, these office-type processors are pretty sophisticated. The operator can be abysmally ignorant of what goes on inside the contraption and still turn out first class film. The only trouble is trouble; it occurs once in a while even in the best regulated of families, and when it does, a working knowledge of what has happened and why helps.

On the other hand, while total ignorance may give an operator a false sense of security (I don't know what's wrong with this damn machine; why should I?), a little knowledge, as the old adage says, can be a dangerous thing. The individual responsible for production in a good size laboratory should be a thoroughly trained technician; he should pass this knowledge on to the actual operator or operators. Sometimes only part of this information filters through. Read the sad story that follows.

Possibly the first thing that anyone connected with photography should learn is that film is sensitive to light. As a matter of fact its so obvious that it would appear unnecessary to even tell anyone; in fact, it should be an insult to their intelligence. The operator then learns that print film can be safely handled under a red light, and consequently can be observed while it is being developed; negative film must be loaded in total darkness. Although most processors are constructed for daylight operation, the cover over the developing

and short stop tanks may be easily removed — for maintenance or simply to observe the positive film as it is being developed as there may be some reason to change the speed of the processor to compensate for exposure errors.

Once several years ago (and of course while we were in the process of changing brands of negative film), my attention was drawn to the fact that the new film had a much higher background fog than our regular film. In simpler terms, it was grayer. Consequently, our quality control department was quick to condemn the new film. Since the new film had equal or better specifications than the old and was materially chaper at the same time, I wasn't quite so willing to condemn it without at least a thorough investigation. I instructed processing to hand develop a strip of the new but unexposed film and similarly a strip of the regular film. The base density of both were the same, well within tolerances. Something was wrong. The tests had been rigidly controlled: 5 minutes development at 68°. Our basic processor temperature was 82° with a corresponding drop in development time. The supervisor suggested the new film was allergic to this elevated temperature. I suggested one more test; run through the processor two more strips of unexposed film, one from each batch. *Both* films showed up with high base density! We were getting somewhere, not far but we were at least localizing our problem: it must be in the processing. Normal procedures were being followed scrupulously, the operator insisted, except special care was being taken to observe that everything was normal.

Clutching at straws, I thought maybe the stop solution was not being changed frequently enough. This condition had occurred once before, and we knew it could cause fogging. So I left my office and went through the light trap into the processing room. Two machines were running, and the red light was on. After a moment my eyes adjusted themselves to the dim illumination, and I could see the covers of both

machines were off. In one minute I could see the images of 35mm positive film standing out against a yellowish background. Good. The other, to my horror, was 16mm and dark — 16mm negative! The red light of course was causing the fog. "Well," said the operator, "I knew negative film has to be loaded in the dark, but no one told me it has to be *developed* in the dark."

The moral is twofold, I suppose. One should properly instruct a technician, and the other is one shouldn't make judgments casually.

Back to the processors themselves for one more glance. The faster ones generally have a *replenishment system*. All chemicals have a limited life, in small part due to oxidation but largely due to exhaustion. A given quantity of developer will give out after a certain footage or film has passed through it. Furthermore, its efficiency is affected from the start; the latent image will not appear as quickly on the thousandth foot of film as it did on the first. Hence to compensate, the speed must be gradually slowed down as the film advances, or the developer must be constantly replenished to keep it at full strength. This latter is much the preferred method. Through a calibrated meter, replacement developer is fed into the tank, and the chemicals can be used for thousands of feet before changing. The same applies for the stop and hypo tanks.

The hypo, in addition to replenishment, can have its useful life extended by utilizing some form of silver collector, usually an electric precipitator, which removes the recoverable silver. Silver, these days, can be disposed of at a handsome profit.

Just as important an accessory is the squeegee. In fact like the windshield wiper on a car, it can hardly be classified as an accessory; it's virtually a necessity. There is a noticeable carry-off, or transfer, of chemicals from one tank to another as the various liquids tend to cling to both sides of the film. Without replenishment, the level in the developer tank, for

instance, will get lower and lower as the liquid is carried over into the stop tank. This would weaken the solution, which in turn would contaminate the hypo tank, and so forth. The squeegee can minimize this carry-off and contamination. Whereas, it is optional, and hence an accessory, for the first few tanks, when the film finally emerges from its final wash, the squeegee becomes a necessity. All excess moisture must be removed so that the film can properly dry, but the squeegee performs an even more important function; it helps to eliminate any water spots on the film.

The squeegee may be two thin rubber blades, like miniature windshield wipers, opposing each other and barely touching. The excess moisture is removed as the film passes between the blades. The same can be accomplished with a pair of damp sponges. The most effective and popular type, however, is the more sophisticated air squeegee. Two small pipes with longitudinal slits something under two inches long face each other about a half inch apart. Compressed air is driven through these slits which are slanted slightly away from the direction of travel of the film. As the film passes between the two, without touching either one, the surface moisture is literally blown off. Which type is preferable? The air squeegee. If properly mounted, it neither scratches the film, wears out or becomes soggy.

We are now ready to study for a bit the actual operation of this most important piece of equipment. What is the function of a processing department and its objective? To produce a uniform product, free of blemishes and capable of meeting archival standards. We may have the best machine made, but the man (or woman) who runs it has to be pretty good too.

Uniformity should be quite simple. If the same temperature is maintained day after day, the processor run at the same speed and the replenishment rate correctly calibrated, the film produced should be of uniform density

and contrast. What can go wrong? Plenty.

Some small plant operations have a relatively simple job of accomplishing this uniformity. They use one size film, let us say 35mm, and this film is negative. They have bought the same film from the same supplier for years. They have a strict routine; filming is performed in the morning only, and processing takes place the following morning. These operators can be blissfully ignorant of all the things that can go wrong. Take for example the other end of the spectrum, a large service organization. This firm consumes internally 16mm negative, 16mm positive, 35mm negative, 35mm positive. Each one of these products requires a different rate of replenishment, but unfortunately the service company either does not have four processors it can allocate to each type of film or it is impractical to do so. To further complicate the problem, the films of more than one manufacturer are used, and the chemical reaction of some of these films on the developing solutions may vary, necessitating different replenishment rates. Even more, the company processes film from outside sources, which may be from still another manufacturer. If this isn't enough, microfilm possesses a pecularity called "latent image fade", meaning that freshly exposed film processes darker than film that has been in transit or simply lying on the shelf for a few days. We'll go into more detail on this particular problem in another chapter.

If all of this is taken into proper consideration by the department and the proper allowances made, there's not much left to do to achieve uniformity; just observe temperatures, speed and replenishment. Consistency can be verified by running what is called a "strip test" at least once a day. This consists of cutting a short strip from a roll of pre-exposed film with known densities, and splicing it into a regular run. This test roll, which incidentally is kept in a freezer to prevent image fade, and even so should be used up within

thirty days, has been made under very carefully controlled conditions so that if developed *properly*, the background density in the image area will be 1.2. If the densitometer reading is 1.3, the temperature is too high, the speed too low, or the rate of replenishment is excessive. If the reading is 1.15, the reverse is true. Since temperature and speed should never change, the key is the rate of replenishment.

There are many blemishes that may be found on microfilm, but ones that are readily apparent are water spots, scratches, edge abrasions and simply dirt. Water spots are rare, and when they do occur, simply show that the squeegee is not working properly. They will disappear on rewashing. Unfortunately scratches are considerably more serious and can't be washed away. Scratches can come from many sources, but in a processor generally — but not always — they occur when the film for some reason gets untracked, or walks off a roller. This may be caused by the machine, such as improper tension on a clutch or a frozen bearing, but more often it is the handiwork of the technician; a faulty splice. Sadly enough, if the faulty splice is at the beginning of a long run, and the film gets untracked, all the film will be scratched from that point on. These scratches are very nearly impossible to detect with the naked eye; and this means that each succeeding run will have scratches too — until observed and corrected. It is good practice for the operator to check the last few feet of every run with a magnifying glass, and do it immediately. The fact that scratches, unless on the emulsion side, detract more from the aesthetic appearance of the film than from its legibility doesn't help much. No one wants scratched film.

Abrasions on the edge of the film are equally annoying, and significantly harder to cope with as some processors, even the most modern and expensive, seem to love chewing on film edges. The drive rollers as well as the idlers on most machines are beveled, particularly if the unit is a combination

16-35mm machine, so all of the traction is on the edges. The result: abrasions, unless the degree of tension on the film is absolutely correct, which it never seems to be. These abrasions are often called, if one is kindly disposed, chicken feet.

In addition to water spots, scratches and abrasions, the processor is capable of impregnating the surface of the emulsion with dirt particles. I use the word impregnate because they cannot be removed with a camel's hair brush or often with film cleaner. Although replenishment makes chemicals last longer, it does not prevent sludge and other impurities from accumulating in the various tanks, even when a filtering system is used. Hence it behooves management to see that these chemicals are changed periodically. The spots can often be removed simply by running the faulty rolls through the entire processor again — this time with fresh solutions. Simple dust that can be brushed off can be quite annoying, and can be minimized by keeping clean filters on the dry-box air intake, and of course keeping down the dust level in the processing department.

Lastly, we come to "processing according to archival standards." All first class processors have more than ample facilities for removing excess hypo. There is a rinse, followed by a hypo eliminator, and then a final wash. Just the final wash without the insurance of the other two should be sufficient. So what can go wrong? Frankly, I don't know. I can only surmise. We had a job rejected once but only once for residual hypo, and I can assure you it was most embarrassing. Also pretty bad. Out of some 65 rolls, hypo was detected on 30 odd. Of course, all we had to do was rewash the questionable ones, but that didn't explain anything. We finally decided it had to be operator error; there didn't seem to be any other possibility. Maybe the operator simply forgot to turn on the wash water, and either never knew the difference or didn't care enough to rewash these

particular rolls. Or maybe the hypo eliminator and the hypo both were weak (hardly likely), or, for one reason or other, the film was run through at an accelerated speed and hence wasn't in the wash long enough (not very likely either). I might add that since that time we have regularly checked for hypo residue and never found any that didn't meet archival requirements.

Included in the processing department are the positive printer and that now rare species of bird, the manual enlarger. The physical aspects of both have been previously discussed, so here's a bit about the operation, or what they can do.

The positive printer or roll-to-roll printer is an amazingly rugged piece of equipment that can produce millions of feet of beautiful print film. And as long as the master and copy film remain in perfect contact through proper tension, as long as the light source is functioning, as long as the drive mechanism together with the brakes and clutches drive the film smoothly, one can expect excellent results. Most printers can be modified to accept contact paper or direct negative film as well as positive. Dust is the bane of the microfilm industry and nowhere is this more evident than in the dark room. If the negative film is not clean and free of dust, the results will be pretty spotty in more ways than one. This is particularly true of X-ray prints. Dust may make a brain look like its owner has rocks in his head.

Enlarging by hand is now limited to strictly custom work. If absolute top quality is required, it can best be achieved with a point-source-of-light enlarger, like the now-discontinued Recordak Model B. Not only can the best resolution and contrast be obtained with this type of equipment, the projections can be made on a variety of surfaces. As for paper, one can select thin, regular or extra heavy stock; in purity the range is from 100% rag to pure sulphite; the contrast low medium or high; the surface glossy, semi-glossy or matte; and the emulsion can be on one side or both. And

if paper isn't suitable, cloth and either clear or matte (frosty) film are obtainable. Drawings can be blown back up to the same scale as the original – or it may be changed at will. Whole sections can be blocked out; in fact a whole book could be written about the versatility of the manual enlarger. Any hand operation of course is slow, but more important in this instance, it takes an experienced man to operate it.

Then we come to the "dip test," an ever-recurring performance in anyone's dark room. It's not scientific but certainly essential. This little ritual must be performed unobtrusively or it can become disruptive. This daily or maybe almost hourly incident takes place in the dark room but does not necessarily have to be performed by one of the processing technicians. Indeed, it is more frequently performed by a camera serviceman or a camera operator (if qualified). To determine that a given camera is in focus, or spacing properly, or that the copy is in alignment – in other words that everything is as it should be, a dip test will either verify or disprove the fact, and quickly. A short section of film is exposed, removed from the camera, and then in the confines of the dark room unceremoniously hand dipped into a tray of developer or, if the camera operator is on an off-premises job, in a light tight tank. After a few minutes or so, the strip is removed and dunked into a tray of water and from there into a tray of hypo to remain a minute or until it has cleared. One more pass through the water and the strip is partially dried by wiping with a sponge or a terry towel. Thus in a very few minutes it is ready for inspection. This method is invaluable for correcting camera misfunctions or confirming corrections except, and I'll repeat, *except* it is totally valueless in determining correct exposures.

Correct exposures can be determined only by *step* tests. To reiterate: the dip test is used to confirm the performance of a camera; the daily run (or strip) test gauges the calibration of the processor; the step test is used to determine the correct

voltage for any given camera. The procedure is simple, but the rules must be followed precisely. We wish to calibrate the correct voltages for different colored documents on a new camera. First we select a white document, typical of what we wish to film. From past experience we know that this type camera should require a voltage in the neighborhood of 90 for correct density. So we adjust the camera rheostat for an initial exposure of 84 volts, and note this on the document, and rephotograph it. Next we use 88 volts, and so forth until we reach 96. We then select one of the colored pages, medium blue. We make a similar run, but instead of using the 84-96 range, we commence at 94 and end with 106 as we know it will require a higher level of illumination. If there are any other colors we film these too at various voltages. After we have removed the test film from the camera we age it if it is practical. Usually there isn't enough time for patience, so we run it through the processor, noting carefully the delay between filming and processing. If it has been only a few minutes we will compensate accordingly. If the densitometer shows, for instance, that the correct voltage for the white document is 86, we set the meter to read 88, because we know if the film had aged normally it would have faded somewhat.

Some funny things happen in the processing department of dark rooms, and not what you think either. Some are not so funny. Back in those "on the ground floor days," I personally started up our processing department, and after coming as close as I could to mastering the technique, I expected to train someone else. While I was still busy training myself, I noticed that something was wrong with our newspaper film. The bottom quarter of each newspaper page came out dark, in fact so dark as to be almost illegible. To compensate I had to print lighter, and that meant the headlines came out light gray. This certainly was no way to send out film, so I set out to correct the problem. The lights on the camera bed were

obviously out of adjustment. It seems they weren't. Then, I decided, the light source in the printer must be uneven and favoring one side. Wrong again. Then I noticed when more than one print was being made from a negative, on the second run the top section was dark, not the bottom. This proved it couldn't be the camera's fault. I got desperate and called Recordak and anyone else I could think of. No one offered a solution. The positive work piled up, but I was afraid to run any. Then one day, while sulking in the dark room, I turned off the red lamp in the gooseneck lamp placed near the printer to see if there were any light leaks in the printer itself that could be causing what was now judged to be fogging. And then I had it, the solution, in my hand. The red bulb was simply too close to the exposed positive film, regardless of the fact that it was supposed to be insensitive to red. The bulb omitted small quantities of other colors of the spectrum, and one edge of the film caught these rays. All that was necessary was to move the offending lamp about two feet further away from the printer, and we were back in business.

Once, for instance, we thought a shipment of film was faulty because black jagged shafts similar in shape to miniature bolts of lightning showed up here and there on the film. This turned out to be static electricity released when the exposed film was being transferred from one reel to another. It was wintertime and we had let the humidity drop too low. This was not exactly solved but circumvented by grounding the rewinds.

Harder to pinpoint, and again while testing out some new film, was the unexplained appearance of whole fogged sections on certain rolls of film. There didn't seem to be any pattern at all, so we were inclined to blame the manufacturer. The cause, discovered quite accidentally, was one little old technician. She paused ever so often as she was transferring exposed film to a large reel and took a puff off her cigarette. Of course she had orders not to smoke in the dark room at

all, but you know, who'll ever know the difference.

We can't leave you without a word about *stretches*, and in this case we are not referring to elongated images on the film; we are referring to the film itself. First of all it's a misnomer, because no matter what anyone tells you, acetate film does not stretch. It expands a little, but stretch — never. A few years ago, it was common practice for unscrupulous salesmen and servicemen (yes, we have a few of those too) to condemn a competitor's film when a camera started acting up by saying it stretched, and that the customer would do well to start using their film, the unstretchable film. Most users today are sophisticated enough to dismiss this as hogwash. What we do call stretches, and again I say it is a misnomer, is caused by the processor and results in the film emerging with its edges crimped or scalloped. This is usually caused by too much tension on the film in the drive mechanism, or excessive heat in the dry box. Sometimes the film will simply not lie flat when stretched out on a table, and this is a manifestation of the same problem, though not so severe.

What else can a processor do to innocent film? Many other irritating things, but let's overlook them. We know one other thing it can do; and usually does: turn out beautiful film.

THE USES OF MICROFILM

Any attempt to discuss all the uses of microfilm is doomed to failure at the outset, because the field is broadening daily. Consequently, we will confine ourselves to the classic uses, the ones of more modern vintage that show promise of becoming classic in time, and we'll throw in a few oddball examples of what restless minds can produce.

Before we even get started, let's admit here and now that microfilm is not the medicine to cure all problems involving information transfer any more than is the computer, television or the printing press. Microfilm has the misfortune of being considered glamorous, and this has too often led to misapplications. Sometimes these failures have been due to the efforts of overzealous salesmen, sometimes to the pipe dreams of misinformed executives. In either case, it is most unfortunate since it's microfilm that received the bad name rather than the real villain. A competent salesman should recognize a valid use for microfilm when he sees it, and if he is in the least conscientious will steer the buyer in the right direction, even at the cost of an order.

One instance of absurdity — or impractical application if you prefer — came to us not long ago. The gentleman who requested that we call on him was charming and normal in all ways but one; he had the pushbutton syndrome. He had been delegated to purchase the equipment necessary to run the control room of a large utility's distribution system. He showed me the layout and an artist's conception of what the room would finally look like. I am sure in impressiveness it would rival the control center for Apollo rocketry at Cape Kennedy — all flashing lights and buttons and toggle switches

and cathode ray tubes and piped in music, and though I can't remember there must have been a computer or two stuck in a corner.

After the usual pleasantries and a brief tour of the neighboring offices, we settled down to the issue.

"So glad you could come," Mr. Smith opened. "Because we have a problem, and hope you are the people to solve it. We have maps here of the entire system to which we constantly refer. We also have maps of the tie-ins with the adjoining utilities. When a breakdown occurs anywhere on our system, or when we want to tap some power from another power company, we have to route and reroute the current as the case may be. These maps give us the key, and the actual switching will be done by these controls here." He pointed to the artists drawing. "Now, at present, these maps are in a book, and we have to thumb through the pages to find a designated map. We would much prefer to have the map projected on a screen, and selection made by pushing buttons. Automation sort of." He leaned back and smiled.

This we could do, simply and at reasonable cost. Nothing but rapid retrieval. Inquired about the quantity of maps that were involved, and hoped there wouldn't be too many. Not over ten thousand anyway.

He side-stepped the issue. "This is a booklet, and the maps are numbered in the right hand corner. See? And we update them all the time — might have as many as ten map changes in a single day."

The situation was deteriorating. "How many maps are there?" I asked again.

"Oh," he said, "thirty two. They're all here in this booklet. It's possible we might eventually have as many as fifty."

That did it. We could have satisfied his pushbutton mania for a few hundred dollars at most, but to do what he wanted required more than a reader with built-in retrieval capabilities.

He needed a camera in order to make daily updatings and also a processor, and either a digital retrieval outfit or some microfiche making equipment. Not to mention quite a bit of ancillary equipment, a dark-room, and some specially trained employees. For forty or fifty maps, this was ridiculous. Let him continue thumbing through his booklet; you couldn't improve on that.

Oh yes, the classic uses of microfilm.

Space Saving. When John Q. Public thinks of Microfilm, he immediately thinks of all the space that can be saved, and there he stops. But it is certainly true that the first classic use of microfilm was to save space —or in the case of the siege of Paris, weight. Using a nominal 24x reduction ratio and conventional roll film, space requirements can be reduced as much as 98%. Where all the documents are two-sided, the space saving is halved. With higher reduction ratios, even greater economies can be effected.

There are many instances where the need to conserve space warrants the employment of microfilm. With building and land costs spiralling, it becomes unfeasible to store old records in high rent districts. Even items that can be destroyed after three years can be so voluminous that to microfilm them is quite economical. So-called permanent records, those that must be retained in perpetuity, present an even more serious problem. The reason for this classification varies; it may be due strictly to custom or even sentimentality, although most businesses today are perforce rather cold-blooded about storing records longer than necessary, even in microfilm. The principal victims who are legally bound to retain certain records are those which come under Federal regulation, such as banks, power companies, railroads, trucking lines, savings and loan associations, broadcasting stations — and the Federal bodies themselves. Even though most records can be filmed and then disposed of, certain ones must be kept in their original form, never to be destroyed. Did you know, for

instance, if a utility buys a roll of cable, say 1000 ft. long, and uses 950 ft. of it for replacement and only 50 ft (or less) for a new transmission line, the record of this purchase and all supporting documents such as invoices, acknowledgements, bills of lading, etc. become permanent records as this represents a capital outlay?

Quite often space saving is only one of several reasons for filming, but still the dominant one. Take the government. One department, Social Security, turned to microfilm primarily because there simply wasn't enough space to store all its information in its original form. The late Edward Rosse, former Management Analysis Officer of the Social Security Administration, said this in 1962, which will give you some idea as to the size and scope of his operation:

"Within 1,300,000 square feet of new office space, our Division now handles more than 144 million accounts, of which some 72 million are for currently employed persons. . .

"We are known as the 'largest bookkeeping operation in the world.' Actually any books or papers that we use are only as a temporary support for data because most of the Division's operations are concerned with magnetic tape and microfilm.

"The Social Security Administration turned to the use of electronic computers and microfilm not only to avoid being drowned in a tidal wave of paper, but because coupled they make a superior high-speed information retrieval system. . .

"We use over 1,400 microfilm readers, through which we make approximately 200,000 references per day."

A little later on in his talk, Mr. Rosse summed up completely the case for microfilm: "Too many people still think of microfilm as merely a means of recording and storing information while reducing its size. Tied in with modern computers and tabulating equipment, it can carry out the functions of a primary records source while keeping its inherent ability to minimize storage space. The high speed,

semi-automatic film readers available today make retrieval of the information much faster than it could ever be done with paper. . ."

This brings us to the second classic use of microfilm.

Insurance. In the same speech, and actually in the next sentence, **Mr.** **Rosse** brought out a hidden advantage; premium-free insurance.

"One additional important factor in favor of the use of microfilm instead of paper," he added, "that is frequently overlooked and is worth mentioning, is record security.

"In working with paper, we use the original record and as long as everything goes merrily along, we are not conscious of any special problems, beyond the usual wear and tear, misfiles, etc. However, many things can happen to our files during the sixteen hours of each day that we are away from the office. Fires, floods, and other catastrophies, not to mention military warfare and other conditions beyond our control, can destroy our records and endanger our National Security or put a company out of business.

"On the other hand, by transferring our records to microfilm, the original camera film may be designated as the 'master' and stored away in one of the many public record centers, some of them deep underground. Inexpensive duplicate film copies for everyday operations may be prepared by any one of several processes, and are easily available. . ."

Very often microfilm is the only practical method of insuring records. How else can you accurately reproduce a record that has been destroyed, the only one of its type in existence? Obviously microfilm is of limited value in the case of a painting or a first edition, but wherever the document itself is of no particular intrinsic worth, but what it says is, then a copy is as valuable as the original. A single architectural drawing may cost in excess of $5,000 to produce, but an intermediate made either from the original or microfilm is just as useful, and hence as valuable. Some

newspaper files will always remain incomplete, either because the originals were lost or destroyed, but the integrity of current day files will always be secure — through microfilm. Take a glance at your court house deeds. Theoretically they can be reconstructed in case of fire or destruction since the original deeds are in their owners' possession. But this reconstruction from originals would not only be laborious and costly, it might never be finished. Yet from microfilm, the complete set could be reproduced quickly and economically. The premium cost over a period of years can be counted in mils, not cents, for either a deed or a drawing.

One of the earliest users of microfilm insurance are the transit departments of banks. If a mail pouch is lost, the bank is not unnerved, for it has the microfilm of these items. Paper reproductions are made and presented for collection with no questions asked. There are many other types of documents which are filmed primarily for security reasons; individual time-payment records of banks, finance companies, furniture and jewelry stores — anyone in the credit business. Also real estate plats, wills, marriage, birth and death records, minutes — indeed any document which has informational value and few or no copies exist. We even had a local member of the Daughters of the Confederacy ask us to microfilm her grandfather's federal pardon. This was hardly understandable because this dame was very proud, and to most Southerners, this would be no more than an acknowledgement of abject surrender.

(3) *Preservation* As you have noticed, quite often microfilm is used for more than one reason, but usually one is dominant. Such is the case for newspaper filming. Space saving, particularly in the case of libraries, is an important factor. Distribution in the case of back files is another. But even if current papers had no microfilm subscribers. (*The New York Times* for example sends microfilm editions to more than a thousand libraries twice a month), they would still be

filmed for preservation purposes. I know because we have a few scores of weeklies which film for just this purpose; they have *no* subscribers.

Newsprint is of notoriously poor quality and may last no more than twenty years, even if care is exercised in storage. Your daily paper — or at least mine — will turn yellow if exposed to direct sunlight in a few short hours. Prior to 1875, newsprint contained a high percentage of rag content, and quite often papers of this vintage are in a better state of preservation than those printed during World War II. However, after 1875 as the cheaper grades became available, rag paper was quickly discarded. It became progressively sorrier and sorrier, and the bottom of the pulp barrel was scraped during the War years of 1917-18 and 1942-45. Even the illustrious New York Times, the guardian and preserver of world history, discontinued their rag edition a decade ago because the cost of this type of paper was prohibitive and because microfilm editions were readily available. All of this means that microfilm has become the only method for preserving newspapers; the originals will all too soon crumble to dust.

Engineering drawings, unless treated with care and devotion, have a limited life, particularly modern ones of paper rather than linen. Unfortunately many drafting departments are oblivious of this fact, and rather than use intermediates or duplicate tracings, use and re-use the originals which, in time, become dirty, dog-eared or torn, and the resulting prints sometimes border on illegibility. This is of course assuming that an up to date aperture system is not in use. If these tracings have been previously filmed for security, the film has taken on an added use, that of preservation. New intermediates from microfilms made hopefully in the early life of the drawing can replace the worn-out tracing.

There are other types of documents that wear out. Real estate or tax plats are typical, caused by the constant references by lawyers, real estate agents and tax officials.

Today the more modern county records keepers (whether called Clerks of the Court, Register of Deeds, Clerk of Mesnes and Conveyances, etc.) require that an original or duplicate tracing be filed together with a cloth print on any real estate development so that replacement is possible. Of course the most modern offices keep the plats on microfilm aperture cards, with prints being instantly obtainable, but that again is another story. Early in the century, no precautions were taken whatever. The original sketch very often became part of the plat book. Consequently, very often plat books, filmed for insurance purposes before serious disintegration set in, have been replaced via film. Preservation again.

(4) *Copying*. Of course any microfilm image is a copy, but we quite often overlook its use as a copying medium, despite the fact that this is one of the historic uses. Indeed it is unquestionably the least expensive copying method. Even when it is only the means rather than the end (original to hard copy), it still is the cheapest.

Let's assume you have access to a rare or out-of-print book for a few hours only, and you couldn't possibly digest it in less than a few days of intensive reading, or perhaps you are a lawyer who must present at court a mass of evidence which can not be removed from its point of origin, or you're a bank auditor who wishes to inspect certain records that are in constant use during working hours, and furthermore are subject to alteration — in cases such as these, microfilm can play an indispensable role.

One of the best examples of economic microfilm copying is its utilization by concerns specializing in indexing county records. Before they discovered what microfilm could do these companies sent teams of employees to the county seat to search through every deed for the names of the grantors and grantees, there being one of each in every deed. In a large and ancient county, a squadron of twenty or thirty clerks might sail in and remain for a year or more, complete with

expense accounts, homesickness and plain sickness. Not so today. Today, these essential books can be microfilmed by one or two operators in a fraction of the time, while the actual indexing work is performed at the index company's home office. And, by the way, the film in this case also performs a double service. After the job has been completed the indexing company has no further use for the film, and so it is generally turned over to the county which in turn keeps it permanently for security purposes.

Having disposed of the classic uses of microfilm, for better or for worse, let's take a look at some of the more recent applications. One of these is called, rather prosaicly, "throw away microfilm." In this case, the microfilm is strictly a means to the end, and when that end has been achieved, the film becomes useless and is destroyed. Here we are concerned with the density of the film and its resolution, but have no interest whatever in its archival qualities.

Were it not for the fact that the usefulness of the film has a rebirth as insurance, the preceding example of the indexing company would be an ideal instance of throw-away film.

More obvious are the occasions when filming is performed strictly as as intermediate step in the making of hard copies on electrostatic or other enlarging devices. Duplicate signature cards for banks is one such application, and so for that matter is the reproduction of library cards and monthly statements. Or, in an engineering department, it may become desirable to reduce all drawings regardless of size to a uniform 8½ x 11 for field use. After the desired number of sets are run off, the film is discarded.

A particularly thrifty application is demonstrated in the reprinting of an out-of-print book if the circulation promises to be modest. Instead of resetting the type or even making new plates from the copy negatives of a process camera, the book is merely filmed on a 35mm planetary camera and run through a Copyflo printer that has been loaded with a special

roll of mat paper. The finished roll is cut up and trimmed, mounted as plates on an off-set press, and the book is inexpensively duplicated in lots up to 500. Not only no type setting or copper plates, but no proofreading either.

Now before we proceed to some more good applications, let's divert once more into the realm of mis-applications. Let's reaffirm our belief in microfilm to this extent: it is not a panacea, the answer to all problems, but it is a tool that, in the right hands, can solve many seemingly insuperable obstacles. On the other hand, sometimes it not only doesn't solve them, it creates new problems all its own.

Take the case of the large eastern utility which in 1946 set out to solve the paper work problem. One of its officials had just returned from the wars, completely entranced with the idea of microfilm. He knew that V-mail's success was due to microfilm, that spies carried messages in microfilm form secreted in unmentionable places, and that priceless documents had been copied by film and stored underground, so he figured if microfilm could do all that, it could also solve other things, like too many records. He transmitted his enthusiasm sufficiently to his superiors and they gave him *carte blanche*. He bought a couple of planetary cameras, a couple of flow cameras, hired a dozen new employees, and started filming at random, a method not recommended for random retrieval. Having fortified his knowledge from his lawyers that the Federal Power Commission smiled upon microfilm provided nothing of importance was destroyed, our man proceeded to film inter-office telephone slips, miscellaneous correspondence, duplicate vouchers, in fact anything that could have been safely thrown away. Thousands of dollars later, management called a halt. Very few references were attempted, and the indexing so incomplete that these searchings were fruitless. The FPC wouldn't sanction filming the great bulk of their records, and filming the scrap solved no problems.

More recently, a savings and loan association installed a cartridge semi-automatic retrieval system so that its branches would have immediate access to all customers balances. This was not a job for microfilm. If balances were to be current, all ledger cards had to be filmed daily, or an elaborate up-dating system devised. Although the push button retrieval system was impressive, the up-dating problem made the whole system unwieldy. Shortly after installation, the whole thing was scrapped in favor of a computer, which provided the branches with daily printouts of balances.

This proved excellent, but costly. Finally the problem was solved by a COM unit. Today, the daily balance on all accounts is on microfiche readily accessible to the tellers, and the cost is relatively modest. And speaking of computers, microfilm and data processing work hand in hand; they are more compatible than competitive. It was only a few short years ago that they were considered deadly adversaries. No longer. I remember some eight or nine years ago an x-ray technician telling me with a pitying glance that the computer was going to kill the microfilm industry. Just that year IBM announced its entrance into the micrographic field and there are several manufacturers who produce monsters to directly convert computer information into microfilm.

We have mentioned COM earlier, Computer Output Microfilmer.

Your immediate reaction is "Aha, another space-saving device." You're right and wrong. Space is saved indeed. Paper print-out is terribly bulky, and even magnetic tape itself requires more space than its microfilm counterpart, but space saving is not the primary reason for the existence of COM.

Computers digest tons of data and spew out miles of print-out. This print-out is, in comparison to the digestion, a very slow process although to the casual observer it seems incredibly fast. Not only is it slow, the continuous forms it requires are expensive.

Although several carbon copies can be produced at the same time, distribution requirements may be such that two or more complete runs are necessary. This added to being slow and costly creates a distribution problem. COM solves all problems at once. It converts data from tape direct to microfilm, by-passing the print-out altogether, and at speeds up to ten times that of the printer. After processing, positive prints for distribution can be made even more rapidly, and sent out in roll film form, or more likely cartridges or microfiche.

All costs are dramatically reduced from beginning to end, even mailing costs, but that isn't all. Although tapes and particularly discs can store a monumental quantity of information, there is a limit to on-line capacity. If the computer is kept busy, and it's a sad installation that isn't, information on discs must be transferred to tape, and the tapes accumulate into a library, and the library grows and grows — and whenever information on a stored tape is required, it goes back on the computer. There is frequently a delay, maybe only a few minutes, maybe a few hours, and sometimes a few days. So the problem of storing expensive (and not too compact) tapes is compounded by the problem of access. COM takes care of all this.

One step further. Let us suppose a hospital has all medical record information on discs or tapes. As soon as a patient is discharged, his record is removed from the disc memory and transferred to a tape and stored in the library. We have readmitted a rather neurotic patient with a record on three separate rolls of tape. All three must be reconstructed, but the computer is tied up. How long do you suppose it will be before the data processing people will find enough free time to run through three rolls? If COM were part and parcel of the installation, that chart with three admissions would be instantly available, probably in microfiche form.

Microfilm can work on the input end of a computer as

happily as the output. During the 1960 census taking, a case in point illustrates the virtual marriage of the two. The individual census takers filled out lenghty questionaires, as you remember asking, by the way, some rather personal questions. It would have been a monumental task to tabulate all of this information by any ordinary method, even including a key-punch input into a computer. The Bureau of Standards, working in conjunction with Eastman Kodak, came up with the answer named FOSDIC, more formidable than fearless, and translated as Film Optical Sensing Device for Input to Computers. The completed questionnaires were precision filmed on special 16mm film, and after processing the film was read by this optical sensor and the information transferred direct to a computer. If you are of an inquisitive nature, you might ask yourself why not have the optical scanner read the original questionnaires rather than go through the microfilming process. Because the scanner can work at near computer speeds when reading film; feeding bulky questionnaires into a scanning device, even with automatic feed, would have been infinitely slower.

County recording with microfilm rather than the conventional photocopy is a fast growing field, dictated primarily by the law of economics. If you have ever sold or bought a piece of real estate, you know that evidence of the transaction should be recorded in the local county court house; otherwise you might have difficulty proving ownership or sale. As late as the end of nineteenth century, recording consisted of laboriously copying by hand the instrument into the official deed book. As soon as the typewriter came into general use, loose-leaf deed books were substituted, and the deeds were typed. These methods both required proof-reading. When photo-copying, commonly called Photostating, came along, proof reading became superflous but more important a buyer might have his deed recorded and the original returned in the short space of a day, although often even this

procedure required a week or more. While a few counties scattered over the country still type their records either because they are bureaucratic or backward, photostatic recording is today the classic medium. But someone always has to come along and ruin a good thing. Although photoprinting was good, it wasn't perfect. Sometimes the chemicals were not renewed in time, and the photostats faded. As the machines became faster and more automated, they increased in price and size. The cost of paper and leather bindings continued to mount. Now photocopies don't save any space; in fact they often actually increase the physical volume of the original. New court houses must be built to accommodate the geometrically growing records — not only deeds but deeds of trust, court minutes, wills, liens, marriages, plats, tax records — and all the other agglomeration of paper that a bureaucracy can accumulate. The need for space has become acute.

Meanwhile, an innovation involving microfilm started making in-roads on the photocopying process, and managed to save a few but only a few feet of space. In place of the cumbersome photo recorder, a compact 35mm camera was substituted. The instruments to be recorded were photographed at the end of the day, the film cut, put in a can and mailed to a service company. The latter developed the film, made silver enlargements on linen paper stock, and returned them to the county to be inserted in the appropriate book. Thereafter the film served as a security roll. Costs were somewhat lowered, but the space problem hardly alleviated. The first step in that direction occurred when half scale enlargements were substituted for full size; two deed books could be stored where before there had been one. That helped, but it merely delayed the inevitable.

The ideal solution (particularly to us in the business) is to use the microfilm image itself as the official evidence of documentation. This concept has already been implemented in nearly all sections of the country and received enthusiastically

by the lawyers. It has now reached the point where it can be called a movement. Among progressive public officials, it is generally forecast that within a few years, micro-recording will supplant the photo-copying as surely as the photostat replaced the typewriter.

Since laws governing recording procedures vary from state to state, and even from county to county, we will not attempt to detail the precise methods of indexing, recording and cancelling, but simply mention the physical forms the recording might take. Thirty five millimeter film has been historically the size designated by public officials for security film. It was only natural then, when microfilm recording was officially commenced some few years ago, that 35mm aperture cards or 35mm acetate jackets be adopted, not only from force of habit but for the sake of compatability with the existing film. It has been belatedly realized by the guardians of public records that excellent quality can also be obtained with 16mm film. As a result, 16mm cartridges combined with automatic retrieval is being closely regarded. No particular size of film or form — cartridge, aperture card, microthin jacket or microfiche — will dominate the market for each has its particular virtues and, need we say proponents. One thing does seem fairly clear; the salad days for the photocopying process are over. Microfilm seems to be the up-and-coming medium, but we can't casually dismiss the computer or video recording.

Some twenty odd years ago Mr. Rau of the General Electric Company up in Rochester suggested that the life of a draftsman would be greatly enriched if a print distribution system involving aperture cards supplanted the blue-print method. Although he failed to initiate such a system himself, he put the bug into some other ears (Filmsort ears), and as a result the use of microfilm in the drafting room is old hat. Several books have been written describing fully the methods and techniques involved; mentioning the advantages requires less space.

In such a set-up, the aperture card replaces the original drawing. The latter, while it may perhaps be destroyed, more likely will end up in another and less expensive location, waiting for revisions. This aperture card, like a full scale intermediate becomes the master for producing working prints. The enlarging equipment turns out prints at a speed and cost comparable with diazo machines. In fact, in many instances the speed is greater and the material cost lower. Quite obviously, tremendous amounts of space are saved, and tremendously expensive filing equipment is eliminated. Searching and filing become simple tasks; damaged work cards can be quickly duplicated − no need for expensive retracing; and there are other, more sophisticated advantages. For a few cents each, duplicate cards can be run off for distribution, either to satellite plants, technical libraries, vendors or customers. The cards can be key punched and interpreted, and if need be, machine sorted. The information contained on the card may differ materially from the drawing's title block. Multiple sets of cards can be produced and each set filed differently − numerically, by location, by type of machine, etc. There can be a security file of either roll film or another deck of cards; cards made before a revision can now be retained in an inactive file since so little space is involved.

One might think with so many obvious advantages, the practice would become universal. Not so. Unfortunately there are some engineering offices where such an installation is simply not economically feasible. There are others where revisions are the rule and not the exception, and in these cases constant rephotographing can become so cumbersome that any advantages are cancelled out. The most usual deterrent however is contained in the old maxim, "You can't make a purse out of a sow's ear." If the drawing is not good, if the film made from it is not good, then the print is quite apt to be lousy. If it is not clearly legible, if it is necessary to call a conference to distinguish between a 2 or a 7, then

the print is clearly unacceptable. While today's drafting methods have been updated to compensate for microfilm's deficiencies, many old drawings, particularly large architectural ones, are in active use and not suitable for any ,microfilm system.

Publishing and particularly re-publishing in one microform or another is one of the most promising uses of microfilm and, if we can safely ignore the prophecies of the COM boys, may well command a dominant position in the total market. Of course microfilm editions of all the leading newspapers and most of the better magazines have been available for years, and to a lesser degree technical publications and rare books. But the future for the book in the information transfer business looks pretty cloudy as you will see in a later chapter; it has served man long and well, but many librarians and their customers (the scientists) think the death knell is near. Microfilm combined with the computer will supercede it. Maybe

Thus far, publishers have not taken too kindly to original publishing in microform. In fact, the only thing that comes to mind is Jerry Sophar's *Wildlife Disease Journal*, a journal that was originally published on microcards. Sooner or later the situation will change, and Brother Sophar will go down in history as a pioneer. Re-publishing, however, is gaining headway all the time, and will continue to do so, what with the advent of microfiche and cartridges. Indeed in the information transfer business, which is a rather inclusive term, microfilm may well play its most important role.

QUALITY CONTROLS AND STANDARDS

In the old days (notice I didn't say "good"), there were no quality control departments as such. There were supervisors and there were inspectors and quality was maintained on a comparatively haphazard basis. Sometimes it was very good and sometimes terrible. Whatever one might be manufacturing, socks or canned peas or stamping out bottle tops or even microfilming records, one did the best one could and let it go at that.

The Jurassic Period of microfilm (circa 1951) found me the watch dog of our quality. This was quite essential, as I was the only employee. It was mortifying, however, to have no one to blame except myself. Well, almost no one. The processing was farmed out to another service company so there was at least something on which to vent my spleen. Sometimes the film came back with no scratches and with good density, but just as often it was too light or too dark, complete with abrasions. Since my processing friend was also a competitor, and didn't care if he ever saw me again, much less my film, there wasn't much I could do but froth. So eager was I to find evidence of laxness on his part that quite often I overlooked my own errors. Thus film went out in a multitude of shades, quite often slightly out of focus or with fogged ends, faulty splices or incorrect title sheets, or what have you. As I have often said these past few years when emphasizing to a customer or prospect the tremendous value of quality control, "If I had known then what I know now and had I been you, I would never have dealt with me."

Even a few years later when I had a whole handful of employees, Quality Control was more of a thought than a

fact. One spring morning we sent a young operator up to the eastern shore of Virginia to film the deed books of a historic county. Some six months later, after the operator was gone, the customer (an indexing company) called up from Ohio with the news that one deed book was missing — Book 38 had been filmed twice and 39 skipped. Our inspection department had checked for everything else — missing pages, focus, format, density, indexing, title pages, alignment — but had failed to verify the Book number, a very easy thing to do. Well, there was no problem. We just had to pack up a camera, and send back an operator, set the camera up, film one book, tear the camera down and come back home, a six hundred mile round trip. Triumph into defeat. Stories like this can go on forever. Like the time we had a good sized project with the Georgia Department of Archives and History filming their Confederate Rosters. The operator was most competent; he *never* made an error — or almost never. Our processing department was running smoothly, and there were no density problems. Consequently inspection was more casual than it should have been. We ground out roll after roll. Then one day, for no reason at all, I requested a hard copy of a page or two selected at random to send to Archives to show what beautiful work we were doing. Lo and behold, the print was fuzzy. I suggested sarcastically the reader-printer be focussed before running off a print. It came back the same way. The film it seems was slightly out of focus, some fifty rolls of it. Of course we immediately stopped the camera, had it focussed and started the project all over again.

You get the picture: A good quality control department is worth its weight in recovered silver. No vast amount of expensive equipment is required either. A good densitometer, a hypo residual kit, a first rate microscope, an inspection bench, a couple of readers, some magnifying glasses, and a few sundry items like a set of calipers, a comparator, and you're in business. The priceless ingredient you must have is

an intelligent staff, technically oriented and capable of making objective judgments. Therein hangs the tale.

What specifically should Quality Control look for. Even if I knew, I couldn't tell you everything, because everything hasn't been discovered, but here are some of the basic things:

(1) *Density* — Since we normally have only limited control of contrast, we must perforce control our images by setting boundaries for density. Visual diffuse transmission density if you want to be technical. The scale on a densitometer runs the microfilm gamut, indicating light resistance on a scale running from zero to about 4.0. The higher the figure, the darker the image. No film is so optically transparent that it will not register on the scale. When the base is combined with processed emulsion, the combined background density in the clear area should run somewhere between .07 and .1. If higher, too much developer fog is evident, at least for clear base films such as AHU or dye-back. Blue or gray base films, which are growing daily less popular, will run from .27 to .3. After exposure and processing, the image area normally should be about 1.1 for clear base film and 1.3 for blue-base. Note the use of the word *normally*.

The microfilm committee of the Department of Defense has decreed that the background on engineering film be 1.1 + .1. This was determined to be the best compromise for all the functions the film might be expected to perform. Film of this specification shows up well on a reading screen, makes a good hard copy, is quite adequate for silver contact prints, and can be used equally well for either thermal or diazo copies. Of primary importance is reproductability through several generations. A second generation film, by the way, is the first contact print made from an original negative. A third generation print is a copy of that copy. And so on. It was determined that resolution held up better from generation to generation with this norm, and at the same time uniform density was more easily maintained.

Now this 1.1 standard is *not* best for all applications. At least an awful lot of knowledgeable people seem to think not. Note the following:

While 1.1 is fine for engineering drawings, a lower density background is preferable for 16mm film. Very fine lines or light print may "block out" even with a 1.1 density. The higher the reduction ratio, the more obvious this becomes. It may be necessary to end up with .8 or even .7 film to retain these lines.

Xerox prints, diazo and Kalvar copies all prefer the light treatment. Though 1.1 is all right, .9 is better and 1.4 is to be abhorred.

On the other hand, a higher density is sometimes preferable. Positive copies of newspapers are "cleaner" when the negative from which it is printed has a density of 1.3 or even higher. Any time the original copy is of high contrast and the lines are not too fine a higher density is acceptable or even desirable.

Quality Control faces an entirely different problem when it judges the quality of film made from blueprints or any other type of negative material. Just as the light meter is not of much service to the camera operator, so is the densitometer to the inspector, since both instruments are basically designed for use with positive copy. Legibility is what we have to settle for here, and the background density may necessarily be dark or light, depending on the background of the original, the contrast and the thickness of the lines. In other words, negative materials are hard to film and the rules governing are not hard and fast.

(2) *Resolution* – Before the D.O.D. specifications came on the scene, most of us were content to accept film that appeared sharp to the human eye, and let it go at that. Good *acutance*, or the semblance of sharpness, was enough. Enlargements were made by hand, and because of the

conventional optical system on most enlargers, were usually pretty fuzzy particularly when the blow-up exceeded 16x or so. So if images on a screen looked pleasing to the eye, and enlargements on paper looked sorry, there wasn't much reason to try to improve either or worry too much about density. But when reader-printers and Copy-Flo machines came along, and when 40x enlargements and third and fourth generation prints became desirable, everything had to be improved; the film, the camera, and the copying device. Old Mother Necessity and the engineers took care of it.

Consequently, we must have a means to determine how good a negative is. The national Bureau of Standards supplies resolution charts for measuring the resolving power of micro-filming systems. It is the criteria of the industry. Five charts are normally photographed simultaneously; one in the center of the area to be filmed and the other four at the corners. Positioning is critical. After exposure and processing, the film is viewed through a microscope (usually 40x or 50x), and the smallest set in which the direction of lines can be clearly noted determines the resolution. If your eyes are exception-ally good, you should change your method by stopping at the group in which the lines can be definitely counted. Choose the number opposite the set and multiply it by the reduction ratio. For example, your block is 4.0 and the film was shot at 30x. Your resolution is 4.0x30 or 120 — 120 lines per millimeter. Similarly at 16x your block is 6.3. 6.3x16=100.8. What is good resolution? And what is bad? Referring once again to D.O.D. specs, 120 at 30x is the minimum acceptable for military work, 108 for 24x and 100.8 for 16x. For ordinary work, resolution of this calibre is not a requisite, but let's say this: whenever an image on the screen appears less than sharp, the resolution is insufficient, regardless of the reduction ratio. And for Quality Control's information, this resolution is dependent on the film used, the developer together with the time and temperature of the development,

the camera itself, the lens, the focus, vibration and other factors.

(3) *Processing Integrity* – What should quality control look for in the physical characteristics of the processed film?

First of all, it should be reasonably free of residual hypo. This is determined with a kit containing test tubes and beakers and scales and other parapharnelia described elsewhere. The Bureau of Standards has set the allowable quantity to qualify for archival quality at .005 milligrams per square inch. Theoretically, a good processor should always produce film within this tolerance. Nonetheless, it's a good idea to verify this frequently, and if D.O.D. work is in the mill, it's mandatory. Thorough washing, with or without the aid of a hypo eliminator, will safely remove the hypo and prevent the film from future fading.

Next, the film should be free from abrasions and scratches. Some processors have the ugly habit of implanting "crow's feet" on the edge of the film despite any precautionary measures that might have been taken. So long as these abrasions are on the edge and outside the image area, they do little harm. One simply gets the impression that the film has not been treated gently. Some cameras incorporate an over-size aperture, and the image area extends very close to the edges. In this case the abrasions definitely get within the picture area, and the only cure is a new processor.

Scratching is something else, and can be avoided. But to run down the source can be difficult. Perhaps the camera caused it; or something went wrong when the film was being transferred to a thousand foot reel prior to processing, or the film became untracked in the processor for any one of a dozen reasons or – and we haven't finished yet – the film became scratched as it was being unwound from the reel, or the microfilm reader scratched it while it was being inspected. I can assure you that each department will be righteously indignant at the mere suggestion of guilt. Voluntary

confessions are rare.

Scratches on the emulsion side of the film wherein portions of the image have been gouged out are pretty disastrous, but if on the base side, they can often be minimized by the application of lacquer (or various patented preparations) when it is impractical or impossible to refilm.

Added to all of the other problems, dust or other foreign matter may cling to the film, caused by dirty chemicals or an inefficient filter in the dry box or simply by static electricity. And finger prints, if not promptly removed, may cause eventual disintegration of the film images.

Fortunately or unfortunately, as the case might be, imperfections can also be a manufacturing error. Fogged areas, emulsionless spots, black dots and minute abrasions can and do occur. It's not always a departmental error. In the process of manufacture, microfilm is formed in long wide rolls, which are subsequently slit for width and cut for length. Incorrect slitting may result in rolls either too wide or too narrow, sometimes even both within the same roll. If the slitter is dull, the edges, particularly the emulsion, can be ragged. These are rare manifestations of bad quality control on the part of the manufacturer. Too, sometimes different batches of film from the same source vary noticeably in speed.

(4) *Camera Malfunctions and Operator Errors* — Elsewhere in this book we have discussed these problems in detail. Here let it suffice to say that Quality Control should be able to spot them, diagnose the trouble and suggest the remedies. Let's take a page from the Library of Congress's code as expressed by Donald Holmes at the NMA Convention in 1964:

"The Library's quality control program is directed at film produced in its own laboratories as well as [film from outside sources], and here the tests applied are even more stringent. The approach is also different; instead of merely testing the final product, effort is made to control quality at each stage

of production, from the initial preparation of the original to the final inspection. . . .

"The cameras used are modern, high-resolution planetary cameras, and the ones used for newspaper microfilming have a resolving power sufficient to give at least 110 lines of resolution at twenty diameters in the corners of a double-page newspaper image. . . .

"All cameras are tested at least monthly with Bureau of Standards resolution test charts. A 'step test' to determine proper levels of light intensity is also made periodically. In addition, the lighting at various points in the copy plane is checked frequently and adjusted so that there is even illumination of the entire image area. If one bulb burns out, all bulbs are replaced so that the lighting can be more readily balanced, and the accomplishment will last for a reasonable time.

". . . . Water alone is used for removal of hypo [in our processors] : there are ten wash rack assemblies, with three tiers of spray heads on each side of each rack.

"After processing has been completed, the thousand-foot rolls of film are broken down into individual orders and reels by an inspector who, at the same time, makes a pre-editing check for such obvious flaws as scratched film, blurred pages due to page movement and camera troubles. This preliminary check is designed to alert the laboratory as soon as possible to defects in cameras or processor which should be corrected immediately, before any further damage is done.

"Negative film, which passes this first test is then assigned to a film editor, who makes a frame-by-frame inspection to see that all pages were filmed, and filmed in the proper order; that the film images are properly aligned; that the proper targets have been used; that each image is in focus, evenly lighted; and that each has good contrast. The background density is checked by eye, and double-checked every few feet with an electronic densitometer.

"...For inspection of newspaper microfilm, reading machines are also used. Each reader has glass flats which are pushed away from the film manually before it is advanced, thus giving positive protection against the possibility of scratching the film...."

Quality Control is thus part watchdog, part inspector, part teacher, part referee. For instance, it must act as coordinator between the filming and processing departments to control what is known as *latent image fade*. Strange. Many years ago, when a Western Electric department chief told me they "aged" their exposed film before processing, I thought he must be some sort of a nut. Imagine aging film, like cheese or wine.

"Age it?" I asked incredulously. "Why?"

"Latent image fade," he answered, rather smugly I thought. This was the first time I'd heard that. The Western Electric man patiently gave me a detailed explantion. It amounted to this: Immediately after exposure, a slight deterioration of the latent image commences becoming apparent after processing in the form of a lessening of density, with the greater the time interval between the exposure and the processing, the greater the deterioration. Nothing exactly alarming, but nice to know if one is attempting to maintain uniform density day after day. Western Electric aged its film approximately 30 hours to "average" the fading to a narrow bracket. Memories floated before me as I recalled how our film varied from day to day with no apparent reason. I learned that the density can drop .17 in three days (and some people claim the drop is even more precipitous). This means that a roll of film can be started in a camera on Friday, finished up on Monday, processed immediately and have a density of 1.15 at the beginning and 1.32 at the end. Maybe more. The worst part about it is that this fading varies from product to product and manufacturer to manufacturer. One manufacturer even claims

to have no-fade film.

Things like this are what make a job in Quality Control interesting.

Of course Quality Control is a sort of nebulous word, and frequently used *ad extremis*. I recall just such a case when we were negotiating with a large airline regarding the installation of a rapid retrieval system in their reservations department. I was being escorted by a minor dignitary through the airlines divisional offices when we came upon a large room containing some three hundred ladies and gentlemen, all talking madly into telephones. There were some fifteen double rows, each row seating some twenty clerks at compartmentalized tables. These were the reservation clerks, I was told. What did the person at the head of each table do, I asked. These fifteen were supervisors, who helped newly employed clerks if they had any trouble and who spot-checked the others on a routine basis to see that they were efficient, courteous and wasted no time. There were three individual desks set somewhat to one side. What did the persons there do, I asked. These were the assistant department chiefs, I was informed, who checked the supervisors. Finally, I was escorted past a small, glass-encased white tiled office with only one desk and one gentleman complete, of course, with telephone. "And he?" I asked. "Quality Control," said my friend. "He monitors the monitors."

What kind of Quality Control does the Metropolitan Opera have? And does the Congress for Racial Equality publish a manual for a protest march and check for quality control?

Standards

While there are plenty of standards, there is little standardization. With reason too. Al Baptie, at the NMA in 1965, gave one good reason.

"The lament of all of us," he said, "who manufacture

equipment for the microform field is that after spending $25,000 to $50,000 (or more) to tool a new piece of equipment, the chorus commences: "Just what I need except. . . .the screen should be larger (or smaller), the reduction ratio should be more (or less), the device should also accept 16mm film, 35mm film, and aperture cards as well as microfiche, or should be 'universal' and accept every microform. It should also be high quality, low cost, small size, low weight, durable and should fold to fit in a briefcase. Of course, I don't need very many, so the volume is limited. . . ."

So whether it is in the manufacturing of equipment or the application, everyone wants standards, but they must be keyed for personal needs. Mr. Baptie continued. . . .

"Perhaps I exaggerate a bit, but a few experiences such as this make the engineers and designers within a company frustrated, the market group puzzled, and the financial group furious. . .It also leaves the consumer without the answer he really needs. Standards can solve this impasse.

"Standards can also, as I am fond of pointing out, prevent a reduction race, which is detrimental to all the industry and to its consumers.

"Standards can set a definite level of quality in the finished product so the purchaser is assured in advance that the microform is serviceable and suitable.

"Because all standards are a compromise, and are based on existing technical capabilities, they should be regularly reviewed for suitability, and modified when it becomes necessary. . . ."

This indicates that the consumer should become more adaptable, and design his system around equipment that has become standardized rather than insist that equipment be designed for his particular use.

My first inclination when writing this chapter was to describe in relative detail many of the standards which have been adopted and set by various bodies. In fact, the first two

drafts included quite an enumeration of standards. Then it became apparent, as I began using my head instead of my typing fingers, that standards like life are transitory, particularly in a field that is still evolving. What may be a reasonable standard today may be totally inadequate tomorrow. Let's take that ,venerable D.O.D. Military Standard 9868 with its subsequent alpha suffixes. Once perhaps 100 lines per mm. resolution was a hoped for ideal. By the time 9868 came around, 120 was the minimum. With improvements in film, lenses, cameras processing, it is quite possible that 140, 160, 180 or even 200 lines will be the norm.

The accepted standard for the production of archival film may well be changed. The lack or residual hypo in film is certainly indicative of proper processing, but certainly not a guarantee of its performance. The size and thickness of aperture cards has been stabilized and standardized, but who knows, techniques may be developed making logical a certain degree of miniaturization. And so on. Nevertheless, in the past few years there have been tremendous strides in standardizing certain techniques, certain forms and certain tests. The NMA's Standards Committee is in the fore acting as a sort of catalyst for the viewpoints of the Department of Defense, the Library of Congress, the Society of American Archivists, the American Library Association and the International Standards Organization. Although some standards have been mutually adopted, to a noticeable degree the various groups differ. One might say their work is more parallel than confluent. There is cooperation however. As a good example a joint committee of the National Micrographic Association and the Society of American Archivists headed by Frank Evans of the National Archives recently came up with a "Recommended Practice for Identification of Microforms." All States with the exception of one have what is known as the Uniform Photographic Reproduction Evidence Act, which is a statute which

recognizes the validity of microfilmed evidence in court if properly identified. Therein lies the rub. Heretofore this identification posed a problem, explained Dr. Richard Hale, a member of the Committee and the Massachusetts State Archivist. Unfriendly lawyers could make things difficult by summoning to court the custodian of the original records, or the person who actually filmed the records, or both. The Committee came up with the recommendation that, in the case of records with any possible legal significance, the custodian sign a certificate stating he was in charge of the records filmed; that the microfilmer sign a certificate that he personally has filmed what the custodian gave him to film, and that these certificates be filmed at the beginning and end of each roll, with the added information regarding the starting and ending points of the material on that reel.

I must perforce break in here amidst all this solemnity to recall three stories told me by Dick Loud and Bob Boylan. Military Spec. 9868 requires source inspection at times, and this, with all due apologies to the military, means a government inspector comes snooping around to discover if things are being done according to Hoyle. During World War II, because of the necessarily short training period, many inspectors had only perfunctory knowledge of microfilm. An entirely different set of inspectors saw to it that proper security measures were taken with classified materials, and these too might know lots about security practices but little about microfilm. All in all there was much laughing as well as gnashing of teeth when the inspectors appeared and displayed their ignorance.

Dick Loud tells these: "I remember the time a Navy inspector came into our plant while we were doing D.O.D. work. He had to constantly refer to the manual, and finally he came to the problem of density. 'Now what is this thing density?' he asked. 'Do you buy it from Eastman Kodak Company?'

"Similarly, several years ago we had a big Federal job, and the specs provided that certain drafting practices be observed. Since the tracings had already been completed, it meant that most of them would have to be redrawn. In Washington, one of our men suggested to a high ranking officer that if they would waive some of the specs, the filming could proceed and valuable time saved. The thin lines, he continued, could be retained if the Army would accept a thinner density film, and furthermore this film would make good prints. . .'Fine,' said the officer, 'Thinner film. We can get more images to the roll.' '

Bob Boylan tells a story that involves security: "Back during the war period, when everything was on a strict high-level security basis, we, The Microfilm Corporation of Cleveland, Ohio, were doing some confidential material for the Navy Department here in Cleveland. One of the newly commissioned ensigns arrived at our office one day with a roll of film which he informed us was highly confidential in nature and had to be processed in exactly that manner and given back to him immediately for return to the proper authorities at the Navy Department. We assured him that our people were cleared and that there would be no difficulty if he just gave us the film and let us proceed with our normal processing operations. He felt, however, that this could not be done and that he would have to stay with the film until the entire process was completed. After much discussion, we decided that this would be the easiest way and invited him to come into the processing room with the film, so that it could be loaded and processed. There were some preliminary adjustments that had to be made prior to processing and our operator took care of these, at which point he turned to the ensign and said, 'Fine, now we can turn off the lights and proceed with the processing.' " It was at this point that he noticed the ensign had already opened the can, partially unrolled the film, and handed it to him for processing.

Needless to say, the entire roll was spoiled. . . .Need we go on?''

Although the previously mentioned standards are used as guide lines in private industry for internal use, by no means are they accepted *in toto*. Western Electric, for instance, may prefer reduction ratios other than the 16-24-30 demanded by the military. General Electric may let down the bars on resolution a bit at the lower reduction ratios. The public works department of say Chicago may settle for two reduction ratios instead of three. The Library of Congress may insist on a background density of 1.6 rather than 1.1, and so on.

Microform publishing has received a stabilizing shot in the arm by most publishers' adoption of the COSATI specifications for microfiche and the ALA recommendations for cartridges. But about here we start running out of working standards of any great consequence. Microfilm recording of public records, for instance, varies from state to state, even from county to county. The members of the American Archivists Society talk about standardization, but each one films his records the way he wants to. Each to his own.

Yes, too many standards and too little standardization.

PREPARATION AND INDEXING

Both preparation and indexing deserve more than passing notice, and though they are mentioned briefly in other chapters, we should dwell on both a bit more.

The importance of proper preparation cannot be overstressed, neither can a realistic appraisal of possible costs. A friend of mine whose in-plant department was exceptionally efficient sighed to me one day, "Preparation! What we need are a few high class morons." Nothing could be further from the truth. Preparation clerks are often put in the same category as file clerks. Now as you know the file clerk is usually located below ground on the totem pole of the business office hierarchy. The pay is low, but the cost is high when a misfile occurs. Costly too is inadequate and sloppy preparation of records to be filmed. The clerk need not be a Ph.D. but should be sufficiently intelligent to be discerning, nimble (with the fingers, that is) and accurate.

First of all, our clerk must be a sort of human threshing machine, spewing to one side paper clips, staples, rubber bands, loose bits of Scotch tape and other non-filmables. Equally important to be discarded are items not worth filming, such as duplicate copies, blank pages and predetermined trivia. Possibly most important of all, the clerk is responsible for sequential integrity, and in the event the clerk cannot translate this phrase, it simply means that the copy be in proper order. Now these three operations are not done in this order; they are concurrent.

Some material of course requires minimal preparation, consisting of simply removing it from a file drawer and loading it into a camera's automatic feeder hopper. Filed checks,

signature cards, library cards — these are good examples. On the other hand preparation may be maximal. We once bid on a job for the National Archives and fortunately didn't get the reward. The documents were Civil War personnel files consisting of thousands of open end envelopes stuffed with tattered brittle pages folded twice. These documents had to be removed and unfolded and each page filmed in a protective acetate jacket, refolded and reinserted in the envelopes as filmed. Not only was this a laborious process, but there was a hidden cost. To this day, we have never completed a major job without having to make a certain number of retakes. Sometimes for unforeseen reasons there have been many retakes. And also times when we were not sufficiently prudent (or too hungry) and our bid did not take into consideration the cost of retakes. Well, you know the story. We lost money. In this Civil War job we bid high because, along with the other obstacles, we realized that the cost of retakes per unit would be materially more than the cost of original filming. Searching perhaps for individual items, unfolding and then refolding documents already brittle with age, refiling this should put fear in the heart of any brave microfilmer.

Sometimes labor costs are rather predictable. For example in the processing of medical records (in this case processing means the complete conversion from paper to microfiche), two clerks are normally assigned to ready charts for each camera operator. At least that is our standard procedure in this particular field.

Planetary camera work is a bit different. In most instances the preparation is performed by the camera operator as the filming proceeds. Turned corners are straightened, torn pages repaired and proper sequence verified. This applies to newspapers, books and similar copy. Sometimes engineering drawings require a bit of outside help. Older drawings are often rolled, copy side in. If re-rolled inside out for twelve to

twenty-four hours in advance, they will fairly well straighten out. Even drawings stored flat have a curling tendency and can be helped by rolling inside-out for short periods. The camera operator for radiographs can also stand some help. X-rays come in envelopes with supporting data. These have to be removed and sequence verified.

Anyway, preparation can be a major problem and the cost sometimes so excessive that microfilming is no longer the economical and sensible solution. Fortunately, this is not often the case.

Indexing, although an entirely different matter, has one thing in common with preparation: it too can be simple or complicated, depending. The rule of thumb is that the frequency of referral dictates the complexity and thoroughness of the indexing. If one is filming just for filming sake (and this has been done) and reference will be zero or thereabouts, then one might remember the hospital that simply numbered its microfilm rolls. The charts were filmed in sequence, so it was possible to find a case history – not too probably but still possible. Any large file can be inexpensively indexed if it is in either alphabetical or numeric sequence by simply noting on the roll and the box the roll number and the first and last item on the roll. The complexity of indexing increases as the reference increases. The ultimate is reached when each individual frame is indexed so the retrieval can become almost instant. Parts catalogues, telephone directories – these are examples of high reference documents.

This Seek and Ye Shall Find objective can be achieved during three parts of the microfilming process. During *preparation*, targets may be inserted throughout the material designating certain sections of the roll separating subjects, identifying individual files or charts and notating missing data. It can also take place during the actual *filming*. Targets designating beginning and end of a roll, and targets identifying

the material included are all supplied by the operator. The most complex indexing, using digital and binaural code to identify specific frames, obviously is performed at the time of filming. And lastly, it may be done *after processing*. Identifying and labelling individual fiche, odometer locating for roll film and cartridges, notching film, utilizing the vertical lines system — all of these are necessarily performed after processing.

However achieved, preparation and indexing are of the utmost importance. Quite obviously film is useless if the images cannot be located. If tedious searching is required because of inadequate indexing, it is exasperating. And if finally located, the images are upside down, part of the information obliterated because of a turned down corner or a crease in the page, then the searcher, whoever he may be, may well dismiss microfilm as an impractical commodity, more toy than tool.

THE CARE AND PRESERVATION OF MICROFILM

Pamphlets on the Care and Preservation of Microfilm are legion, and they share a common ingredient — uncertainty. While many practices are generally accepted or proven, others are strewn with *ifs* and *buts* and *howevers,* and with reason. No one knows for certain how little care is essential to longevity; consequently, to stay on the safe side, maximum protection is always suggested, otherwise, "no. . . .warranty is implied. . . ."

First of all, we recognize that the film base, cellulose acetate or cellulose triacetate or cellulose acetate butyrate, is a stable and inert compound requiring little care under normal conditions. The polyesters are even more durable but have not been readily accepted until recently by the micrographic industry. Silver based polyester is now in bountiful supply and diazo and thermal polyesters are on the shelf. But back to acetate: incorporated in the manufacture of the film are certain plasticizers which can be driven off if subjected to intense heat or extremely low humidity. The emulsion is even more demanding of respect. Consequently, it behooves us to take care from the very beginning.

(1) *Raw Film* — Microfilm packaging carries an expiration legend, after which time the film is "out of date" and all warranties cease. Thus microfilm has a limited shelf life, something over two years or so if stored under average conditions which, by the way, does not include unventilated attics or damp basements. Pure cold itself will not adversely affect the film; in fact its shelf life will be extended. Heat, even 90^o Farenheit, will shorten its life. And although the film generally comes packed in relatively airtight containers,

extreme dampness may damage the emulsion. Some films even require refrigeration; direct negative print film lasts a very few months unless kept cold. And if one has the facilities, it's good practice to keep *all* film in the refrigerator or deep freeze. Note: To prevent condensation, it must be "warmed up" to room temperature before using.

One word more about out-of-date film. If the legend states that the film should be used before August, 1970, that does not mean that on July 31st the film was in good health but the next day had decomposed. There is a gradual deterioration evidenced by increased base fog, decreased light sensitivity and lowered contrast, but film even a year out of date may still be in good condition if it has been cared for properly.

(2) *Post-Exposure-Pre-Development*. This has been discussed in the previous chapter under *latent image fade*. To preserve existing densities, either refrigeration or freezing is invaluable. And, as noted above, sudden changes in temperature, from low to normal, can cause condensation, which in turn can cause uneven development.

Frozen but exposed film can be kept indefinitely. Several years ago, an arctic exploration team came upon the deserted camp of an earlier unsuccessful team which had tried and perished some fifty years before. Found was some exposed film, frozen all those years. Returned to civilization and processed, the film produced creditable negatives. Like prehistoric whale flesh, it was still good.

(3) *Use and Care*. After the film has been processed, post-natal care commences, and therein lies the rub, or abrasion if you insist. From the time it emerges safely and with nary a scratch from the processor, its useful life commences, and hopefully a long and uneventful one.

It is not given a clean bill of health, of course, until it has passed through inspection and perhaps received some splices. Care must be exercised in these operations to prevent

abrasions and the acquisiton of fingerprints. Lintless cotton gloves are a *must* as fingerprints can cause permanent damage if not immediately removed.

At one point or other in the inspection process, the film is observed on a viewer. A decade or two ago the glass flats on the better class readers separated as the film was advanced. This, as long as the mechanism functioned, prevented scratching. But the mere fact that the flats separated meant that the film was out of plane as it advanced, and hence was out of focus. This was not only a hardship on the inspector's eyes; it slowed down the whole process. In deference to convenience, most of today's readers allow the observer to go from frame to frame while all images remain in focus. This is accomplished by employing either rotating or fixed flats which are separated from each other by spacers slightly thicker than the film itself. However, if not in perfect alignment or if foreign particles become lodged on either flat, serious scratching can result. Furthermore, the alignment must be adjusted to accommodate either negative or positive film. (In most readers, the reader is threaded with the emulsion side face down if negative, and face up if positive). The alignment is such that it favors the emulsion side. Needless to say the most serious abrasions occur when the film is improperly threaded. Although scratches may become apparent as they are being created on the reader, quite often they commence *after* the film has passed the screen area. If not re-inspected after leaving the reader, damaged film can unknowingly be sent out. Not too long ago, we received in the mail a few dozen rolls of positive newspaper film from a certain university library. Enclosed was a terse note accusing us of sending film to them so badly scratched that it was illegible. Examination showed that this was indeed true, but the mutilations on each roll ceased abruptly after the film had been advanced about five or ten feet. This was indicative that the scratching had been inflicted by the customer's reader,

not by us; and after seeing scratches for a few feet, the inspector felt he had seen enough to condemn the film, so he simply stopped and rewound. It is manifestly impossible to abrade just the first few feet of a series of rolls. It's either scratched all the way through or not at all. So, my friend, be careful when you have to physically handle the film; be sure that the reader is threaded or loaded properly, see that the machine is clean and in proper adjustment, and after use, store the film in "a cool, dry place." Cabinets, by the way, with chemically controlled humidity are not recommended.

(4) *Preservation.* Microfilm is considered a "permanent material." Peter Scott said in 1958: "While it is obvious that we do not intend a so-called permanent material to last until doomsday, it is less clear what span of life we do envision for it and how much deterioration we can permit before we could consider its usefulness at an end. We speak of the permanence of glass, and that of stainless steel, and of film, in each case denoting a different span of time. In other words we use permanence as a relative statement of stability and not as an absolute term."

Mr. Scott supported the theory that properly processed and stored film could well last four or five hundred years on the basis of the following premises:

1. Rag paper and inferior grades of paper have been observed for several hundred years.

2. Accelerated aging tests quite accurately predict the life of paper.

3. Rag paper is chemically closely related to currently manufactured acetate film base.

4. Accelerated aging tests similar to those used for paper and applied to the film base show it to compare favorably with the best paper stock.

5. The gelatin which holds the photo-sensitive silver halides is chemically very similar to glue whose stability has been established over several centuries, but by virtue

of greater flexibility the gelatin may well exceed glue in stability."

Mr. Scott declined to answer the question how long sub-standard film might last. He remarked, "Unless the film is intended for purely temporary purposes, it is a matter not only of ethics, but of good business to process film to the best obtainable stability for while books can remain legible and usable even in a state of quite severe chemical decomposition, this is rarely the case with microfilm." Consequently, in addition to the other prerequisites to obtain first grade film, it should be stored "as recommended," which means in a temperature approximately 70° and a humidity of 50% or less; the film base should be safety base and the processing according to Bureau of Standards requirements.

But that, alas, is not the end of the story, for microfilm is susceptible to a disease often known as "measles," or perhaps "Microscopic Spots," "Aging Blemishes" or "J-Defects." This horrendous discovery was made in the early sixties and literally rocked the industry. Salesmen had been saying for years that one of the great virtues of microfilm was its permanence, its ability to outlast the original, and here suddenly it was no longer permanent. Articles appeared in the *New York Times* and the *Wall Street Journal* and sundry other publications. Microfilm was decomposing. Blank spots were appearing in film. The images were being eaten up by an invidious fungus. Irreparable damage was being done. Telephones started ringing. Irate or anxious customers called the manufacturers, the service companies, the storage concerns. Many programs were halted; contracts were cancelled. Film was examined for the mysterious spots by experts and pseudo-experts who didn't know what a spot looked like. The film depositories had to take their collective receivers off the hooks. Panic, to use a ripe cliche, was rife.

Meanwhile, the purveyors of films other than silver halide capitalized on the maxim that their films were measles-free.

The dust finally settled, and the chemists were forced to admit that the catastrophe was not catastrophic, that the plague was not bubonic. Spots did occur, true, but percentagewise the overall damage was negligible.

What do spots look like? They range in the size from the diameter of a period at 24x to the size of a zero. The small ones require a low power microscope for detection while the larger ones may be seen with the naked eye. The spots are varicolored from reddish to yellow or may be colorless, and are generally circular in shape. In the center, the film base is exposed and the emulsion removed and redeposited at the edges, rather like a miniature moon crater.

Certain conclusions can be safely drawn:

(1) Although image line damage has and does occur, generally speaking these spots are confined to the opaque areas and hence do not seriously impair the legibility of the image.

(2) The location of these spots is generally confined to the first few feet of film in a roll, in particular on the edges, and seldom penetrates beyond. When it does, the concentration becomes progressively less as the film is played out.

(3) The spots are very infrequently if ever noted on positive silver prints, due perhaps to the lower concentration of silver halide.

(4) There is a greater frequency in rolls than in aperture cards, jackets or fiche.

(5) This phenomenon is confined to microfilm and is not found in motion picture or other roll films.

(6) Films stored in certain geographical areas of the country have a low incidence of blemishes.

No positive conclusions as to the *cause* of these spots can be drawn, however, I received scant comfort from a Bureau of Standards man who visited the plant a year or so after the

Great Discovery. He was pleasant enough but floored me with his helpful suggestions. The humidity in the vault, he explained should be kept between 30% and 35%; the temperature between 60° and 65° Fahrenheit. We should store the film in other sulphite boxes; rubber bands should never be used to hold the film on the reels; or for that matter manila wrap-arounds. Interior air should be filtered and constantly circulated. We should never wax the floors. Interior painting must be banned. Ross-Crabtree and silver nitrate tests should be run at least weekly. The wash water should be filtered. The dry-box temperature in the processor should not exceed a certain temperature (even if it didn't dry the film I thought glumly). It would be advisable to eliminate the hypo eliminator. On he went with more helpful suggestions.

'What causes these spots?" I asked.

'We don't know," he said. "That's the reason for all these precautions. We *think* that a certain combination of conditions produces these blemishes. The trouble is we don't know the key to the combinations."

Although the cause remains a mystery, several preventative treatments show promise. Kodak has its gold protective treatment and gold lacquer for instance. Iodides added to the fixing bath appear to make the film more resistant in accelerated tests. Some claim that the use of hypo eliminator gives one a false sense of security; that it does not truly help to eliminate the corrosive acids in the fixing bath; it merely changes their character so that it cannot be detected in the Ross-Crabtree tests. Whatever the cause, today no one knows what it is. Tomorrow, maybe.

A WORD ABOUT COPYRIGHTING

Ideas and creative thoughts occur only in the mind. These may be expressed vocally, to a limited extent by pantomine, or graphically by some form of intelligible symbols, from Braille to the cathode ray tube. Just as the offset press is a copying machine so surely is the microfilm camera. So we must concern ourselves with the right of copying – copyright laws, plagarism, ethics or just plain stealing. And equally important, the effect of the information explosion and automated information transference upon present and future research.

It is safe to say that thus far practically nothing originates on microfilm, or perhaps we should say makes its first appearance. Even Jerry Sophar's *Wildlife Disease Journal* contains previously printed material, either copyrighted or otherwise. So let's face it; we are, at least at present, just in the copying business, with no *ifs* and *ands* about it. Such being the case, it's nice to know if you are an honest man. Chances are you'll never violate any copyright law, but it's easier than you think.

No one could have been more ignorant than I was back in 1950 when I opened up shop, and I am certainly no expert some twenty-six years later. All during this period I went merrily along my way with my own set of rules (more ethics than law) which I studiously observed, sometimes to my own detriment and sometimes otherwise.

Like the time I received a long distance call from a stranger named, for convenience, George Pincer. Mr. Pincer asked if I would be interested in filming thousands of pamphlets and scientific journals for him on a continuing

basis. The sources were to be university libraries and the scope national. As usual I was pretty hungry at that time, and realized the potentialities of republishing out-of-print scientific data. Two questions tempered my enthusiasm though: What kind of credit rating did he have, and was this project going to be legal? I quickly decided to broach the last subject first and worry about the money later. Very coolly I stated if no copyright laws were violated, I would be glad to do business with him. Mr. Pincher assured me everything was above board; either in the public domain or not copyrighted. Rather loftily I answered that I would consult my lawyer and for him to check back with me. Well, he never checked back, and instead went into the microfilm business himself. Had I been better informed in these matters, I might be rich today. It turned out there would have been other problems, but copyright violation was not one of them.

Rather shamefacedly I admit to another story. A friend of mine, a lawyer no less, brought in four rare maps for me to admire, or so I thought. As he went on talking, he deplored the price the New York dealer wanted. Would I copy them before he sent them back? My innate honest rebelled, but the lawyer was facile. Finally I agreed to copy the maps, and figured a way to salve my conscience at the same time. I would make one set for him, one set for myself (they were beautiful maps), and the third set I would give to my church bazaar, and the bazaar would make $50. Actually, I can't decide what I did that was wrong: No copyright law was involved, no plagarism, no outright theft. A copy of a map is certainly not valuable like an original. Oh well. . . .

Back to the matter in hand. The existing statutes were written long ago, many years before the birth of that tri-headed monster, Xerox-computer-microfilm, reared its ugly heads. These safeguards were adequate if not perfect while the only means of copying was performed by an amanuensis, a lower case artist. Even when the amanuensis gave way to the

typist, there was no problem. But ever since rapid copying methods were introduced, the perpetuation of the safeguards has become so complex that Congress has repeatedly shied away from enacting new legislation for fear of treading on too many voting toes, or to put it more kindly, for fear of being unfair.

Actually the Constitution, in its first Article, eighth section, provides the basis for the protection of authors with this: "The Congress shall have power...to promote the progress of science and useful arts by securing for limited times to authors and inventors the exclusive right to their respective writings and discoveries..." In these United States, this vague guarantee seemed to satisfy most persons (particulary the plagarists) until Noah Webster came along and persuaded the Connecticut Assembly to pass legislation protecting his *Spelling Book* from piracy. That was in 1783. Within three years all of the original colonies except Delaware passed similar laws. A sluggish Congress waited a few more years before it admitted there was no problem and passed a national copyright law. From time to time this law was altered a bit but between 1909 and 1947 there was no updating at all, although some progress was made internationally. Finally in 1947 the 1909 act was codified and re-enacted as Title 17 of the U.S. Code and amended to conform with the Universal Copyright Convention which included reciprocal copyright protection for scientific and technical works on an international basis.

Since that time absolutely nothing has been done by Congress, despite countless committee hearings and agitation by all interested parties. Felix Morley, who has become quite an authority on the subject, thought in 1967 that a new day was finally dawning. Said he in the foreword to *Nearer to the Dust*: "Most knowledgeable persons agree that the 1967 bills, or something very similar to them, will be enacted into law before the term of the 90th Congress expires. This will be

followed by a period of national let down during which copyright revision will be moved to the sidelines on the mistaken impression that 'something has been done.' Something will have been done, of course, but it is the author's opinion that it will not be enough to solve some of the basic problems which the revision set out to correct."

Congress conveniently sidestepped the issue, and failed to pass even what Morley termed inadequate legislation.

What then is the problem? Why should it be difficult to provide legislation that is fair to the author, the composer, the artist? We, or at least quite a few of us, believe in the capitalistic system, the theory that we are entitled to receive monetary rewards for our efforts. But if we manage to protect the producer and the publisher, we are quite apt to retard the flow of information and that is something no one wants, including the publishers. Consequently we have two sets of protagonists, each with opposing interests and naturally views. If the writer, the publisher and the printer are not protected, the writer will not write, the publisher will not publish, and the printer will have nothing to print. Our other group consists of the *avant garde* librarian, the educator, the teacher and the researcher. This vociferous coalition recognizes that a writer must eat, but not necessarily well. Regardless who starves or is hurt, the dissemination of information must not be impeded or restricted. This is a dilemma that will be aggravated as more and more information appears in microform.

Fortunately many areas present no problem. Certain documents cannot be copyrighted, and hence freely copied.

(1) *Standardized Forms.* This includes pre-printed forms, such as checks, graph paper, standardized clauses in contracts, mortgages and other legal forms. Also calendars and music forms — provided no original artwork or composition is involved.

(2) *Government Publications.* It is federal policy that no

goverment publications are copyrighted, and that includes all official documents, reports, bulletins, registers and circulars issued by any agency. There is but one if: if any of these publications include copyrighted material by some non-governmental writer, then permission must then be obtained unless otherwise specified.

(3) *Works in the Public Domain.* The present laws state that a work may be copyrighted for 28 years, and if desired renewed for another 28 years. After the expiration of 56 years at most, it falls into the public domain and cannot be renewed. However, (and in this field of copyright we continually run into those magic qualifiers; (*if, but* and *however*) the law provides that abridgements, adaptations, arrangements, compilations, dramatizations and even translations are regarded as "new works subject to copyright."

(4) *Fraudulent Works.* These can be copied freely if you feel so inclined, since they cannot be copyrighted. You may land in jail for another reason, but certainly not for copyright violation.

Many other types of documents not subject to copyright laws may be copied — with certain restrictions, some of which are plainly evident.

(1) *Public Records.* There are no restrictions in copying any public record, whether it be the minutes of a council meeting or a tax declaration, except when the information resulting differs from its original purpose. Normally permission would not be granted, for example, to film county records for the benefit of the local Merchants' Association, or to compile a mailing list.

(2) *Personal and Private Records.* Copying can be done at the request of the owner only, and obviously no additional copies may be given away, sold or retained without express permission. There have been instances where private organizations refused to film for security purposes because of fear that the service company would betray confidences.

(3) Newspapers fall into a vague neither-fish-nor-fowl category. Newspapers contain copyrighted syndicated articles, press association releases (AP, UPI, etc.), editorials, local news releases and non-copyrighted articles. Yet the right to microfilm, either at the request of the publisher or the owner of the material (a library perhaps) has never been seriously questioned, nor the right to distribute film prints, nor hard copies.

Thus far we have had fair sailing, and it appears we can microfilm pretty much what we want. But there are definitely some forbidden grounds, and quite a bit of gray area.

The copyright problem is intensified, because the book is allegedly going out of style. Mr. Gipe, in his *Nearer to the Dust*, has a fictitous twenty first century historian state the demise thus:

"Late in the twentieth century, the book died. Or was killed. Before the end came, it had functioned as educator to the world, bringer of culture and information to mankind, and, in its own way, was often a work of art or display of fine craftsmanship. Its growth was slow, spanning several centuries; from the hand-copied manuscripts to the hand-operated press, from hand-movable type to the rapid machine-movable type of the mid-twentieth century, the book developed over a long period with no essential change in its character.

"Then, suddenly, it was discovered that an asset which had serviced the world for so many years was no longer serviceable. What had existed for centuries, yet was still a lively youngster, became a senile antique overnight.

"By and large, the book was killed by good intentions. From the book, librarians earned their living, but they killed it; with the book, scholars learned their craft; but they killed it; making the book, publishers prospered, but they killed it; from the book, copiers took their raw materials, but they killed it; and the public, not knowing how deeply affected it would be by the death of the book, made no attempt to

prolong its life. . ."

Regardless of the form in which it appears, we run into copyrighted materials which *cannot* be duplicated without the express permission of the author. The law is explicit. There are however a few minor exceptions generally grouped under what is known as the "fair use" clause, a non-statutory doctrine. Gerald Sophar limits "the 'fair use' concept [as permitting] no more than trival and harmless duplication of the copyright holder's property." The Register of Copyrights isn't much more explicit, saying "That ['fair use'] term eludes precise definition; broadly speaking it means that a reasonably portion of a copyrighted work may be reproduced without permission when necessary for a legitimate purpose which is not competitive with a copyright owner's market for the work." You can copy isolated pages out of a book; possibly you can copy a whole pamphlet if only one is available; and if the purpose is research, you can be more liberal in your copying than if the purpose is only pleasure. No one knows even approximately where the line should be drawn. Upon man's conscience depends the meaning of "fair use."

The G.S.A. "Copying Equipment" handbook leans over backwards in an effort to be just:

"Copying laws are almost in the same category as speed limit laws — people forget they are there. Although the former involves much less risk than the latter, the only penalty can be much greater. Most documents which are prohibited by law from being copied have their source in state or federal government. In case of doubt, legal advice should be obtained.

"The most frequently violated law is the Copyright Law: namely, that law which prohibits the copying of copyrighted material without permission.

"The Copyright Law is intended to protect the publisher or author from plagarism. It gives him the right to say who may reproduce his written or published work, and to demand

payment for it. However, the current widespread use of copying machines in reproducing literary works goes beyond the question of plagiarism. It is beginning seriously to affect the sale of published works, such as magazines, textbooks, and technical papers. Prior to this time, a user of such works desiring to have possession of a copy was obliged to purchase the publication if he could not borrow it for an indefinite period. Today it is relatively simple to make copies of almost any printed matter by means of the office copier.

"Because the copier has made it easy to reproduce published works, extra precaution is necessary. Where a notice of copyright is shown, either on the work itself, or by a general statement in the publication, the law is clear; it may not be copied unless permission of the publisher or author is obtained. Where doubt exists as to whether or not an item is copyrighted, the legal officer should be consulted."

The problem that confronts us is manifest: it is essential to protect the writer-publisher, and just as essential not to impede the dissemination of information. To solve this problem is just as much to our interest as to the printer. Original publishing in some microform is bound to become a factor in publishing at some time; republishing is already here. Making hard copies from microfiche is considerably easier than from a book. The step-and-repeat printers can make enlargements of a whole card, some 40 or more pages, by the twist of a dial at two cents a page. Or the microfiche itself can be duplicated for about a nickel. Is it humanly possible to control this? How? One book on microfiche can easily perform the same function as a dozen volumes. How can the author be adequately rewarded? Or should he?

The Encyclopaedia Brittanica intends to publish a series of resource libraries with all the books contained on ultrafiche. A 20,000 volume stock can be produced thus for approximately $15,000 — one tenth the cost of a book counterpart. Not only this, but search time will be cut

enormously, not to mention the savings in space and shelving. A Brittania spokesman notes that "will enable many institutions to possess the recourses of the world's most distinguished libraries for a relatively small part of their library budgets." This undoubtedly will not jeopardize any author's rights, but it gives one an inkling what micro-publishing can and will do.

I do not pretend to have the solution, and for that matter, I can't find anyone who has. There is one way out — government subsidy for the author, the publisher and the man who converts the work into intelligible form. Although no one wants socialized publishing, the current status of various technical journals shows the seriousness of the situation. The well known *Chemical Abstracts* in 1940 commanded a subscription rate of $6.00 per year. Twenty-five years later, in 1965, subscribers forked out $700 for the year and non-subscribers a discouraging $1,200. In 1940, the journal received no federal assistance. Today it receives funds from both the National Science Foundation and the National Institute of Health. While it is true that the periodical is more voluminous than it was twenty-five years ago, still its curriculum remains small (some 1,420 subscribers). In addition to increased physical size and mounting publishing costs, indiscriminate copying has been largely responsible for the Abstract's troubles.

Now, in small part, you understand why Congress has been derelict in enacting appropriate legislation.

ANECDOTES

If you've taken this book fairly seriously and done your homework, you're ready to enjoy some of the fruits of your endeavors. Maybe that's a bit of an exaggeration, but at least this chapter shouldn't be too arduous. It's designed for your pleasure, and your pleasure should be in proportion to the general knowledge you've absorbed.

A few of the stories, particularly at the beginning, have no bearing on microfilm *per se*, but since the events actually occurred in a microfilm shop, I feel they have a right to be included. Also there may be some stories that would be much more enjoyable if you knew personally the principals. Maybe you'll be that fortunate one of these days.

There was once a charming girl who was being groomed to be my secretary, a formidable position, as I am hard to get along with. This gal had worked her way up, starting with preparation, then camera operator, assistant 16mm supervisor, and finally as receptionist. She was smarter than average, better educated and knew more about microfilming than anyone in the plant except the production manager. But she knew nothing at all about holding down the front desk. The very first day in her new job she called me on the intercom in a gay little voice to tell me a Mr. Brown was waiting to see me. The word *Brown* didn't strike a responsive chord in my memory, so I asked, "Who's he with?" She didn't hesitate. "Oh, he's by himself."

Some months later after she had passed the receptionist's examination with colors (not necessarily flying), she became my secretary. One day I dictated a letter to my friend Hank TenEyck up Syracuse way. Thinking that *anybody* would know how to spell the name of such an international figure, I failed to spell it out. The letter appeared on my desk sometime later neatly typed, addressed to "Mr. Henry 10 Ike."

For many years there was with us a most remarkable fellow, a 35mm microfilm operator not only exceedingly competent but a character on the side. Born and bred in the Carolina mountains, he was a little uncertain about his English, and if the going got rough, he mispronounced without shame; and if the word he wanted was elusive, he didn't hesitate to invent a more colorful one.

One day we were having coffee break, he and I, and the subject turned to women as it has a habit of doing. I remarked that maybe I was getting old, but it certainly seemed that girls had better builds than they did when I was more available.

"Oh, it ain't that, Mr. Mann," he assured me. "It's them girdles they wear. Girges in their bellies and squidges up their hips."

Sometimes he cheated a little bit and stopped filming to read an article in an old newspaper, something we don't advocate for a high production rate. He was reading a story about a certain sheriff who had been bested in a fight.

"Listen to this, Mr. Mann," he said, as I was walking by. "Turner hit the sheriff. He lost his aquarium and fell down prostate."

Somewhere along the line, we hired an alleged bookkeeper who had much more confidence than ability. One of her duties was to type up all purchase orders and send them off. Of course she was supposed to have them checked by either the office manager or myself, but she was so assured that sometimes she just sent them off regardless.

My handwriting leaves a lot to be desired, particularly legibility, but nevertheless one day I scribbled out an order for our new scribe.

This is the way it read:

Microseal Corporation
7307 North Ridgeway Avenue
Skokie, Illinois 60076
6/m Mil-D Aperature Cards @ $18.93/m

Some two weeks later, I got a letter from Tom Anderson, Microseal's President and founder, who sent me a copy of the order he had received with the comment, "Jim, this about the wildest order we've ever received." It read:

Murosial
7307 North Ridgeway Ave.
Spokie, Indiana 60076
6m Mil-D Aperture Cardsl 18 and 93/m

Tom had gotten the order and deciphered it. And by the way, if you think that the zip code is just a nuisance, have another think. Note the city and the state were both wrong.

My position in the company varied from day to day.

Sometimes I was sales manager or administrator, but more often I was father confessor, lawyer, doctor or financial advisor to the employees. This particular morning, my secretary (not the one previously mentioned) called me on the intercom and said she would like to speak to me. She came in and sat down, demurely brushing down her skirt so only her knees showed. This, by the way, is a pretty sensible maneuver around an old goat like me.

"Mr. Mann, I hate to bother you," she began with the standard opening gambit. I readjusted my eye level, uncertain as to the hat I was about to don. "But," she continued, "I have been having some kidney trouble lately, and I wanted to ask your advice."

So I was to be a doctor today. I nodded professionally, and tossed her an encouraging smile.

"Well, Betty Black in the back has kidney trouble too," she continued. I was about to suggest that kidney infections were not contagious, but she added, "She has some pills. Do you think it would be all right if I took her pills?"

"What makes you think you have the same trouble as Betty?" I asked.

She was a pragmatist. "Well," she said, "A kidney's a kidney, isn't it?"

This one came from a Recordak service man. He had received a call from the Charlotte processing station that a customer, a small bank, was sending in perfectly blank film. He wasted no time, and forthwith drove some fifty miles that same afternoon. The doors were closed for it was well after four o'clock, but he knocked long and hard at one of the side doors until he was admitted. He proceeded upstairs to the transit department, and was greeted by a bookkeeper seated at the ailing microfilm camera and feeding through a large

stack of checks.

"What brings you here?" asked the bookkeeper cheerily. "We didn't send for you."

"No," said the serviceman, "But Charlotte called. Your camera is out of whack. You're not getting any pictures."

"That so?" he answered, steadily feeding checks. "As soon as I finish running these through, you can take a look."

There was a time when Blackie Wilson and I were partners. After we merged he ran the shop near Camden, S.C., while I held down the fort in Winston-Salem. We had unmerged by the time the 1958 NMA convention took place in New Orleans, but we were still friends.

One noon, Blackie asked a few of us up to his room for a drink before lunch. We were all sitting around – Henry McGuire, Hugh Fiefield, J. Smith, Blackie's charming wife Sandy and my Mimi, and as usual the subject was mainly shop. Someone asked Blackie how his business was getting along.

Blackie has never been one to underestimate the size of his business, his future prospects, his capabilities – he doesn't brag: he's simply a born optimist. In answer to the query, he bubbled with enthusiasm. "Fine," he said. "Wonderful. Never been better."

About that time I looked in the bathroom. There on the shelf lay the scrawniest toothbrush this world has ever seen. The bristles were worn down to mere nubs. It is doubtful that five years of constant scrubbing could have resulted in such a sorry piece of dental equipment. I simply couldn't resist the temptation, and emerged from the bathroom, holding aloft the toothbrush.

"Gentlemen," I crowed. "And he says business is good!"

* * *

Sometimes problems arise that are not resolved by mere logic, or even reverse thinking. One needs to be clairvoyant. Once, in a certain office, a camera started acting up, and neither the regular serviceman, the branch service manager, the division service superintendent nor even the research department could come up with the cure. This particular camera produced good film part of the time, and part of the time it filmed the reverse side of a check, but refused to photograph the front. The pattern was fairly consistent; the first half of a roll would be faulty, while the last half would be perfect. Sometimes, but rarely, a whole roll would come out all right, or a very short stretch at the beginning plus the last part. Regardless, the Kodak people practically rebuilt the machine, even changed its position in the room it was located, all to no avail.

One day the local serviceman was sitting in the office around noon, glaring balefully at the recalcitrant camera. Promptly at twelve, the office force sifted out into the hall. One girl, on the way out, walked over to the camera, raised the top, pulled out a paper bag containing her lunch, replaced the lid and walked off.

"Eureka!" shouted the serviceman (he actually said something quite different).

The problem was solved. The lunch bag had been deposited daily by this new employee between a mirror and the camera lens, effectively blocking out the image. When she removed the bag, she did the equivalent of opening the shutter.

This industry has had its share of black sheep, one of which "set microfilm back twenty years in North Carolina" according to Kent McDaniels, one of Recordak's old timers. This black sheep we will call George Bowen. He was a carpetbagger come-lately who appeared in Raleigh from northern parts shortly after the end of World War II, while

people still remembered V-Mail. Bowen had at least one good attribute: he was enterprising. His first move was to enlist the financial support of a certain Mr. Parks, the owner and editor of the afternoon paper, *The Raleigh Times*. Mr. Parks commanded the respect of the community, and considered himself progressive; politically, ethically and financially. Hence he easily fell victim to Mr. Bowen's blandishments and dramatization of microfilm's future. Having secured a combination mentor and angel, his next step was to find a suitable location for his shop. So he visited the N.C. State Library and introduced himself to the librarian, Miss Carrie Broughton. No, she had heard quite a bit about microfilm, but she had never seen a camera actually in operation. Wouldn't she like to have him set up a display right in the library, where not only she and her staff could get firsthand knowledge of the process, but the interested public as well? That was very thoughtful of Mr. Bowen, and since he came so well recommended, she would secure a spot for him right away.

The spot turned out to be adequate for setting up a large planetary camera with plenty of working space around it. Now all that Bowen needed was some business. Of course his first client didn't require a hard sell; Mr. Parks gladly turned over his back files for filming. Oh yes, Mr. Bowen also needed someone to operate a camera if he were going to devote his time to selling. He hired a local girl, gave her a minimum of training (since he didn't know too much about the business himself), and set off.

Back in those days, there weren't too many people in the newspaper microfilming business. Recordak and Micro-Photo divided the market between them. Aside from these two, at least in this section of the country, there wasn't any competition. Bowen proceeded to solicit business, gaining little headway until he tried that old and trusted gimmick, price-cutting. In this he became remarkably successful. Soon

he had enough business for his one camera, but to his consternation he didn't seem to be making any money, even with a rent-free office. Meanwhile, he was developing an insatiable taste for wine and women, and these two hobbies added materially to his overhead. Rather foolishly, he cut his prices even lower in a hopeless move to bolster his foundering economy – and stopped paying his bills. The latter gave him temporary relief.

Some six months after he had set up his plant in the State Library, Miss Broughton happened to walk by. Her tacit understanding had been that the display would last for a few days, or two weeks at most, and here was this man free-loading for six months. For some reason, no one had thought to bring it to her attention. She summarily kicked him out of the library. He didn't stop at the sidewalk but packed up and fled from town, leaving a trail of unpaid bills. Mr. Parks was poorer, wiser, and not kindly disposed to microfilming when I called on him a few years later.

The worst is yet to come. No one had thought to inspect the film he produced. The word spread slowly, but finally his customers, *all* of them, discovered their film was out of focus, not illegible but, let us say, it strained the eye. The files, often the only existing ones, disappeared with Bowen.

There's One More River To Cross. . . .
Frank Brady, the sales manager for Atlantic Microfilm in Spring Valley, is too busy selling equipment to worry whether his customer is a Democrat or a Republican, much less what his international status is. So when he received inquiry from Amman he got out his World Atlas and saw Delta Film Ltd. in Tel Aviv was the closest dealer geographically. Tel Aviv is, of course, in Israel and Amman is in Jordan. Frank routinely sent the inquiry to Delta. A few weeks later he received this

reply from a Mr. Sorenson:

Dear Mr. Brady:

Thank you for your letter of May 26, 1969, concerning the request from Amman.

I sincerely regret that we are not able to handle this matter since two years ago we managed to get to the River Jordan but did not cross it and Amman is still the Capital of Jordan.

Yours truly,

Delta Film Ltd.

G. SORENSON

Hidden Treasurers. . . .

The 1915 *Winston-Salem Journal Sentinel* contained an advertisement picturing a handsome wall clock available for $1.50 if accompanied by the ad. Some forty odd years later, the *Journal* received from an individual in New York this clipping with $1.50 dutifully attached. The paper made quite a play of it with lots of news stories including the difficulty of finding a suitable substitute clock. Everyone was happy, particularly the recipient. Turned out he was a microfilm operator, filming the back issues of the *Journal*.

A Real Powerhouse. . . .

Several years ago we received an inquiry from Korea.

The manager of the inquiring firm was justly proud.

"We are powerful importers of machinery. . . ." he began.

Coming Events Cast Their Shadows. . . .
One of our competitors found his newspaper film had unpleasant dark undulations at the bottom, one on each page and looking for all the world like the shadows of a volcano. He was frustrated because the cause could not be located. Finally he watched the actual filming operation one day. The girl was big and strapping with over-developed mammary glands. When she clicked the shutter, she involuntarily leaned forward, casting a pair of shadows on the paper, one on each page.

Ah, yes, the (good) old days! Maybe I'm a sadist, but most of the funny stories are at the same time sad, and originated eons ago, not today as we bask in a milieu of glamour. Karl Adams can regale you for hours on the vicissitudes of the '30s, one of which is particularly appealing. Karl, as you know, started Graphic Microfilm in the middle thirties which later split into Graphic Microfilm of New York and Graphic Microfilm of New England.

Karl told me this story at a meeting down at Ocean Reef on Key Largo one night.

"Jim," he started, "We built this unit, the first reader-printer to be used for submarines during World War II, and we were asked to demonstrate it up and down the coast to the various Navy Yards. With me went this engineer who was a complete screwball — he really

wasn't an engineer at all, but he had lots of brass. He was what they call a 'spit and string' type designer.

"Well, he was demonstrating this unit to a crusty old admiral, and projected some drawings on the viewer, some of which happened to be 25 or 26 feet long, and the admiral said. 'This is no good to us to have to do this in sections. We'd lose the following of a pipe line or anything of that nature.' Whereupon my friend the designer blithely volunteered, 'Well, that's all right, we'll just build you a camera that'll make it in one continuous image.'

"Now these drawings were 25 to 30 inches wide and maybe 25 or 30 feet long. This had never been attempted before in the microfilm business. There were continuous flow cameras as you know — Recordak has made them for checks and even newspapers, but never had anything been designed for engineering drawings.

"Well, here we were, committed to build this camera. After a lot of problems, synchronization and all that, we came out with what we called — and get this — the 'Micromultimatic Camera'. It took care of drawings up to 42 inches wide on either 35mm or 70mm film, and also had a projection device that enabled the camera to double as a reader and an enlarger. Incidentally, as far as I know it used the pinpoint source of light — a locomotive headlight lamp."

Karl leaned back and looked vaguely happy as the past flashed by. "So after we developed this camera," he sighed, "I went out and sold a contract to the United Shoe Machinery Company of Beverly, Mass. — which was the first large engineering contract ever sold on microfilm. This, mind you, was in 1939, thirty-six years ago."

"What about the Navy?" I asked.

Karl looked at me tolerantly. "This is my story," he

said sweetly, "And I'll tell you about the Navy another time.

"Anyway, I went out and sold this contract, and we worked out a whole indexing system on 3x5 cards and so forth. The camera was by now completed. We ran a few tests on it, and the results looked pretty good, so we broke it down, trundled it to Beverly and installed it.

"At this particular moment we were in the process of moving our company from the center of Boston out to Waltham. At the time we were using the good old deep tank and rack system. If you remember you wound the film around the rack and then you dipped it in a tank by hand and timed it and so forth. We were moving all this out to Waltham, and I had it all planned that we would do the moving over the week-end and be able to start processing again on Monday, and we would know exactly how the new camera was going. Best laid plans go awry, and it was a week later before we got our processor going. We developed the first fifty rolls from the new camera. I looked at them, and they were all out of synchronization — double images throughout. You could read it; in fact you could read it twice.

"So here I was faced with a situation, and how was I going to handle it? We'd spent a lot of money building this contraption, it was our first big job, and I didn't know what the attitude at United Shoe was going to be. But I could certainly guess. The guy who was in charge of the filming was a hard-bitten Down-Easter, and I was scared to death. I remember driving all the way down to Beverly with a roll of film in my pocket and wondering "What am I going to say? If he doesn't like it, he's going to throw me out and it's going to be all over, and that's the end of my company and investment and everything!

"So anyway, I walked into his office. In those days we had nothing to view the film on except a ten power

linen tester.

" 'You got some film for me?' he asked. When I said yes he said, 'Let me look at it.' He took the linen tester and the roll of film, walked over to the window and screwed up his eye. 'I think it looks pretty good,' he said. 'I can read most of it okay. That's fine. What do you think of it?'

"This was my chance. 'I think it stinks,' I said.

"There was a dead silence, and he said very quietly, 'What do you mean, it stinks? *I* can read it.'

" 'Yes,' I said. 'You can also read it twice if you look carefully; you've got a double image there.'

" 'What caused that?'

" 'It's out of synchronization. That's all,' I said.

" 'What do you propose doing about it?'

"Well, everything was lost, so there wasn't but one thing to say. 'I'm going to take the machine out.'

" 'When are you going to bring it back?' he asked.

" 'I don't know. I'll bring it back when it's right.'

"I waited for the axe to fall. There was a sort of a pause, and he turned to me. 'Say, Adams,' he said. 'You know what we've got way down at the end of this building?'

"Probably a place where they shoot over-eager salesmen like me, I thought, but I said, No. What is it?'

"He said, 'It's our developing laboratory. It's where we develop and test all our new machinery.' I looked and felt befuddled. He continued. 'How often do you think a new piece of machinery works the first time? Well, I didn't expect this to work right away. It's too new. You take it back, and when it's ready, you bring it back.'

"I could have kissed him. We took the unit out. It took a full month, but when we finally brought it back, it worked, and as a result the old gentleman sold some

of the biggest accounts around New England for us. . . .But I'll never forget that drive down to Beverly with that roll in my pocket."

Speaking of automobile rides, Joe Curtin, who inherited Graphic of New England's throne from Karl Adams, had a rather famous ride of his own. This anecdote has been excerpted from 3M's *The Hole in the Card*:

In 1948, Joe Curtin was sitting in the lobby of a New England clock manufacturer. Next to him a salesman was talking to the office manager. The salesman was holding a McBee "Keysort" card with a frame of microfilm mounted in it. It was the first aperture card Curtin had ever seen. He couldn't help overhearing the ensuing conversation as the McBee salesman explained the principle of attaching the record to the key to its location. Curtin, his mind working furiously, got the general impression that the salesman didn't know any more than the office manager about what to do with the card.

At that time a large volume of work being done by Graphic Microfilm of New England was recording engineering drawings on roll microfilm for security. Curtin immediately saw the possibility of using aperture cards to provide drawing accessibility as well as security.

Back in Waltham, he dropped in on the local McBee sales manager and offered to supplement his coverage in the New England states. The manager was delighted because his own men didn't call on engineering

departments, but McBee's home office scotched the proposal. Headquarters said pointedly that it had a national sales organization with direct distribution.

Although his interest was undiminished, Curtin was unable to do anything further until early 1949. Then, while on a sales call in Bangor, Maine, he received a long-distance phone call. On the other end of the line was Richards in New York City.

Film 'N File had just terminated its relationship with McBee. The firm was still going the "systems" route but was also picking up a few selected microfilm dealers around the country. It now looked like engineering drawings might be a major aperture card application. Would Curtin be interested in taking on a New England dealership for Film 'N File?

The answer was yes. Curtin had decided that only through the "systems" approach would the microfilm field grow and prosper. The aperture card seemed to be the key to this approach.

However, Curtin felt that teaching "microfilm" to "systems" people was putting the cart before the horse. He believed that the best approach was to get "microfilm" people and teach them "systems." To prove his point he made a major decision. He decided to devote 50 per cent of his sales time to attempting to convert present engineering drawing customers to aperture cards. That conversion was to take time.

Meanwhile, Film 'N File was working closely with Rau of General Electric in the development of card-mounting and processing equipment. However, no sales of microfilm aperture cards for engineering drawing applications were being made anywhere.

Six months elapsed. Then one day Curtin received a phone call from Decker, Film 'N File's new sales manager. Decker wanted to spend a day in the field

visiting Curtin's "hottest" engineering drawing prospects. Curtin suspected that Decker was really on a mission to scratch Graphic Microfilm of New England from Film 'N File's distributor list. He could almost feel the ax.

Curtin's three "hottest" prospects were in three counties and two states. Nevertheless he set up the appointments for Decker's arrival. Only recently departed from McBee, Decker was still used to talking to twenty-five or fifty salesmen at a crack in the field. Curtin had only six people in his whole company. When Decker arrived, Curtin brought his vice-president and his office manager to an early morning meeting with the Film 'N File sales manager. The three tried to act like thirty. Then Curtin went with Decker for a ride — possibly his last as Film 'N File distributor.

The Graphic Microfilm president realized Film 'N File wanted no more talk, but that was all he and Decker got at their first two stops in Ashland and Worcester, Massachusetts. The reception at both companies was the same. "These cards are fascinating," they were told. "Maybe someday we'll be able to sell management."

Decker was not pleased. Not only were prospects saying the wrong thing, but he was spending a whole day being driven all over the countryside, from county to county and state to state, to hear them say it.

It was mid-afternoon when Curtin pointed his car in the direction of East Hartford, Connecticut, fifty-five miles southwest of Worcester. In East Hartford was the Hamilton Standard Division of United Aircraft Corp., the last call of the day.

An uncomfortable silence settled in the car as it nosed into the setting summer sun. Gentle peaceful farm lands rolled by as Curtin grimly considered the possibility of six months concentrated sales effort going down the drain. He returned from his reverie at the sound of the

motor coughing and cutting off. The car had run out of gas.

Curtin glanced at his watch. It was 3:30 p.m. That was when he decided it was just going to be one of those days. Fortunately there was a farmhouse close by. He and Decker walked back and bought a dollar's worth of gasoline. They arrived at Hamilton Standard at 4:00 and were ushered into the office of the supervisor of engineering records, Henry H. Clark.

Hamilton Standard was in a very overcrowded location in East Hartford. The firm had run out of space for storing original engineering drawings. Clark had been toying with the idea of using microfilm as a method of storing original but inactive or obsolete tracings. He knew the space saving advantages of microfilm because Hamilton Standard had for many years been using it in roll form for security purposes. However, to find drawings stored on microfilm rolls required the development of an extensive indexing system, a cumbersome and complicated procedure which Clark wanted to avoid. It was at this time that Curtin had made a call and dropped a "Filmsort" aperture card on Clark's desk. From Clark's standpoint, it couldn't have been at a more opportune time, for the "Filmsort" cards could be filed and found by location, eliminating the need for an index.

Now Curtin and Decker sat down in Clark's office. The engineering records supervisor turned to Curtin. "I have good news for you. I have been authorized to issue an order for 25,000 'Filmsort' microfilm aperture cards," Clark said. The Graphic Microfilm president almost fell off his chair. "We will use them to replace inactive and obsolete drawings. This will enable us to remove these drawings from our files but still retain accessible reference to them by means of the microfilm aperture

cards. At the same time we will be making room for newly created tracings. I talked this over with our management and they simply said: 'Anything you can do to save space, go ahead.' "

It was the first sale of aperture cards for an engineering drawing application. In terms of the futures of Graphic Microfilm of New England, Film 'N File, and the engineering drawing market for aperture cards, it was an occasion to be recorded in history.

Elated, Curtin and Decker left to celebrate. The fact that the order amounted to less than $200 was forgotten. The significant point was that now there was a user.

Over cocktails, Decker admitted to Curtin that the sale had relieved him of the unpleasant duty of cutting off Graphic Microfilm's dealership. He added that he was personally pleased because he had great faith in the future of microfilm aperture card systems.

* * * * *

One of the greatest hoaxes ever perpetrated on unsuspecting conventioneers was engineered by Wynn Crew of Dakota Microfilm at the NMA Convention in New Orleans in the year 1958. Rumors were rampant that an incredibly sophisticated piece of equipment was going to be unveiled at the convention by Mr. Crew. The Air Force flew in a few observers for firsthand knowledge, and the entire convention buzzed in anticipation. Here is Dean Ward's unveiling speech:

AUTOMICROMATION MARK IV

The Board of Directors of the National Microfilm Association has given a special dispensation to Dakota Microfilm Service to unveil on program time its new

Automicromation MARK IV in view of the special place it fills in the microfilmm field. As you will see, this machine when operated correctly will accomplish all of the tasks demanded of any machine in the microfilm field better than any other heretofore developed.

At the outset I wish to introduce my assistant at this ceremony, Dean Ward who is Chief Engineer, Designer and Supervisor of the manufacture and assembly of the unit from Dakota Park, St. Paul, Minnesota.

First of all, I would like to state that this machine is now protected by patent, since only this morning I sent a postcard to the Chief of the U.S. Patent Office applying for a patent. Therefore I am sure that many of you dealers in the audience will want a dealership. If you will form a line at the right of the stage after the demonstration we will be glad to take your applications. For your information we are offering a 60% discount. We finance all direct mail and other advertising promotion, and furnish all salesmen for the sale of this equipment. We are fully responsible for installation and service of the equipment, and all that is necessary for you to do is to bill the customer and collect your money. Those customers in the audience who wish to place immediate orders will form a line to the left of the stage when the meeting is over and we will pair you off to make sure that you have a dealer from whom to buy.

The machine will now be unveiled. You will note the series of flashing colored lights on the machine. These lights denote that the machine is operating correctly, and replace the usual lights which signal when the machine is not operating correctly. I would now like to demonstrate the machine in operation.

You will note that we insert a crudely folded engineering drawing into the throat of the machine. The machine will neatly unfold the document, remove all

staples, clips and rubber bands and place the document in the field for photographing. The picture is taken automatically on high quality film with a resolution of 240 lines per millimeter (120 lines on each side of the film). The film is processed immediately and you will note that there is no plumbing connected with this machine except one glass of water on the speaker's rostrum. After the film is processed, it is automatically mounted in an aperture card, the film is inspected and the old drawing is shredded and destroyed, thus eliminating the need for refiling the drawing.

Please note that when additional copies are required, the card is inserted back in the throat of the machine and out comes, not only a reproduction of the drawing, but also a full written analysis of the drawing. The penmanship is excellent. You will note also that the print is made without the use of chemicals, vapors, silver, powder, emulsions or other foreign material.

Finally, the manufacturer is sick and tired of all the usual salesmen's claims for business equipment. Invariably they assert that their particular equipment incorporates everything but the kitchen sink. We have therefore incorporated in this machine a kitchen sink in order to put an end to such claims once and for all. You will note that I insert a dirty dish from our breakfast table, and remove it a few seconds later.

(It was noted at the unveiling that the dish was withdrawn from the machine still dirty, and the unveiling concluded with the final remark, "Well, there are a few bugs left in this machine yet, and as soon as they are whipped, we will place it on the market.")

* * * * *

It helps an awful lot to have a sense of humor in this business. In the beginning it was essential, and even in the late

Metamorphic Period (1959), this attribute enabled a certain blueprinter out in Los Angeles to survive. He gave a talk at the NMA convention that year that is a priceless example of the rigors that the inexperienced can expect to undergo in this game. I am taking the liberty to quote it almost in its entirety.

THE BLUEPRINTER LOOKS AT MICROFILMING

by
Ed Godar

Whenever I make a talk I always try to jot down a number of good opening headlines, something with a punch; and as I put this talk down on paper I have been referring back to some of the headlines I wrote down some time ago. I have been unable to choose between the many, so I am going to use all of them and they go something like this: "A Blueprinter Looks At Microfilm And It Looks Right Back At Him And Says, 'Sucker'." "He IS Crazy If He Does." "He Shouldn't Have." "I Have Been Out Of My Mind Ever Since." "I Almost Went Broke In the Process." The so-called starts are so applicable to my experience in the microfilm business — so I leave them all in.

I didn't want to get into the microfilm business. I just sort of wandered into the back door by virtue of the fact that I got into the Copyflo venture, and as you probably know, this voracious monster turns out thousands of feet of beautifully clear, sharp, positive copies if you put a microfilm — a roll of microfilm — inside the machine. I got very much interested in the Copyflo process first, and it was only later, much later in fact, that I found out you must be an expert in the microfilm business before you can become an expert in

Copyflo. Of all the eighty-odd blueprint establishments in the Los Angeles metropolitan area at the time I went into the microfilm business I believe there was only one or two of them who had had any experience at all in the microfilm field. Several of them had been in it years past, and very sensibly went out of it; and since we blueprinters in the Los Angeles area are always free to exchange ideas among ourselves to help one another with various intriguing processes, you can readily see that I got a lot of advice from my competitors as to what kind of microfilm equipment I needed. The only good and sound advice I got was from Henry Davis of the Rapid Blue Print Company who had an elaborate microfilm installation some years back, and he said: "Stay out of it." But I was determined to get into the Copyflo business because I had a good prospect who said to me that if I were to get into the Copyflo business he had enough work of his own to keep this machine busy. Woe is me! And woe the day that I listened to him, because now that I am up to my ears in the Copyflo process I don't even get any work from this prospect. I don't know what happened to him, but apparently he became disenchanted with the whole idea.

The Haloid Company who sold me the Copyflo machine said, regarding microfilm equipment, "Oh, just get anything, any kind of equipment at all. You can't go far wrong." That was the day -- like leading the lamb to slaughter — me, wide-eyed and eager, minimized the microfilm end — just throw a hunk of film in the Copyflo, stand back and watch the dollars pile up, so it seemed to me.

So I decided then and there that I had better make a very exhaustive survey on the possibilities and the problems of obtaining the best microfilm equipment available. I had a nephew in Los Angeles who is a

salesman for a photo supply house, so I called him up saying, "Come out and tell me what you know about microfilm equipment." Now all he knew about microfilm equipment was that there was an outfit called the Eastman Kodak Company who, he believed, made microfilm cameras. He picked up a few brochures and brought them out to me; and after looking through the catalogs, we decided that the Kodak C-3, being the most expensive microfilm camera, certainly ought to be the best for our purposes. So I told him that he probably better order one. Now it so happened that he couldn't sell me this camera himself because they did not have a microfilm dealership from the Kodak Company. Therefore, he recommended some obscure individual who had a Kodak dealership and that is about all. This guy came rushing out with an order pad and said that I would have to pay him in advance because his credit was so bad with the Kodak Company that they wouldn't ship it unless he paid for it in advance. Believing that this was the normal procedure, I gave him the money. Later, much later, I found out through devious channels that he should have given me a 10 per cent discount, which also seemed to be the normal procedure. Now, I said to mv nephew, "What do we need in the way of processing equipment?" He said, "There is only one good processing machine, and that is the Houston Fearless which sells for $15,000.00." I said, "Now wait a minute. I don't think we are ready for a $15,000 processor at this stage of the game. What else is there that we can use?" He said, "In that case, I recommend the Nycor stainless steel reels and pans which will cost only about $600.00. However, since it is very important to maintain a constant temperature control in the developing, it will be necessary for you to have a temperature controlled tainless steel processing tank, which will cost you about

$3,000.00." Since this was a good deal less than $15,000.00, I told him to go ahead and order this equipment. I was assured by all and sundry that now that I had spent close to $9,000, I was all set in the microfilm business for years to come. There was nothing else that I could possibly buy that would enhance our adventure into the realm of microfilming except the addition of a densitometer, a microscope, a film splicer, and a few other minor items which came to roughly another $1,000.00.

Since there was no one in my organization who knew anything at all about microfilming, including myself, I decided the smart thing to do would be to hire an expert technician who could guide us and set us off on the right path in our new business. So I hired an expert at $600.00 a month, plus an expense account and an automobile, and he agreed to set up our microfilm equipment and get us off to a grand start so that we would make no mistakes. However, he said, "I am not cut out to do this kind of work as a regular profession. What I really want to do is research and experimental work in the construction of special photographic equipment, and after I get your department all set up I want your authority and approval to go ahead on some of my various inventions, all of which you can profit from." I thought this made sense, and I agreed that this looked like a bright future for all of us. So we got all of our equipment in and set up, and found out that we had to build a special darkroom for the temperature control tank and processing equipment.

The new tank was so beautiful and practical that it was promptly usurped by our Robertson camera department, and we never did get to process any microfilm in it. To this day, we are using an old tank with no temperature control. But we were proud of our

brand new expensive set-up. However, the very first Copyflo job that we bid on could not be run on the Kodak planetary camera. It seemed that it was a lot of cards that required a flow camera. This injected an entirely new dimension into our microfilm venture. What is a flow camera?

The guy who was bidding on the job against me did not have any Copyflo equipment, but he was a microfilm dealer, and I was told by my underground spies that he was going to run this on a Documat camera. Not to be outdone, I promptly ordered one of these units from him, in the naive belief that if he were to get the order, surely he would give it to me to run on my Copyflo after microfilming it on his Documat camera. It didn't work out this way. He got the order, microfilmed it, and gave it to somebody else to run on their Copyflo.

I had the Documat shipped to me by Air Express. This was nine months ago. I still have the Documat camera, but have never had occasion to use it; but I am sure that some day a job will come along in which I can use this very valuable piece of equipment.

The second job that came along was one that required Military Specifications. Since we knew nothing at all about this new and intrepid subject, here is where my Research Department came into play. My expert I had hired had reams and reams of so-called Mil Specs, and after poring through his literature, he came out with a plan of attack. It seems that all we had to do was microfilm the job according to the Mil Specs required, and send it to the customer who would then pass it on to the Bureau of Standards, and they would examine it. If it met the specifications, we could then proceed to do the job all over again.

In order to follow the Mil Specs exactly, it seems that we had to buy another $600.00 worth of accessories to

comply with the rigid specifications. By this time we were becoming Specialists, and you know the definition of a Specialist is the guy who is one step above the man who gets paid for overtime.

The second big Copyflo job that we had to bid on was about 50,000 3x5 library cards, and it seemed that these could not be microfilmed under either the planetary camera or the Documat. It required a special Recordak camera with an automatic feed. So we bought an RL Supermatic for $3,000.00 to turn out this $1,500.00 job. All of these cards had to be hand-trimmed, and I'm afraid to add up the cost of this hand-trimming job, but I suspect it came close to $2,000.00. Then we found out to our dismay that the Recordak rotary camera had a reduction ratio of 16 to 1, whereas the Copyflo had a blow-back ratio of 15 to 1; so you can readily see that we were unable to blow-back to original size. I then bought a Recordak Reliant camera which has such a hodge-podge of lenses on it that it has no set reduction ratio, but by a series of machinations it will somehow blow-back to 15 to 1.

I was bemoaning my plight to a competitor the other day who has been in the microfilm business for some 15 years, and he said, "What are you crying about having four cameras? I've got sixteen microfilm cameras, and every day a job comes along that I find I can't do on any one of my sixteen cameras. Before you are in this business very long you are probably going to wind up with a lot more cameras, because there is no microfilm camera made that will do everything."

Why didn't somebody tell me this a long time ago? While all of this was going on, we found out that we had reels of film hanging all over the shop, since we had no automatic processing unit that would fix, wash, and dry film. So my so-called expert who is supposed to be the

inventor, says, "Fear not, Boss, I will build a dryer for the film that will cost you practically nothing, and it will be most efficient."

At the time my expert was building the film dryer, I kept giving him ideas on how it could be improved. Finally, in exasperation, he said, "Now look, Boss, leave me alone. You have got me so loused up with your ideas that I'm afraid this may not work. Just leave me alone and don't louse me up."

Speaking of being loused up reminds me of the story of Leo Durocher and one of his rookies whom he had put out in left field. This rookie was so bad that every time a line drive came out it either went between his legs, over his head, around him, or somewhere else, but he muffed every one of them, and Leo was jumping up and down on the sidelines trying to instruct this rookie as to how to field these balls. Finally, he called him in and said, "Look, son, you are doing a very poor job out there in left field. I'm going out and play left field myself, and you watch how I do it."

Now Leo must have been off his game that day because the first two line drives that came along, one went between his legs and the other went over his head, and he missed them completely. In disgust, Leo threw down his glove, came back into the bull pen, and said to the rookie, "Boy, you've got that left field so loused up, nobody can play it."

We also found out that we should have an underlighted copy board, because many of the engineering drawings that we had to microfilm were printed on both sides, and they required lighting from the top as well as from the bottom. Here again, my expert says, "Leave it to me, Boss, I will build an underlighted copy board for you that will cost practically nothing."

Right about this time we got an order to make a duplicate roll of microfilm, and since there was no one in the area who could do this for us, my expert again stepped into the breach and says, "I know where I can pick up a microfilm roll printer for less than a hundred dollars."

It is now six months later. The elaborate dryer with infra-red lights and blowers and squeeges is still setting over in the corner — encompassed with a mass of wires and aluminum castings. It has never worked. The under-lighted copy board turned out to be a maze of fluorescent tubes underneath a piece of opal glass, and sometimes it works, but usually the lights go out right in the middle of an exposure. Usually the fluorescent lights are going on and off like a pin ball machine.

After we got our under-lighted copy board, we found out that the large 42 inch sized engineering drawings were not coming up sharp because they had to be under glass; so we bought a large piece of French optical plate for $60.00 that took four men to lift on and off the camera, and after three days of use we broke it. Then we found out that we could get a piece of opal plexiglass that could be laid over the under-lighted copy board, and by simply running your hand over the tracing a static was set up which held the tracing as flat as a vacuum board. This is information which I am not going to divulge to those who should find it out the hard way.

The duplicate roll printer has never been successfully used because it seemed that it was scratching the film; and my expert is now up to about $700.00 for repairs in gadgets that he is constantly adding to this unit to eliminate the scratches. In the meantime, we found a source who would duplicate these films for us at a piddling $3.00 a roll. But hope springs eternal with me. I am certain that one of these days we will be able to

make our own duplicates. As soon as my expert spends another thousand dollars on this duplicate roll film machine I will then have invested enough where I could have gone out in the first place and bought a good, workable unit from any one of three sources for less than what we have in this monstrosity.

We are still hanging our film up in loops on clothespins from wires strung around the shop. The reason for this is that I have not as yet found a film processor that I consider a good satisfactory tired and true workable unit.

Speaking of processors, the Remington Rand Company has a small film processor, the basic concepts of which are ones they have apparently stolen from someone else, although they deny this. They claim they make it in their own plant, but it is startingly similar to one put out by the Philadelphia Transport Company.

This processor sells for $1,850.00, and from all indications it may be the answer to what I need. So, the other day I called them up and said I would be interested in trying out one of these processors. But being of a rather skeptical nature at this stage, I said that I must have it on consignment because if it didn't work, I wanted to be free to return it.

They were quite taken aback by this order because apparently they had never sold one before. But after some cogitation on their part, several days later a salesman came out and says, "I'll tell you what I am going to do. We're gonna' give you one of these 'Buy a Package Deal' consisting of three of our microfilm cameras. The reason for this package deal is that we feel this processor is so good that we can only offer it to our dealers; and since you are not a dealer, you will automatically become a good friend if you will also buy three of the microfilm cameras." I daresay that up until

my request to purchase one of these they didn't even know what they had in the way of a processor, so I still don't have a processor.

I tried to become an expert in the microfilm field because I was completely frustrated by the information given me by all of the so-called alleged experts. No matter whom I asked about various microfilm problems I got a diversity of answers that were indeed confusing. So I decided to go to the source and find out for myself.

I went to New York and spent considerable time going through the Recordak installation in the old Wanamaker Building; and here, indeed, I did learn some very important things, as I felt that they had had more experience in our particular type of requirements than anyone else.

I went to the Microfilm Convention in New Orleans last April, but at that time I was such a neophite I didn't know what I was looking for, and I learned practically nothing there except that this was going to be an expensive operation, and that has certainly come true.

I went to Chicago last December to the Visual Communications Show, and there they had a lot of microfilm equipment on display, but unfortunately, they had more literature than they did equipment; because I have found out that everybody is trying to get into the act in this microfilm business, and there is an awful lot of equipment coming out that is still on the drawing boards. Unfortunately, very little of it has been tested or is available at the moment; and each manufacturer tells you, "Don't buy anything until you see ours. We have the answer insofar as adequate microfilm equipment is concerned." Unfortunately again, there isn't a one of them that is building their equipment to work with the Copyflo machine, and the Copyflo machine was designed, not around existing microfilm equipment, but

they went off on their own, with their various reductions
and enlargement ratios; and to this day, neither the
Copyflo people nor the microfilm manufacturers have
gotten together about a standard ratio of reductions and
enlargements. That is one of the reasons why we wind
up with 16 microfilm cameras.

When I was in New York over a year ago, one of the
prime purposes of my trip was to obtain a Filmsort
dealership because I was told by all and sundry that the
Filmsort cards were the coming thing insofar as Copyflo
was concerned, that the 24 inch machine could only
handle Filmsort cards, and that the market was
practically a virgin area; and that the first one in it was
going to make a huge success, so I importuned the
Filmsort people to give me a dealership so that I could
get in on the ground floor. They refused on the basis
that they had already made established dealers, and even
though I was the only one with a 24 inch Copyflo
machine to reproduce these Filmsort cards, they were
sorry, but I would have to wait until such a time as they
could make some adjustments in their dealership
arrangements; and while I was there I told them that one
of the things I must have was an optical mounter that
sold for $5,000. "Regardless, even if you are out of
production," which they said they were, "I must have
one. How can I do business without an optical
mounter?" Since they didn't have any, they sold me a
hand mounter for $650.00, plus about $1,500.00 worth
of other equipment to make duplicards and to view the
Filmsort cards.

Nine months later, I got my first order for Filmsort
cards, 150 of them at 25 cents each, and we mounted
them in this $650.00 hand mounter, which is actually
worth about $200.00. If you don't believe it, take a look
at it. So far, we have had no occasion to use the balance

of the $1,500.000 worth of equipment they sold me. Oh well, my friend, Scottie McArthur probably wouldn't have given me the dealership anyway.

P.S.

We are not yet to be classed as a genius in the microfilm business, because a genius is a guy who evades work by doing the thing right the first time, and to any blueprinter who is going into the microfilm business, I suggest that he become the best informed man in the business before he buys a piece of equipment; and if you are not confused, it is because you are not well informed.

When conversation palls, you can always revive interest by discussing domestic help if you're talking to a woman. If it's a man, be more general, just talk about personnel problems. Back in 1951, I was walking through the lobby of the Wachovia Bank and Trust Company with Dick Buell, the Director of Personnel. He was explaining that even with a few thousand employees it was still hard to find competent help in certain departments. I thoroughly agreed with him, and we moaned and groaned together a paean of pain.

"By the way, Jim," asked Dick, "How many employees do you have?"

"One," I said modestly.

"What's his name?" he asked.

"Damn, I can't remember," I answered.

Dick looked at me sadly. "No wonder," he said, "That you have personnel problems."

For some reason or other I selected the *Raleigh News & Observer* to be oone of the first concerns I called on, and definitely the first newspaper. Frank Daniels, the business manager, was coolly cordial.

"Mr. Mann," he answered after I gave him the pitch. "How many customers do you have?"

"None," I answered, modest as usual.

"And you expect us to be Number One?"

I had him there. "Someone's got to be," I said.

Frank put it in the form of a challenge. "You go home," he said, "And sign up the *Winston-Salem Journal-Sentinel*. Then come back here, and you'll get our business."

Which I did.

At one time Hap Rack was chief totem of Southern Microfilm of Louisiana, and Charlie Fennell ran Southern Microfilm of Texas. But back in 1946 they were just a couple of GI's who were dazzled by the word microfilm, and decided to pool their limited resources and strike out in the promising unknown. They ran into sort of a stone wall to begin with; no one seemed to have any equipment to sell. Recordak simply ignored their inquiries and Remington Rand as well as Burroughs were looking for customers, not dealers. They started searching outside their home town of New Orleans. In Houston they located a company called The Microfilm Corporation of Texas which represented a manufacturer in New York called the Microstat Corporation. This Texas company wasn't out to foster competition, but reluctantly agreed to "share" this dealership in return for a bit of free stock in the new enterprise. So Charlie called Microstat and found out that they had some excellent used equipment that they were loathe to part with, but since the Texas outfit wasn't doing much in Louisiana they *might* let them have

some. At a price.

Charlie said they simply couldn't wait for anything to be shipped to them by conventional means. Furthermore, they wanted to see what they were buying. So they rented a huge trailer, latched it to the rear of their pre-war Oldsmobile and headed North.

They were greeted by a Mr. Heinman and a Mr. Zola at the Microstat headquarters on Park Avenue. These two entrepreneurs left the microfilm industry shortly thereafter, probably the next day, for the greener grass of the movie business. But first they sold Hap and Charlie two moth-eaten J-7 cameras, built of plywood and scrap iron and weighing close to a ton apiece. They also had some used readers that they parted with as well as lot of odds and ends that were lying around the place waiting for the trash truck. But before Mr. Heinman would accept any money for all this equipment, he produced an impressive looking document that appointed Southern Microfilm of Louisiana as a dealer of the Microstat Corporation. In return for this honor, Southern Microfilm would remit 10% of their gross sales. Charlie and Hap happily signed the contract, because, as Charlie told me, "they couldn't wait to get into this easy money business."

The rest of the story is short. After snarling up Manhattan traffic and receiving a few tickets (neither had driven in New York before and didn't know how to handle a trailer), they headed home. They made it, but the Oldsmobile was a complete wreck.

"Needless to say," Charlie confided to me, "It didn't take us long to realize that this 10% royalty would completely eliminate any hopes for any profit for the next ten years."

"Well, how did you get out of it?" I asked.

"Easy," said Charlie. "We went bankrupt."